Drawing
with
Lee Ames

ALSO BY LEE J. AMES

Draw 50 Airplanes, Aircraft, and Spacecraft

Draw 50 Animals

Draw 50 Athletes

Draw 50 Beasties and Yugglies and Turnover Uglies and
 Things That Go Bump in the Night

Draw 50 Boats, Ships, Trucks, and Trains

Draw 50 Buildings and Other Structures

Draw 50 Cars, Trucks, and Motorcycles

Draw 50 Cats

Draw 50 Dinosaurs and Other Prehistoric Animals

Draw 50 Dogs

Draw 50 Famous Caricatures

Draw 50 Famous Cartoons

Draw 50 Creepy Crawlies

Draw 50 Endangered Animals

Draw 50 Famous Faces

Draw 50 Holiday Decorations

Draw 50 Horses

Draw 50 Monsters, Creeps, Superheroes, Demons, Dragons,
 Nerds, Dirts, Ghouls, Giants, Vampires, Zombies,
 and Other Curiosa . . .

Draw 50 Sharks, Whales, and Other Sea Creatures

Draw 50 Vehicles

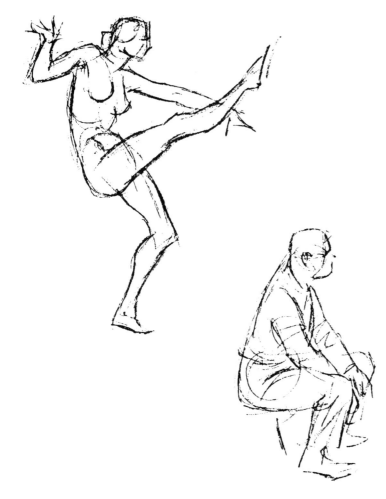
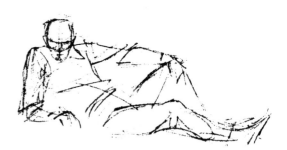

From the bestselling, award-winning
creator of the Draw 50 series,
a proven step-by-step guide
to the fundamentals of drawing
for all ages.

Drawing
with
Lee Ames

Lee J. Ames

**MAIN
STREET
BOOKS**

Doubleday

New York London Toronto Sydney Auckland

A MAIN STREET BOOK
PUBLISHED BY DOUBLEDAY
a division of Bantam Doubleday Dell Publishing Group, Inc.
666 Fifth Avenue, New York, New York 10103

MAIN STREET BOOKS, DOUBLEDAY, and the portrayal of
a building with a tree are trademarks of Doubleday,
a division of Bantam Doubleday Dell Publishing Group, Inc.

Designed by Tamara Scott

Library of Congress Cataloging-in-Publication Data

Ames, Lee J.
 Drawing with Lee Ames : Lee J. Ames. — 1st ed.
 p. cm.
1. Drawing—Technique. I. Title.
NC730.A57 1990 90-31436
741.2–dc20 CIP

ISBN 0-385-23701-4

Printed in the United States of America
September 1990
10 9 8 7 6 5 4

For George Bridgman, J. H. Vanderpoel and the other authors and teachers who taught me and for my wife and family who've had to put up with me. And for wonderful Aunt Sophie who, sadly, has just left us.

TABLE OF CONTENTS

Introduction .1
A Variety of Things3–34
Scenes & Still Lifes35–89
The Nude Human Figure91–165
The Clothed Human Figure167–211
Portraits .213–257
A Note on the Rough Sketching
 of the Preliminary Steps258
Bibliography .261

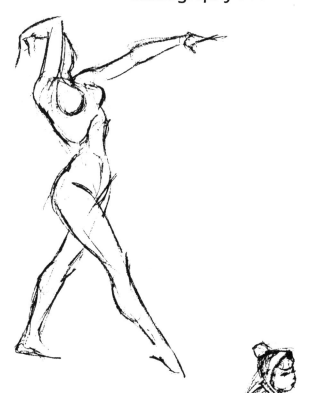

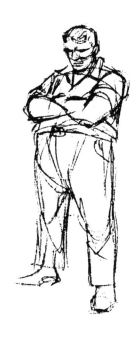

INTRODUCTION

In my early learning years I frequently thought how wonderful it would be if I could watch artists make drawings and paintings from start to finish.

There are certainly many ways to draw. It would be a grand gift, I dreamed, if a variety of accomplished artists could show us how they do it; if one could follow, from beginning to completion, the process these artists used. Imagine being able to choose from a bookshelf a dozen different drawing approaches, each enabling you to build full drawings stage by stage.

This is my dream for this book. It shows my method. You can follow along and construct drawings as I've done. Following step-by-step has proven itself an effective learning tool for many of my readers.

The process does work. I've often been asked, "What should I draw?" "How does one begin?" Here I offer you a variety of subjects and a hands-on way to start, develop, and complete drawings.

What I offer, primarily, is a pleasurable experience. Additionally there is sound teaching value.

Mimicry is prerequisite to creativity. In any endeavor, one must learn the use of his tools before one can create. For example, one learns language (by mimicry) before becoming a poet or an author. A music student learns to play simple selections by copying, mimicking, and perhaps memorizing, note by note, another's composition. This before the student is weighed down with music theory. Encouraged, later, he willingly goes on to a much broader involvement in musical education.

Pleasurable achievement is a most encouraging turn-on. Small, but complete and satisfying, accomplishments can be heady stimulants. The intention of this book is to enable the reader to achieve this satisfaction and then to move on to the joys of creation.

Here I offer you my way of developing drawings. I would hope other artists would come out with books showing *their* step-by-step approaches. It pleases me to feel I may be helping to revive an effective, but much neglected, teaching method.

A VARIETY OF THINGS

Selections from the Draw 50 series

Draw 50 Animals, which started in the early 1970s, became an instant success. Many Draw 50 volumes followed and enjoy continuing popularity. The demand from children, adults, professionals, and senior citizens has kept me happily busy for many years.

In this section you'll find samplings from a variety of Draw 50 titles. The following pages offer you thirty different subjects to put to paper.

Some tips: Look at my final drawing, on each page, as your model. As you form and build your drawing, step-by-step, do so very lightly. This will enable you to make adjustments easily. Don't hesitate to use an eraser to keep the construction light.

Consider the first step to be the most important. Draw carefully and lightly. Watch the proportion of spaces as well as the shaping of the lines. Judge the overall relationship of your sketch to the size of your drawing paper. Now consider the second step the most important, then the third, then the fourth, and so on.

When you've got it all in place, lightly, when the framework and the details are all just right, lightly, you are entitled to your dessert. Completing the final drawing with strength and conviction can provide very sweet satisfaction.

Drawing with Lee Ames

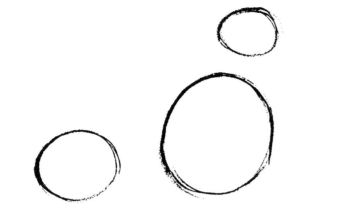
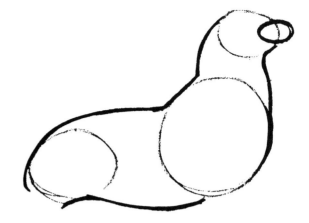
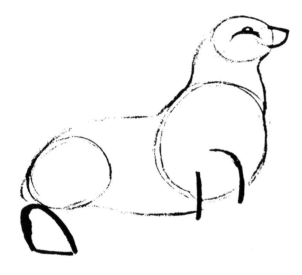
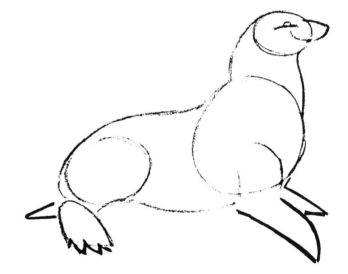
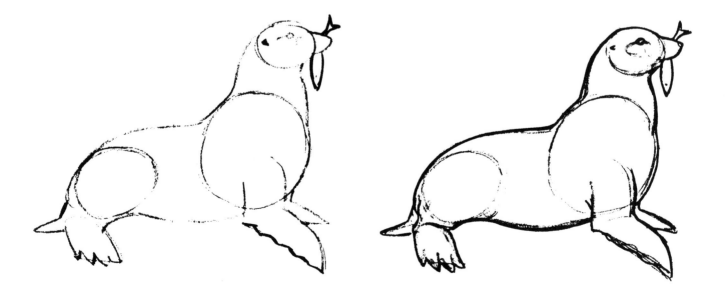

From *Draw 50 Animals* SEAL

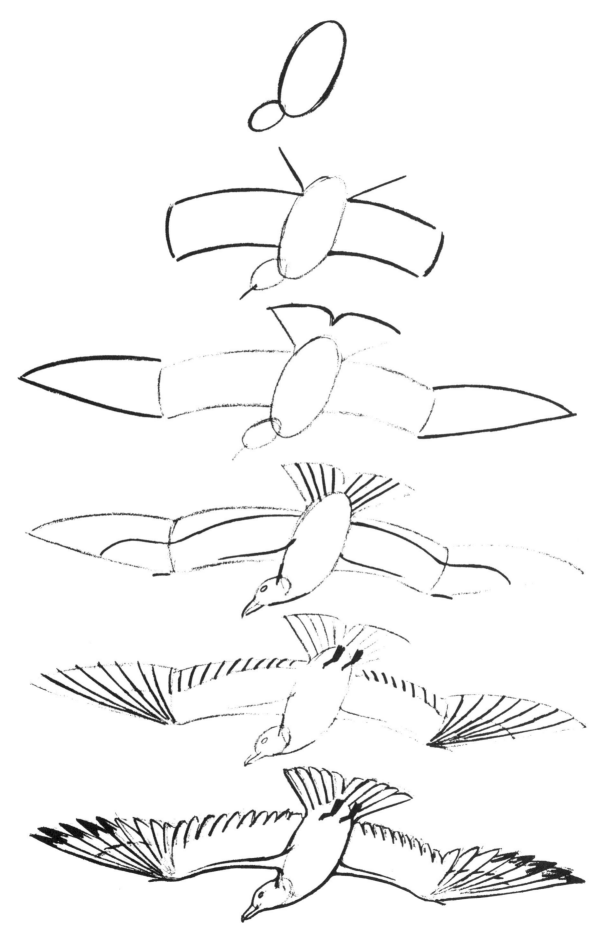

SEAGULL From *Draw 50 Animals* **5**

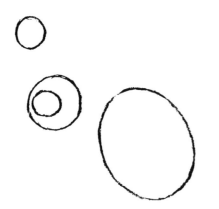
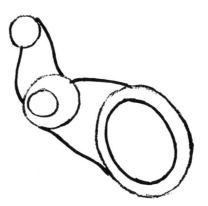
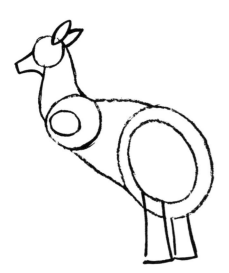
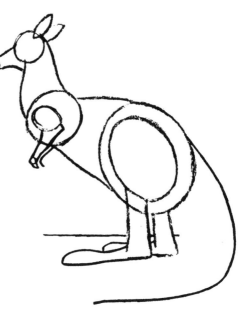
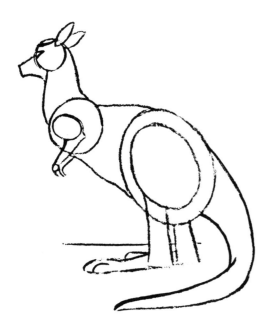
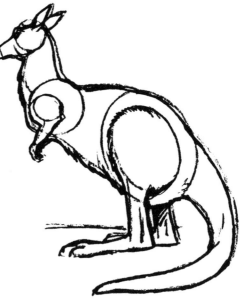

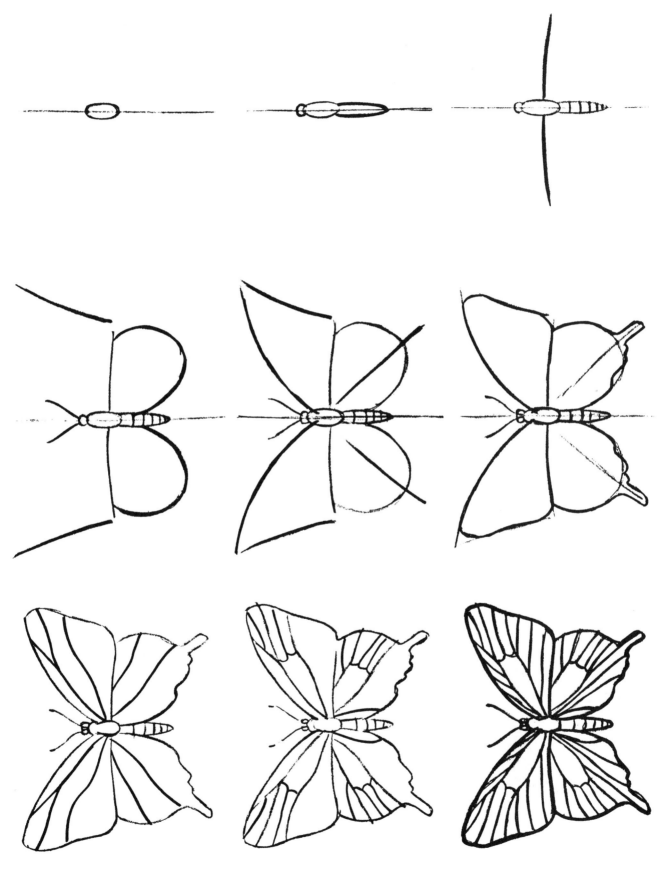

BUTTERFLY From *Draw 50 Animals* **7**

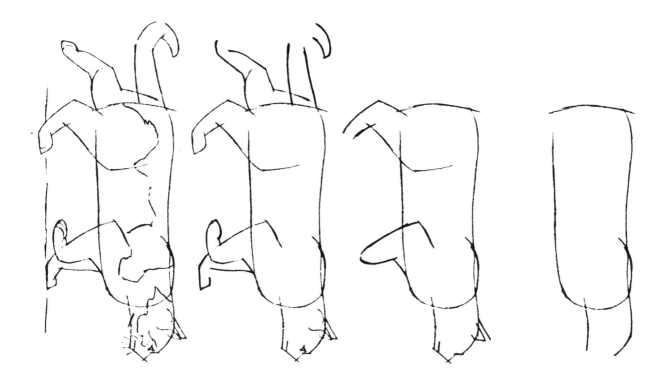

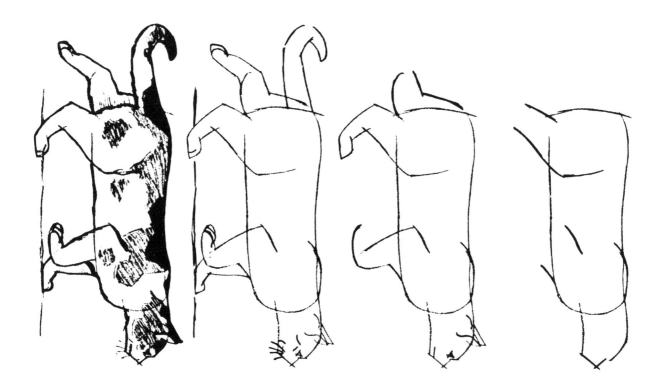

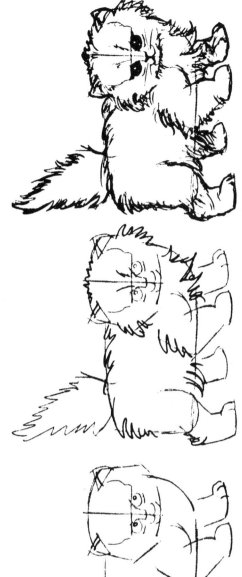

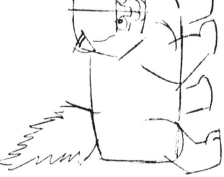

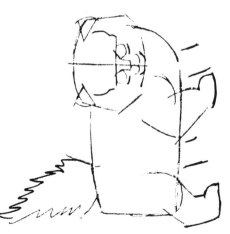

PERSIAN KITTEN　　　　From *Draw 50 Cats*　**9**

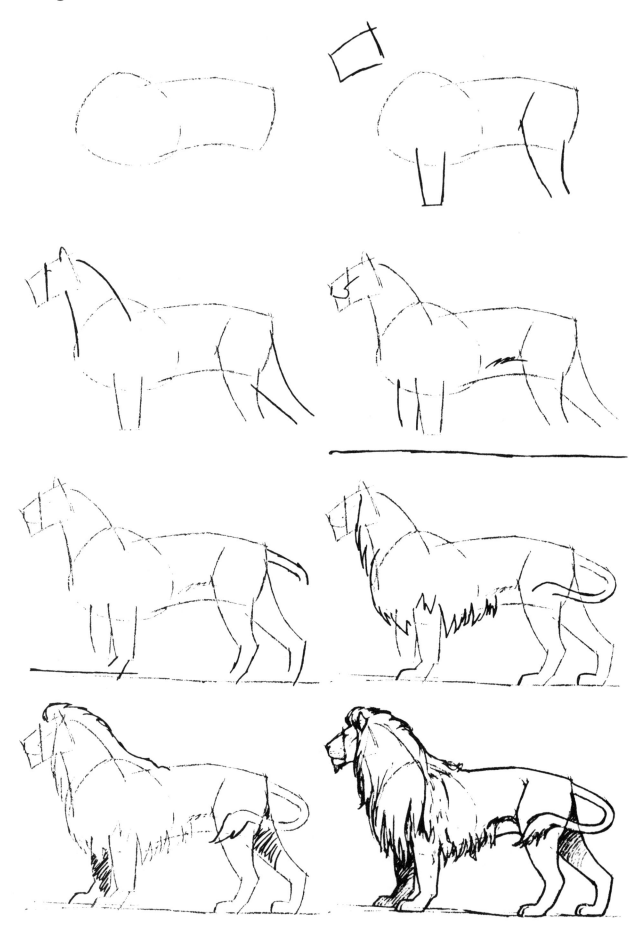

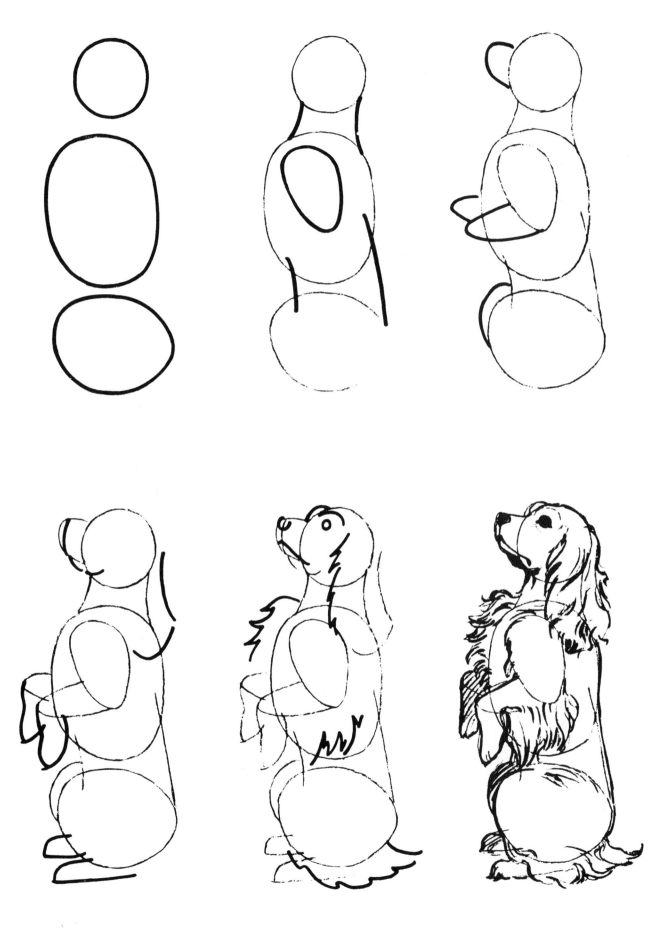

COCKER SPANIEL From *Draw 50 Dogs* **11**

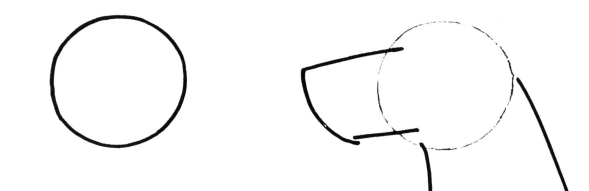

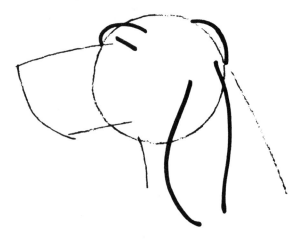
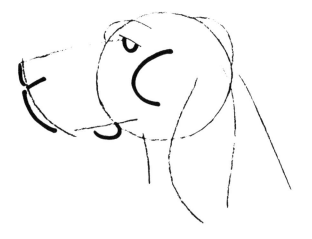

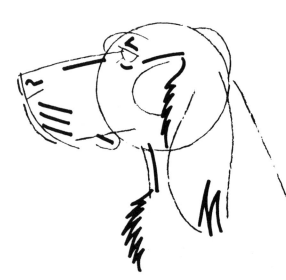
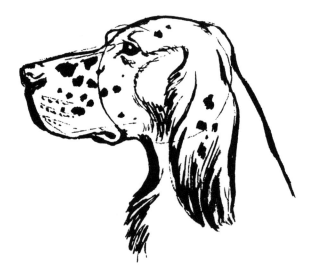

From *Draw 50 Dogs* ENGLISH SETTER

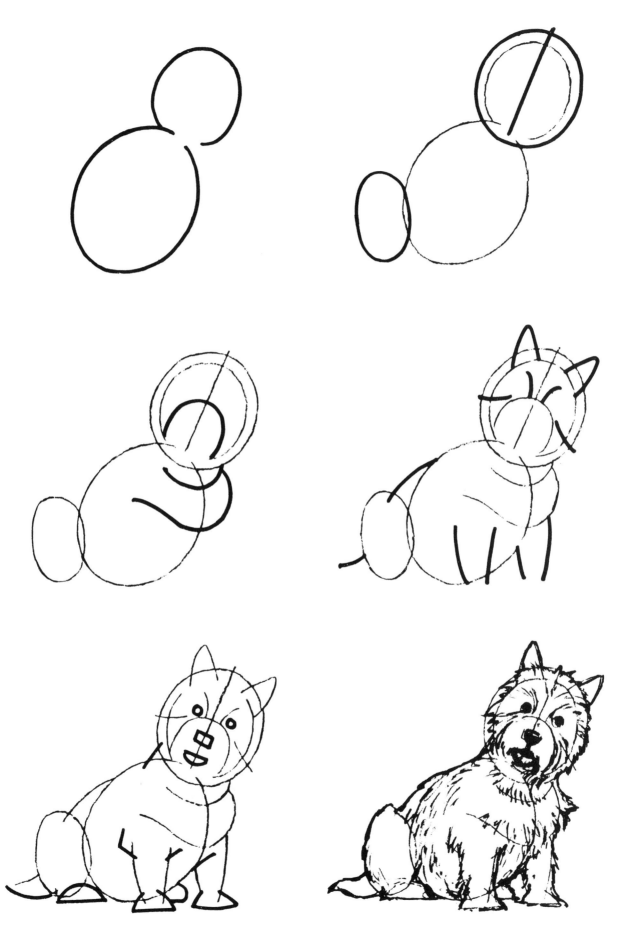

WESTIE TERRIER From *Draw 50 Dogs* **13**

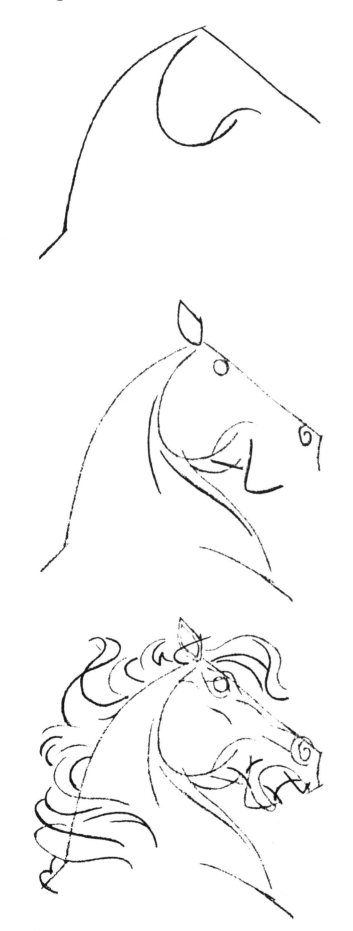
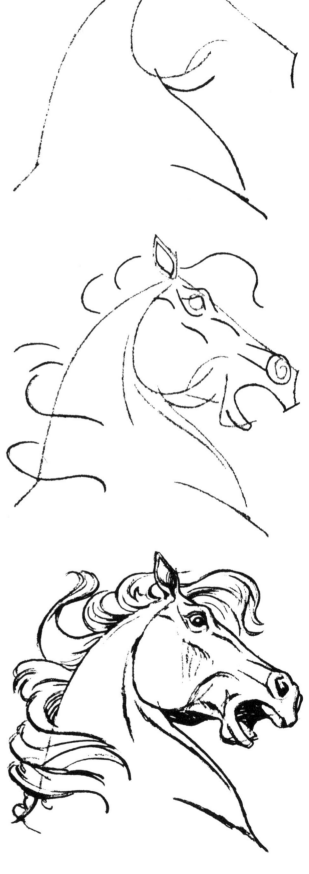

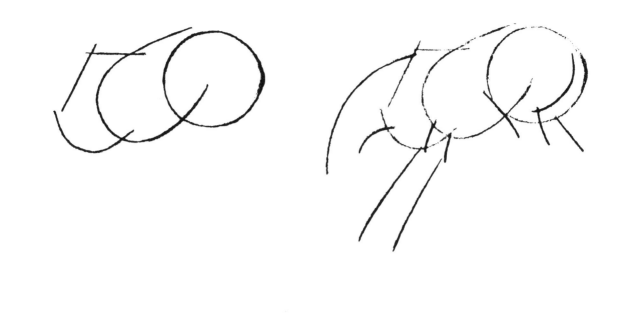

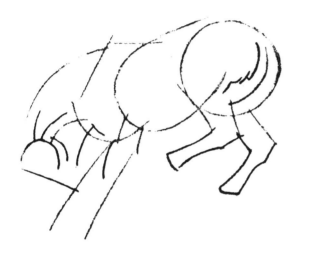

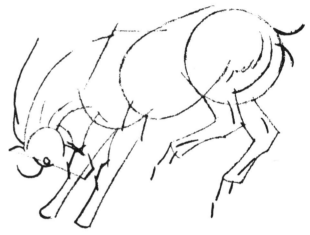

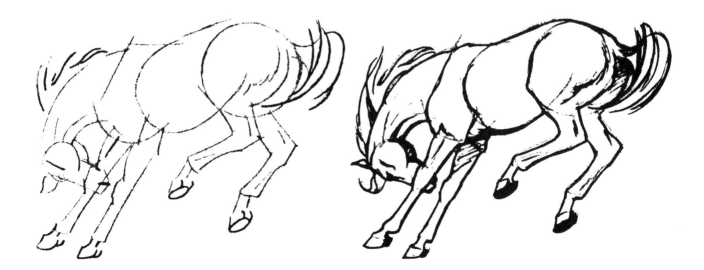

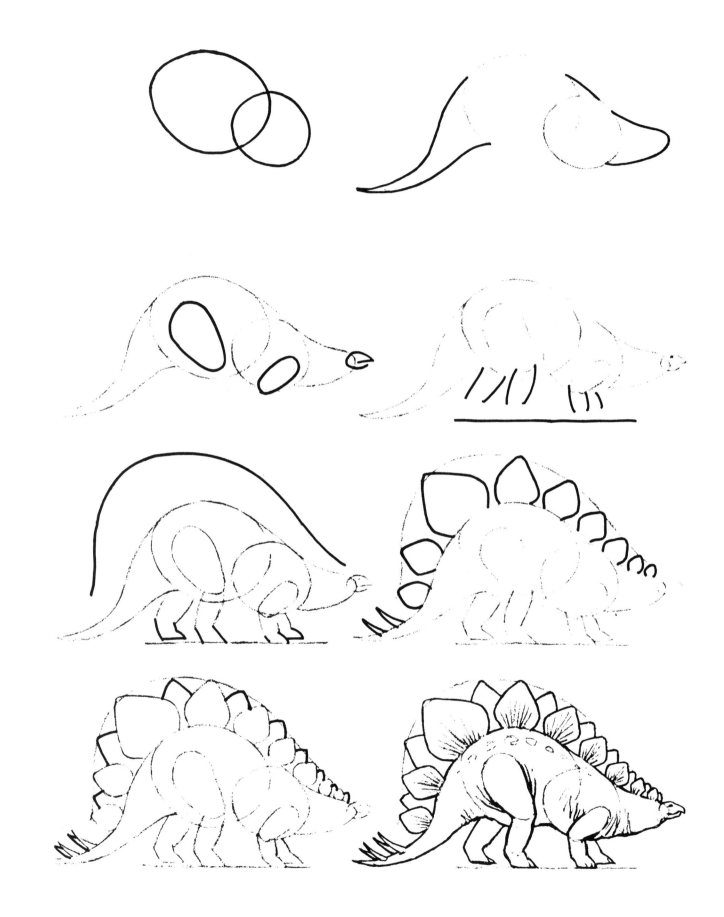

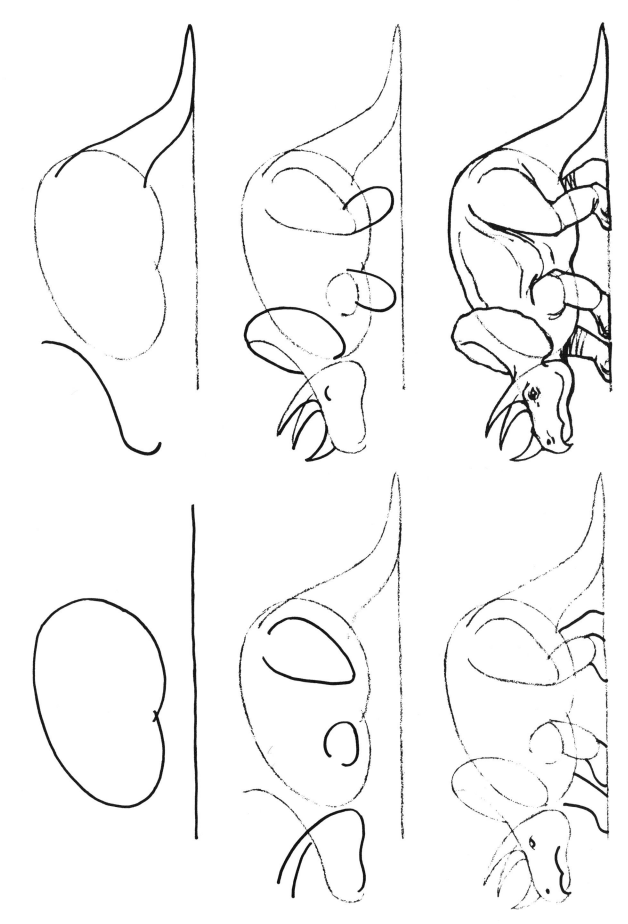

TRICERATOPS From *Draw 50 Dinosaurs* **17**

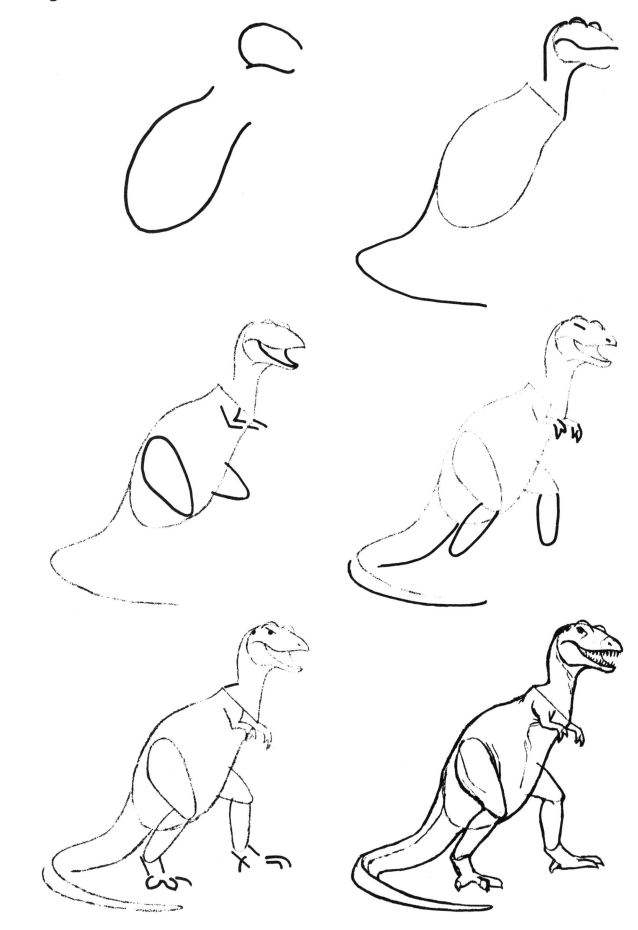

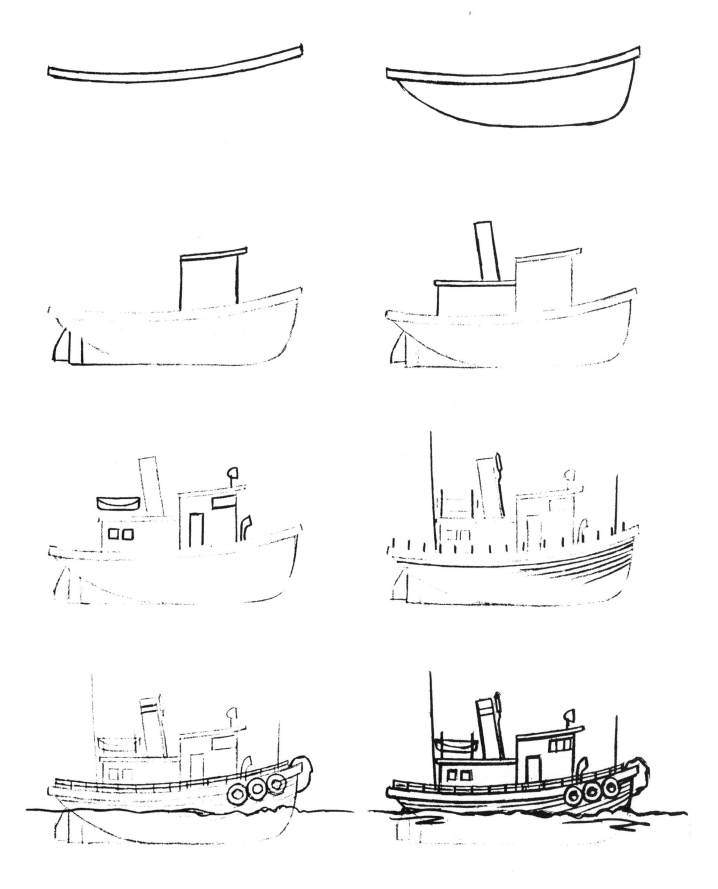

MINI TUG From *Draw 50 Boats and Ships* **19**

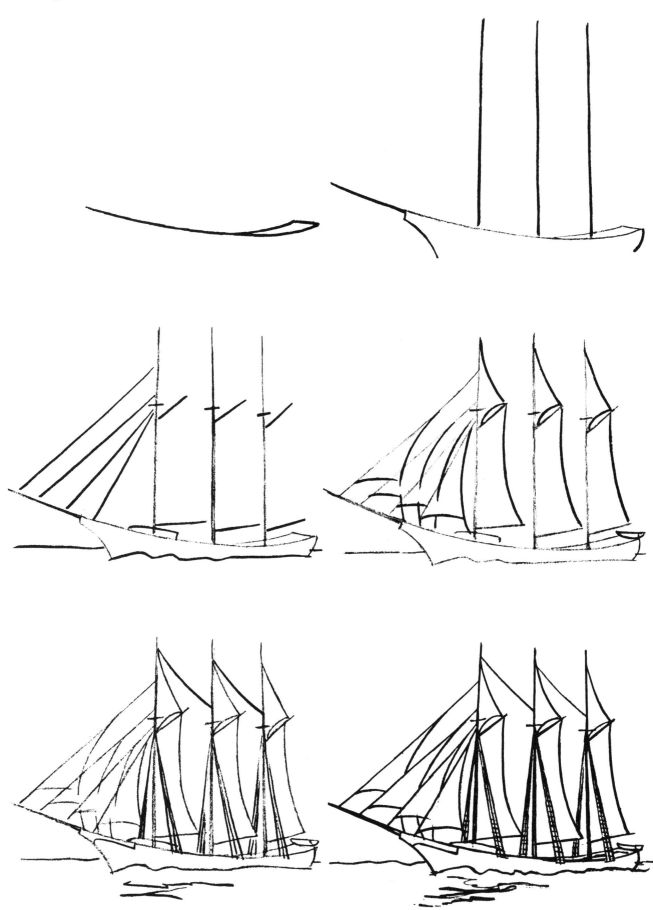

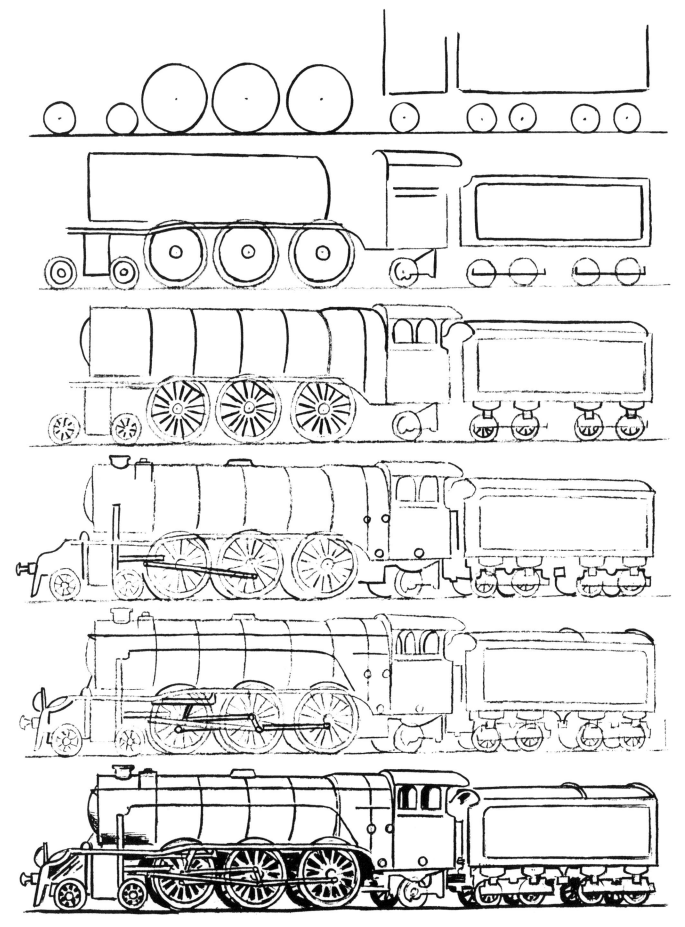

LOCOMOTIVE From *Draw 50 Vehicles* **21**

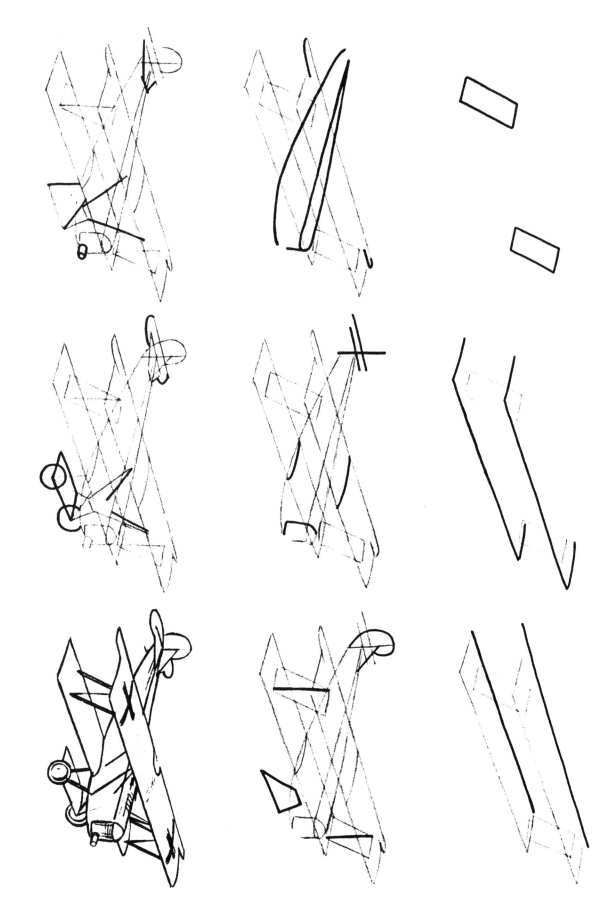

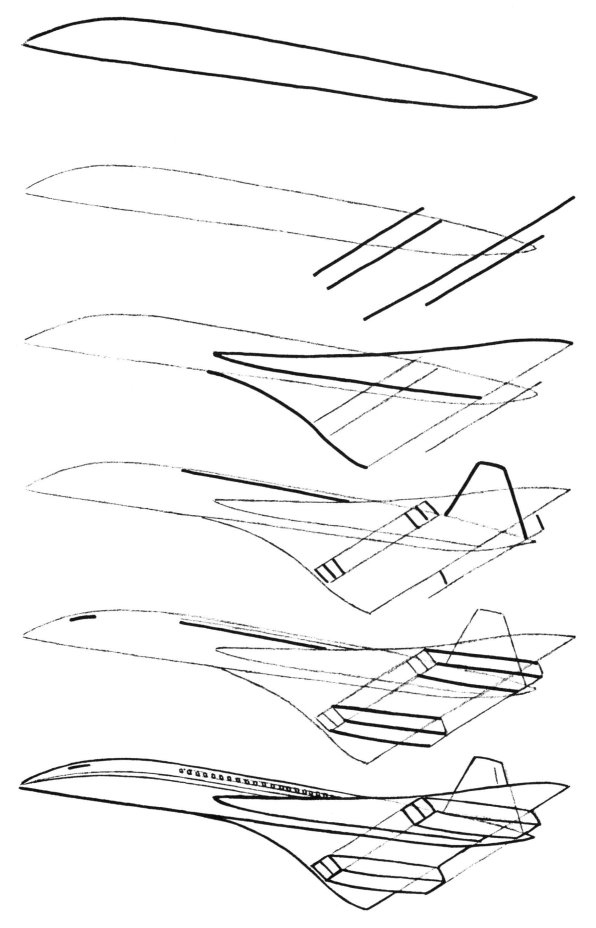

CONCORD SST From *Draw 50 Airplanes* **23**

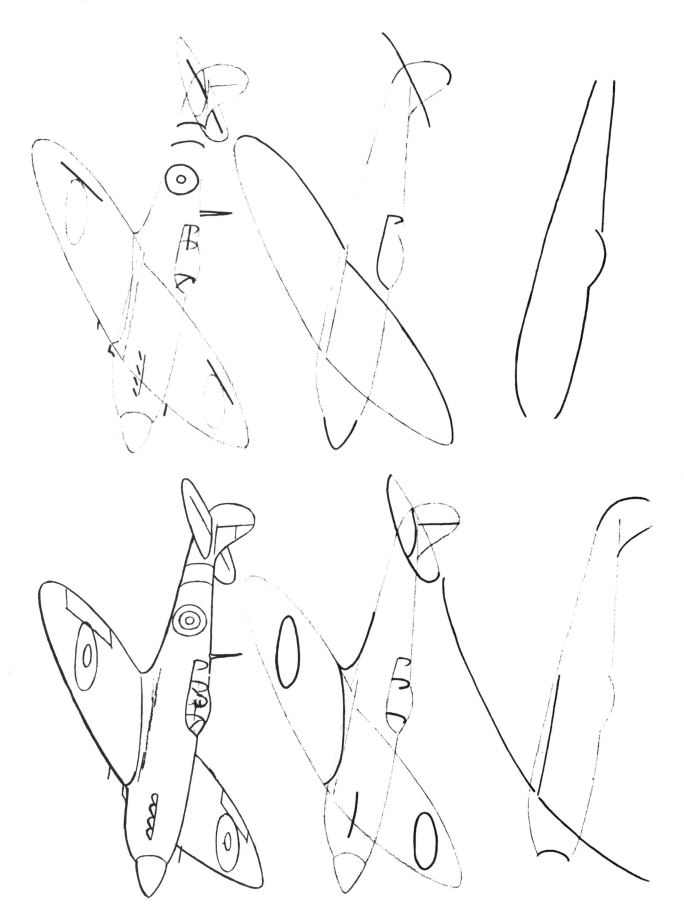

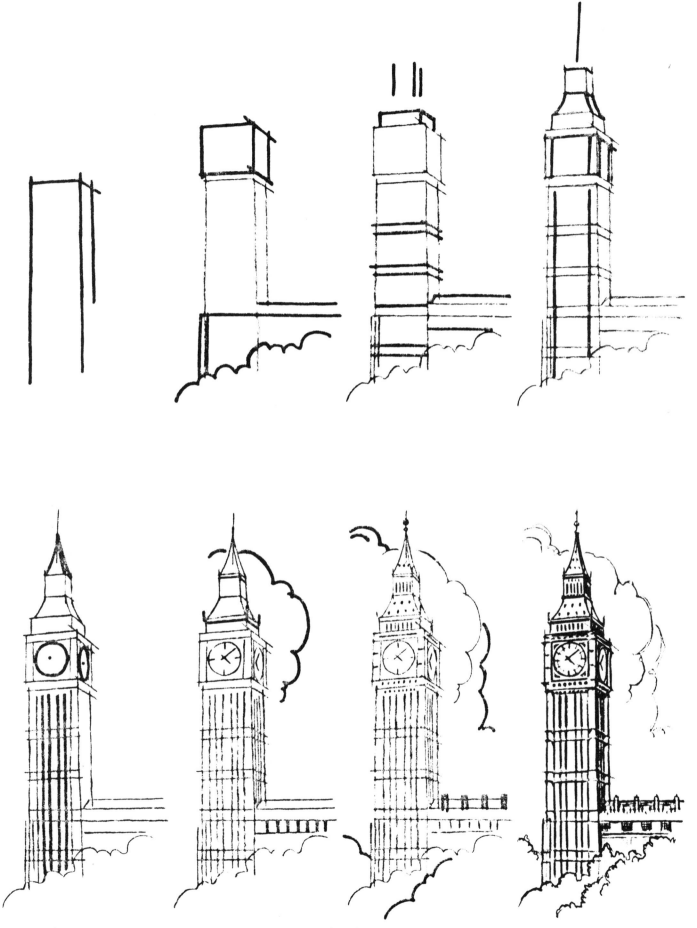

BIG BEN From *Draw 50 Buildings* **25**

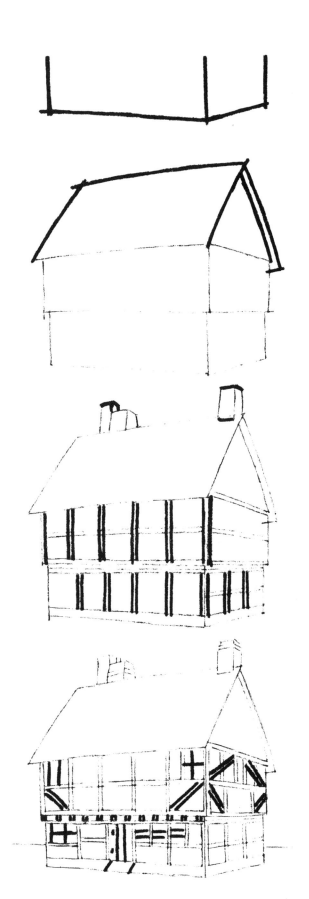
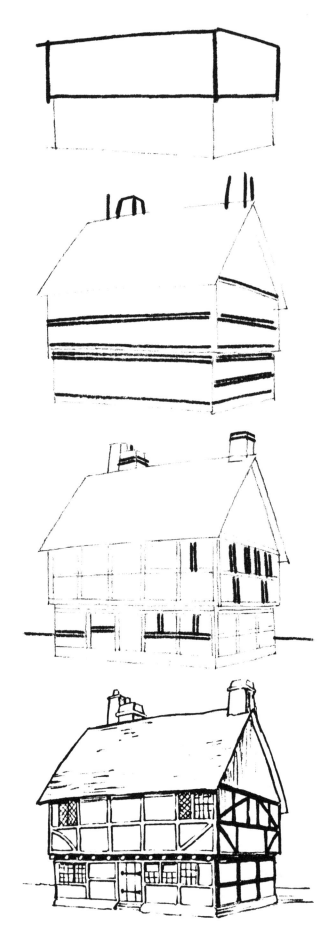

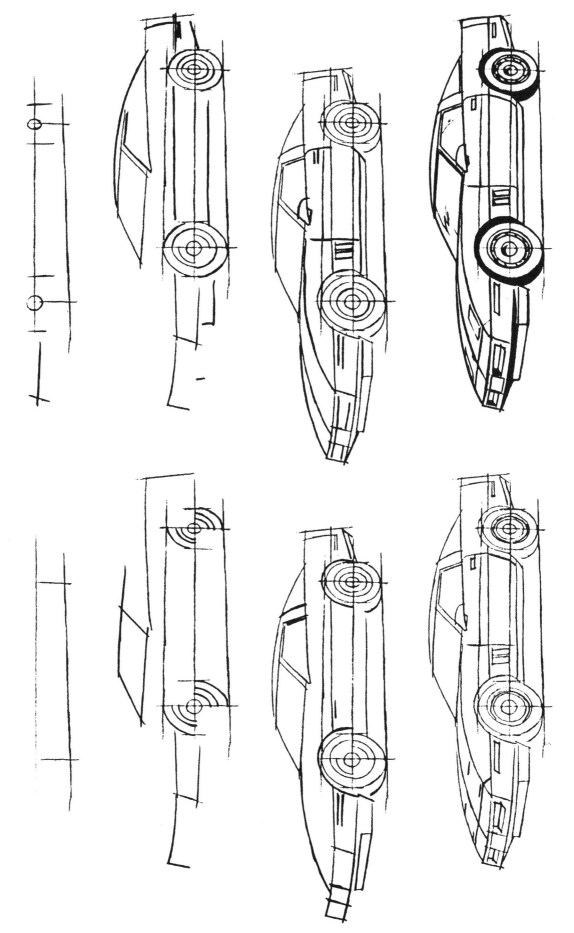

CORVETTE, 1984 From *Draw 50 Cars* **27**

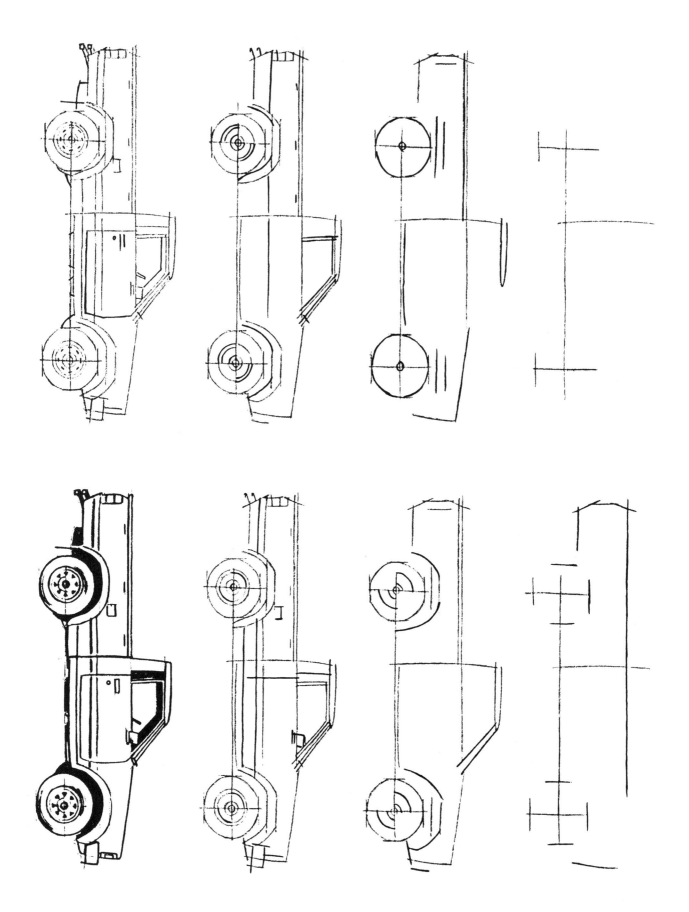

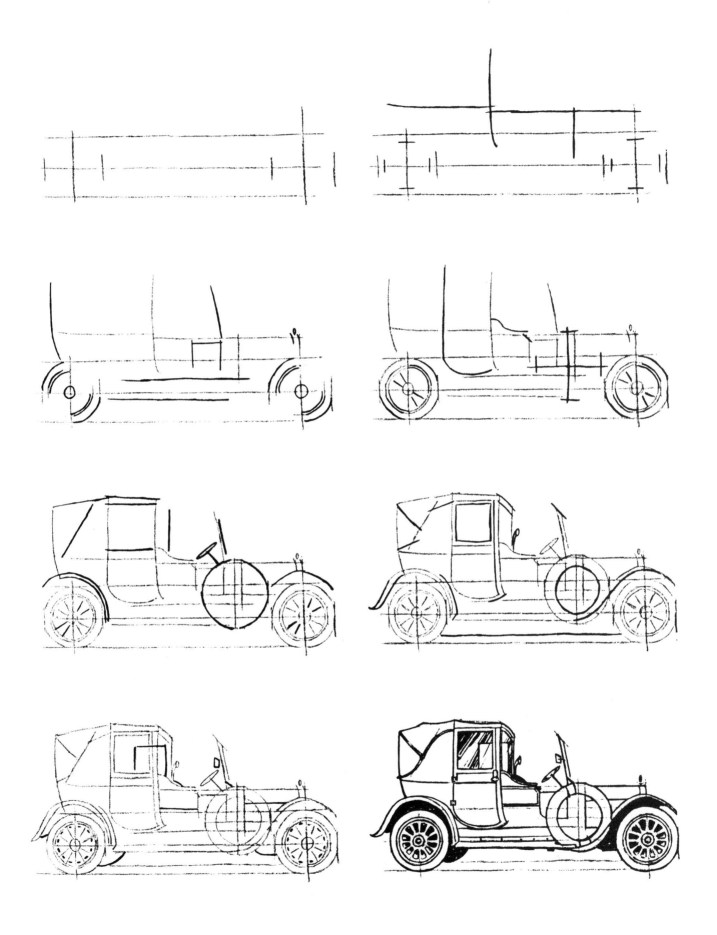

1912 BREWSTER

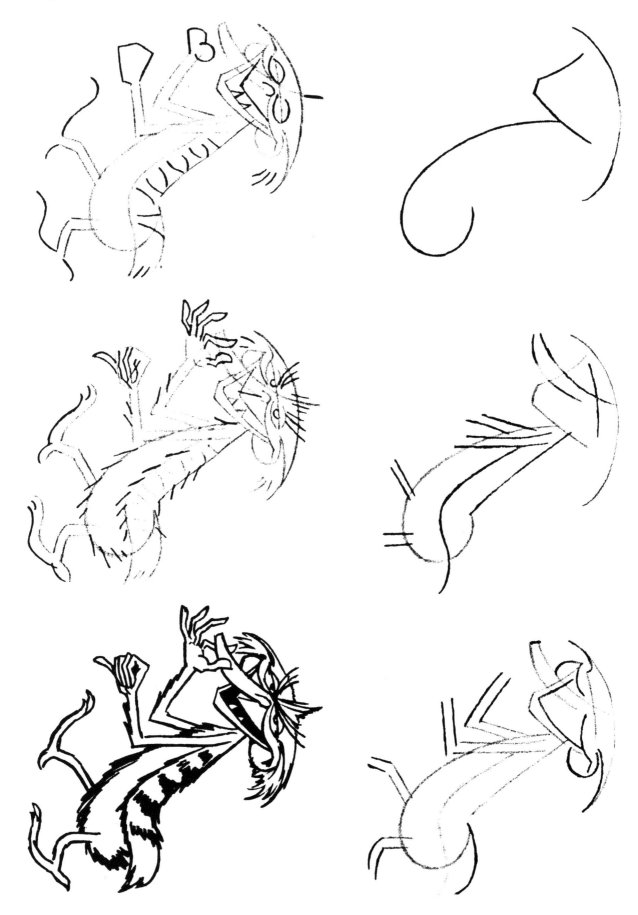

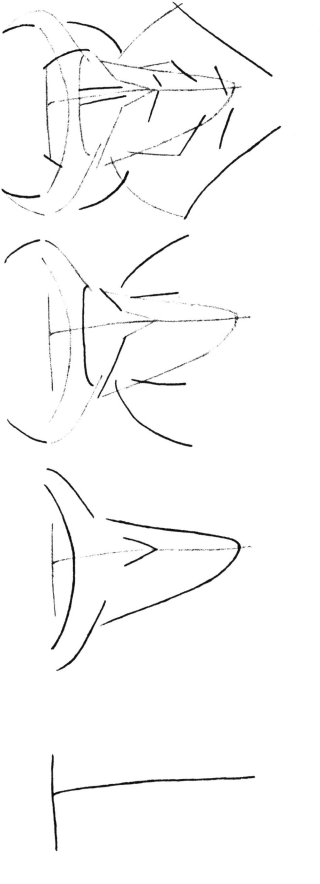

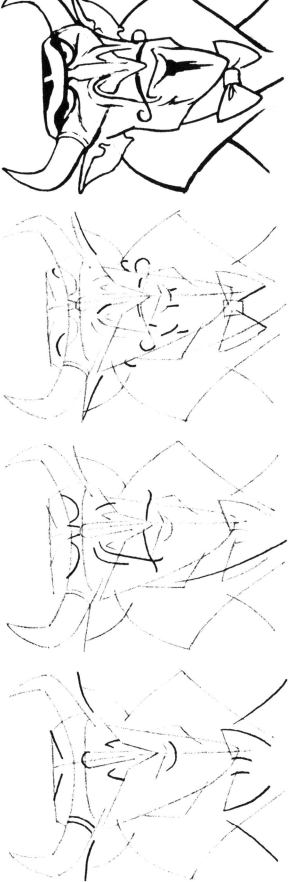

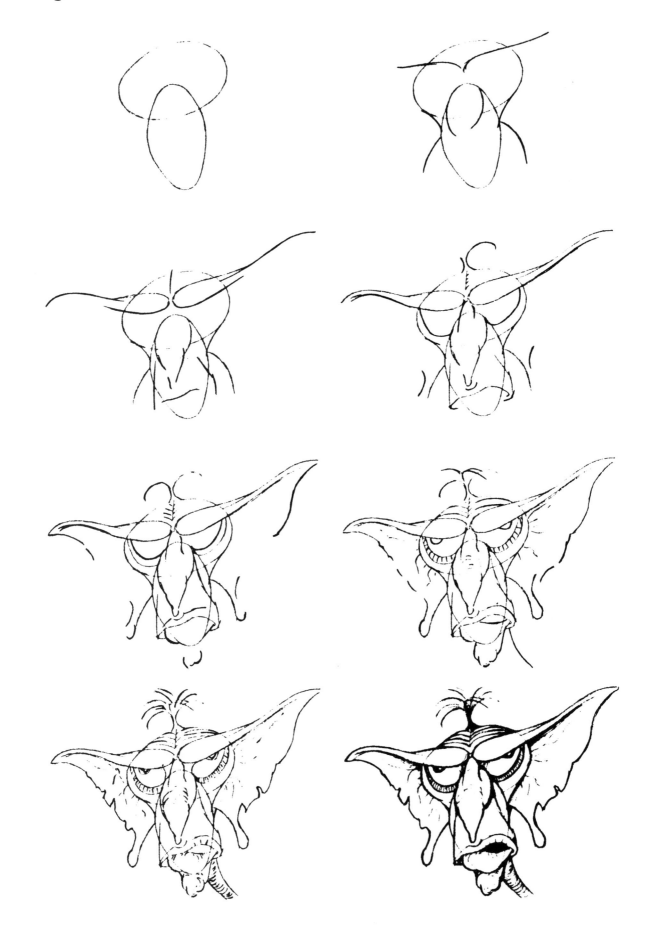

From *Draw 50 Beasties* IMP ERIE AL

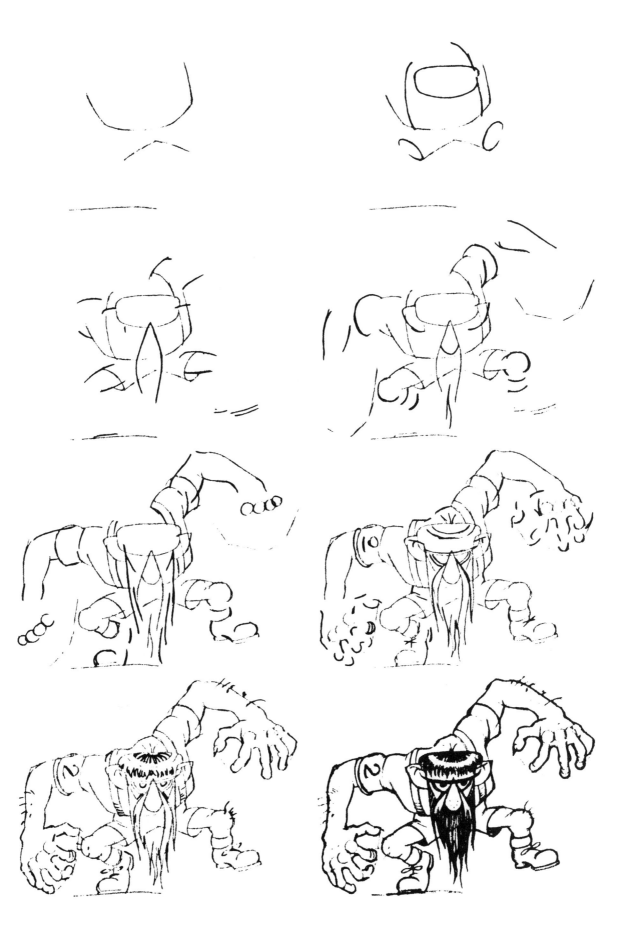

GNOME BURT 000 From *Draw 50 Beasties* **33**

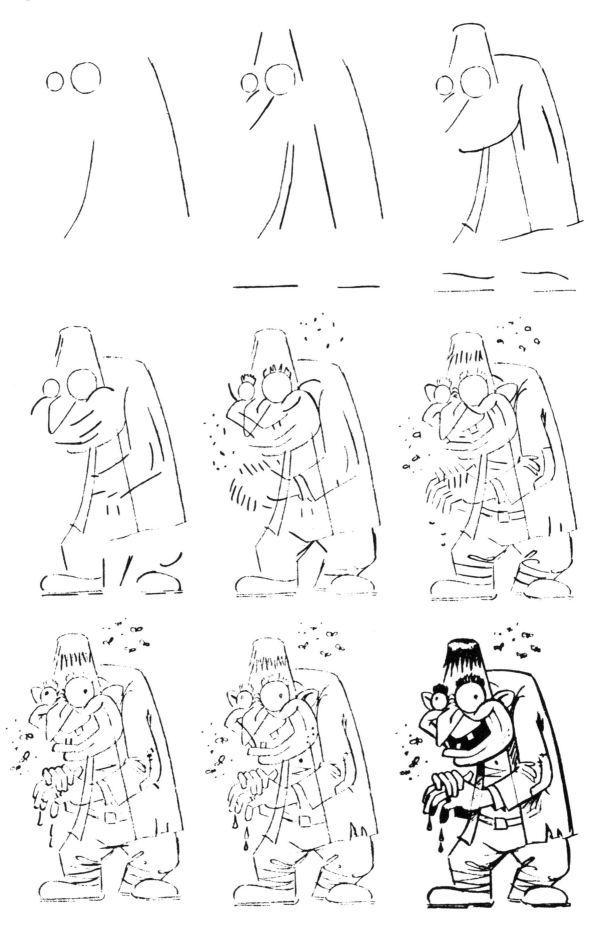

From *Draw 50 Beasties* EYE GORE

SCENES & STILL LIFES

The Mini-roughs for Scenes and Still Lifes

Many years ago my doting, artist aunt advised me there were two kinds of artists. The first type consisted of artists who approached drawing with their eyes first, the second drew with their hands first. I interpreted "eyes first" to mean the cautious planning, thinking, looking, then doing. "Hands first" suggested instinctive doing.

I sketched this assortment of "thumbnails" (reproduced in actual size) using the "hands first" method. Over an extended period I assembled them from various sources—a photograph, a memory, an imagining, an illustration.

The more one practices working "eyes first" the more easily one develops the ability to use "hands first"!

The completed drawings that follow were elaborations of some of these mini-roughs. I look upon these finished pieces as the result of using my "eyes first."

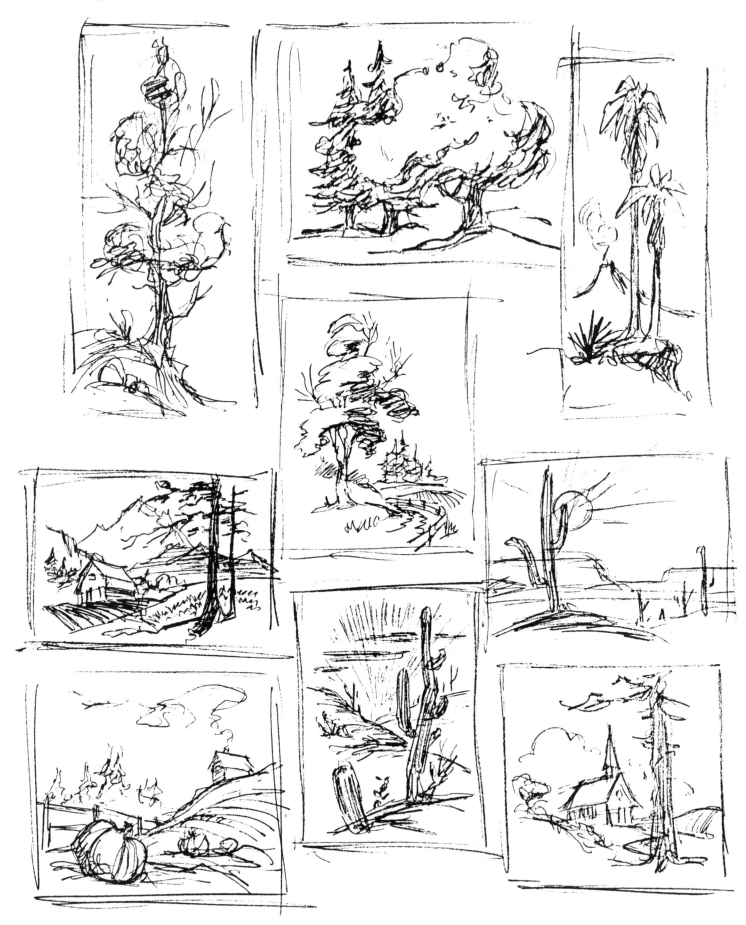

The Mini-roughs

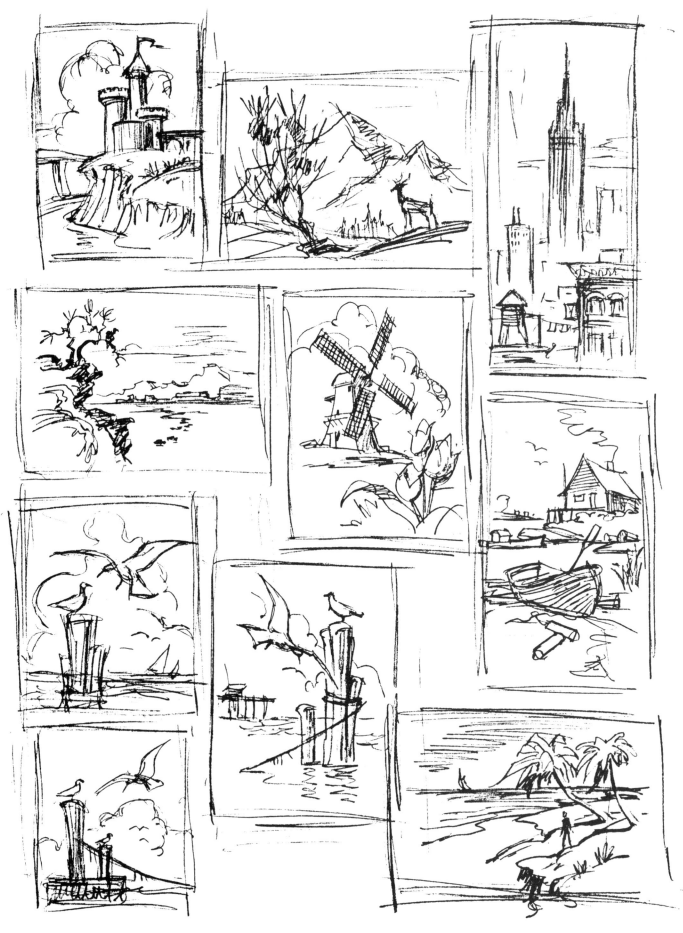

The Mini-roughs

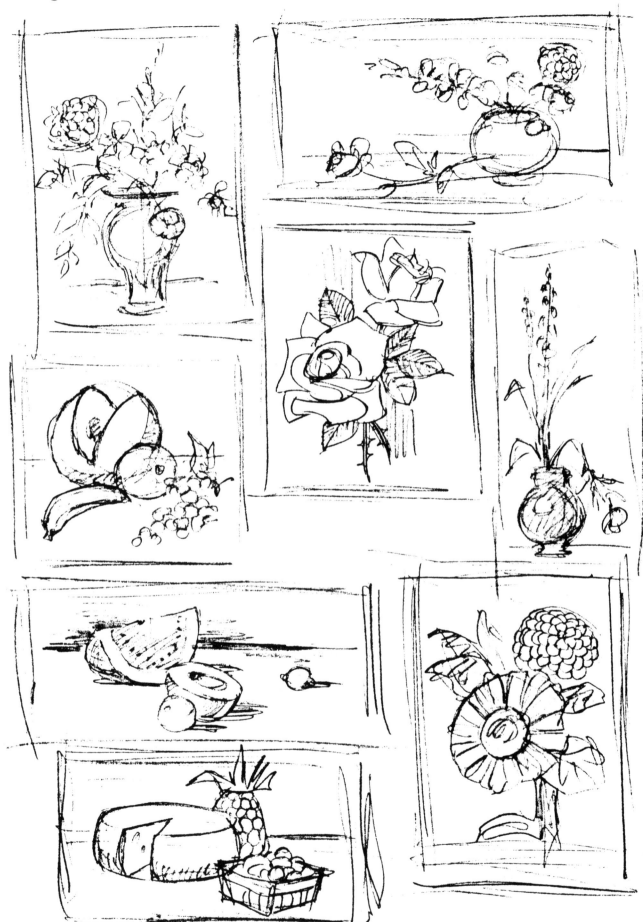

The Mini-roughs

Drawing Scenes & Still Lifes

Use the following ten pages as "models" for the ten scenes and still life subjects. These also serve as a guide for a reasonably good working size (same size as my originals), and for showing finer detail.

The drawings in this take you step-by-step to completions. Draw each step with a "camera" eye. What you see is what you draw! Be aware of what each step contributes to the formation. I've purposely avoided offering basic principles, theories of perspective, graphite techniques, etc. There are many fine books available in all of these areas. Get them, use them. This book has another purpose. It intends to offer "hands-on" agreeable achievement.

There are twelve or sixteen steps that lead to each complete drawing. When I make a drawing the actual number of steps would, on average, be much greater. Since it would be impractical to show the sixty, seventy, or more steps usually required, I've minimized the number. The steps chosen are the essential ones. Remember, do everything lightly until you've got it right. Watch the lines, the spaces, and the relative proportions between. When you are certain it's all correctly developed, finish it up slowly but with conviction.

THESE DRAWINGS WERE DONE ON 8 ½" × 11" OR 9" × 12" SHEETS OF BOND PAPER (USE OTHER QUALITY DRAWING PAPER, IF YOU PREFER). PROVIDE YOURSELF AS WELL WITH A SOFT PENCIL, GRADE HB OR B, AND A KNEADED ERASER.

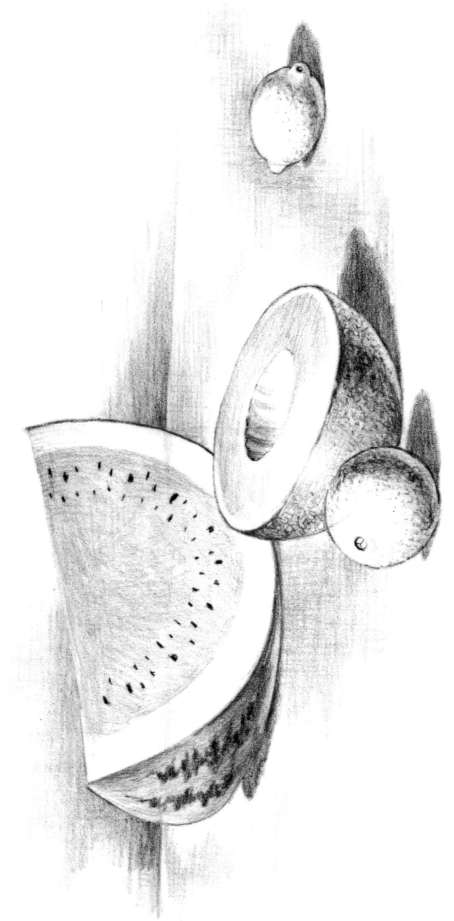

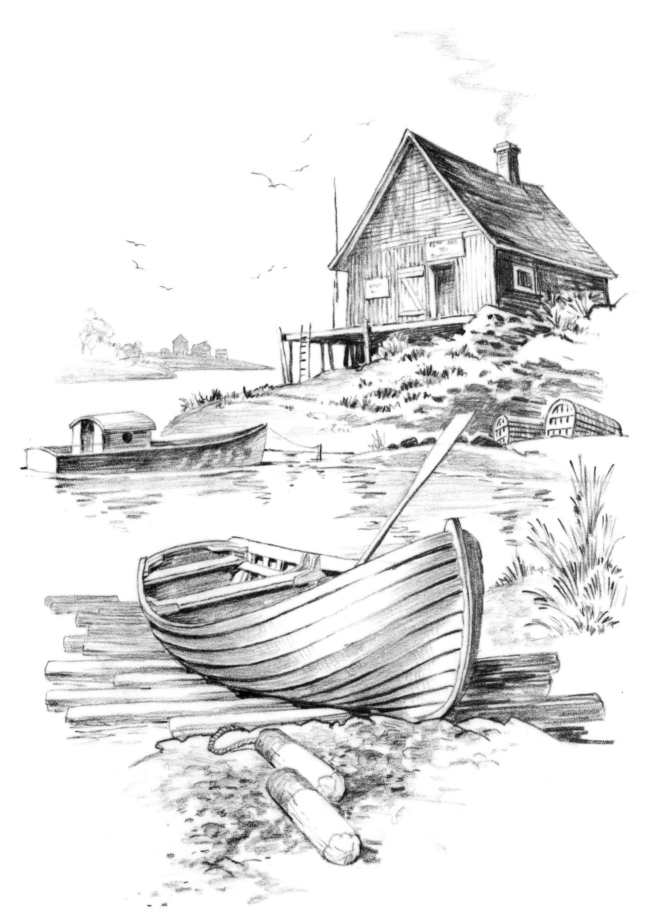

CAPE COD

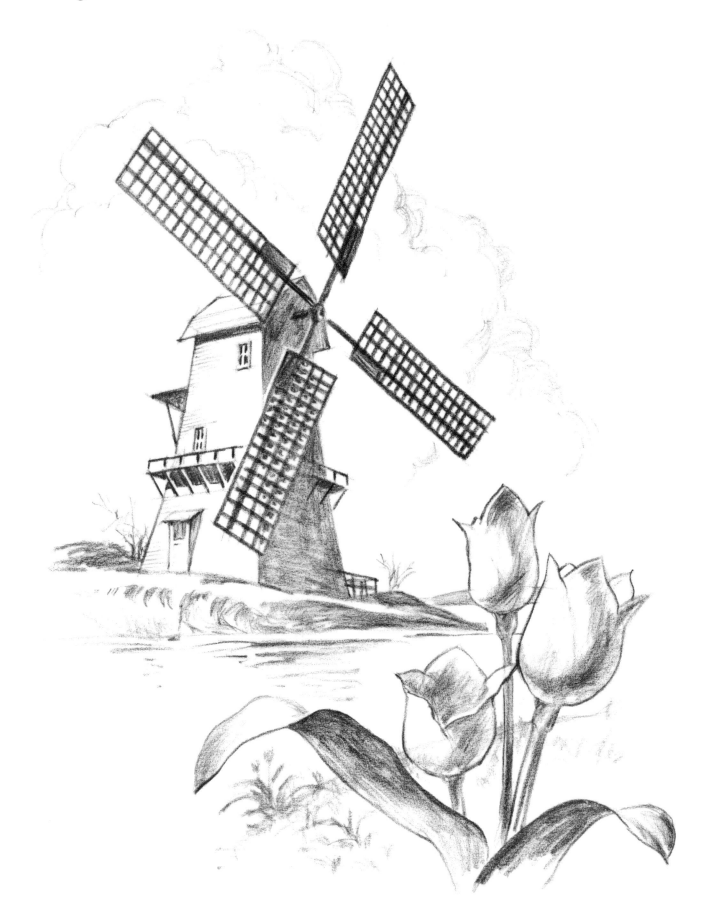

WINDMILL AND TULIPS

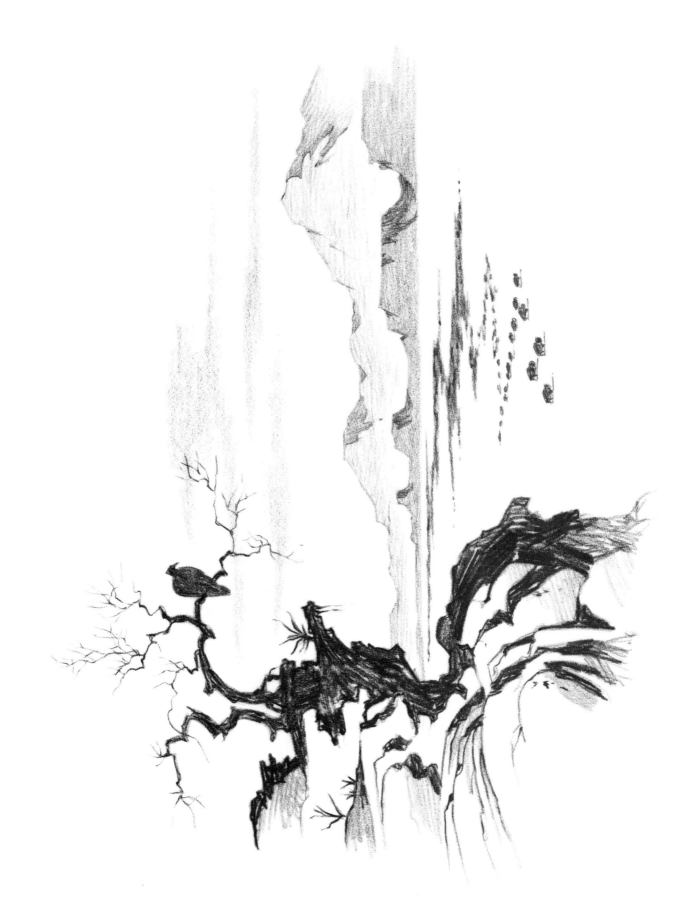

A HERD OF BISON

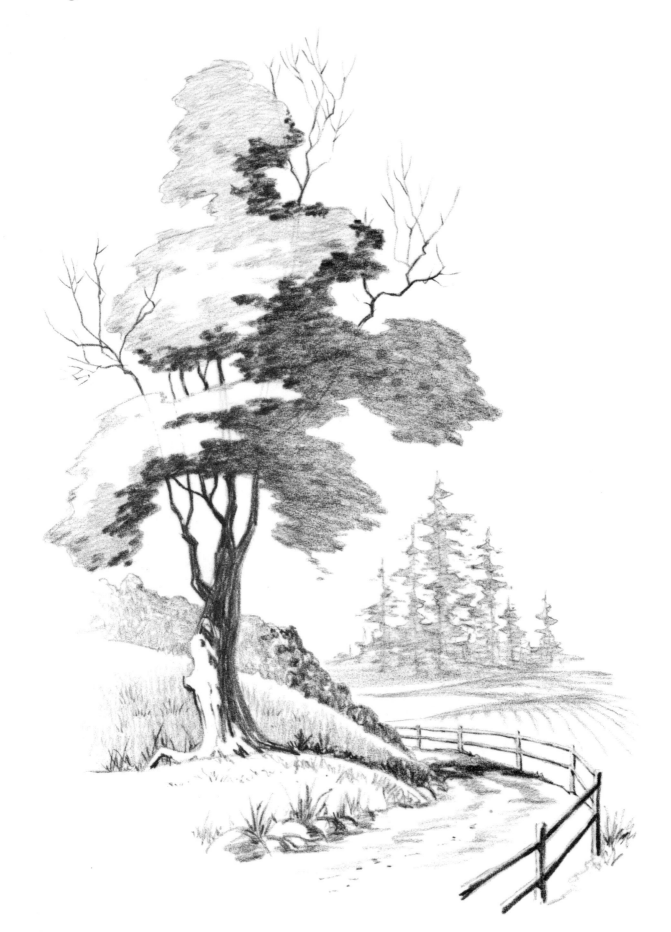

TREES AND FURROWS

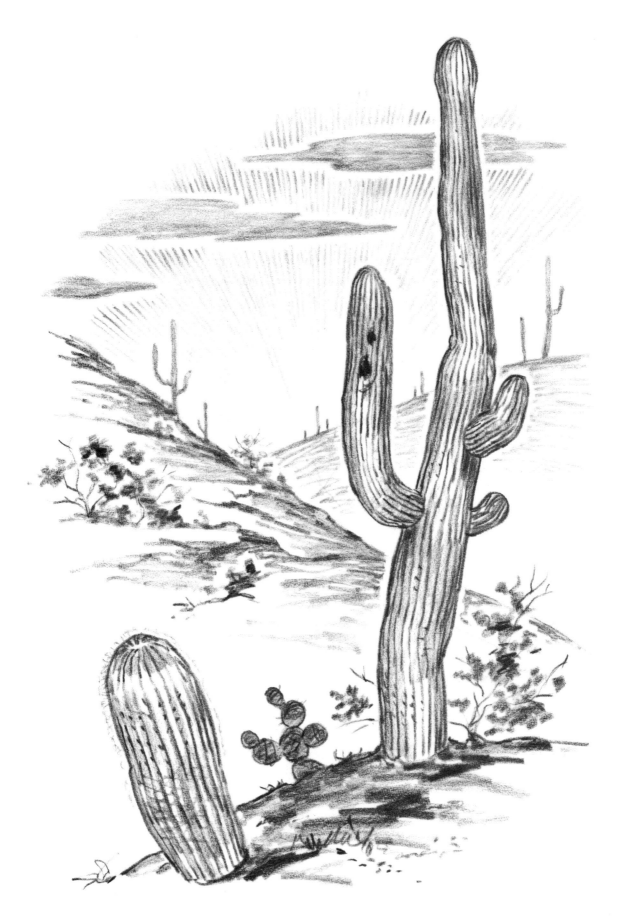

SAGUAROS The Models **45**

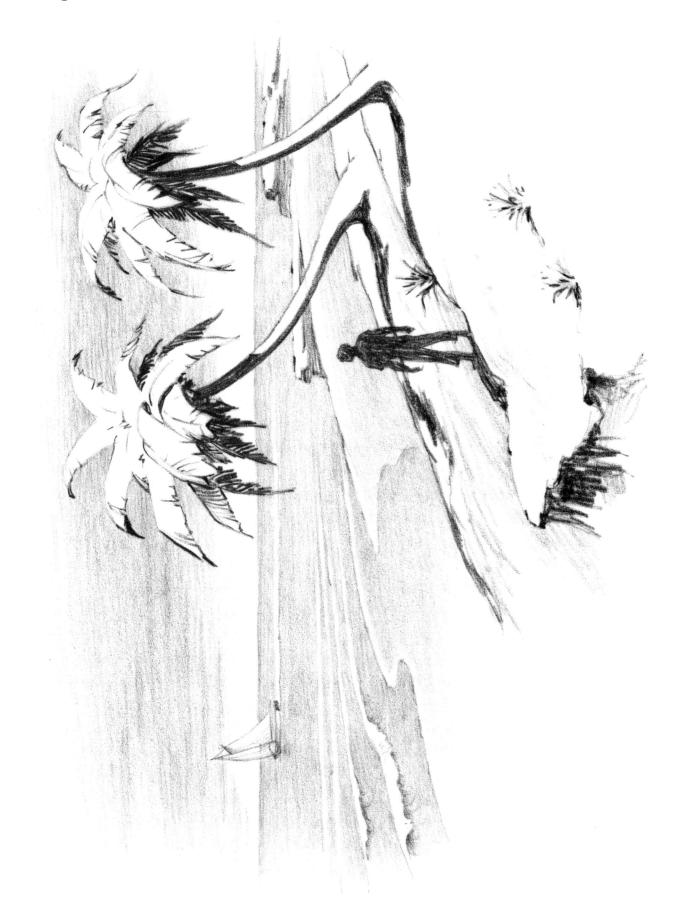

ROSES The Models **47**

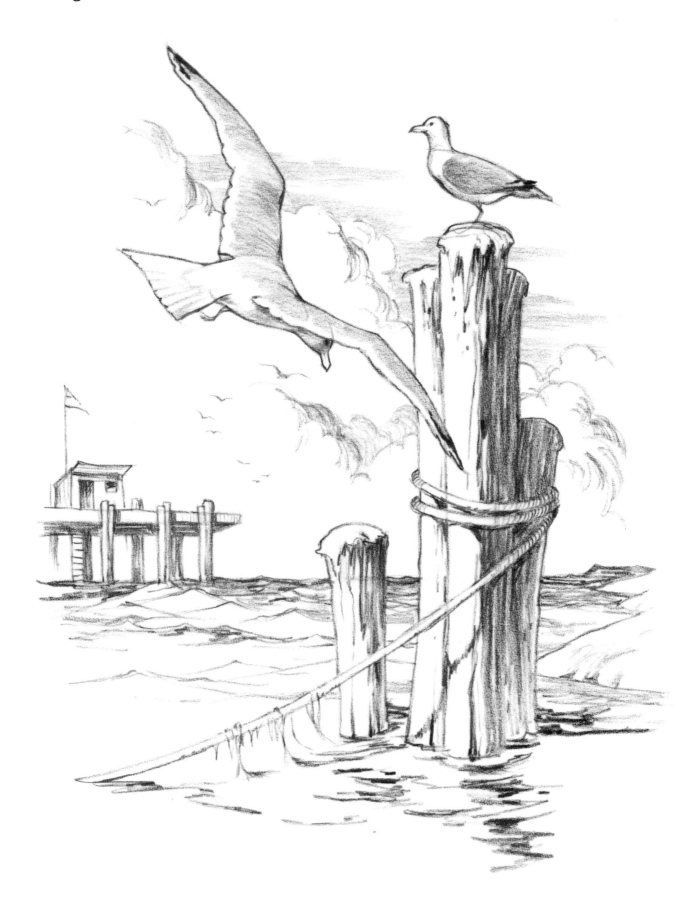

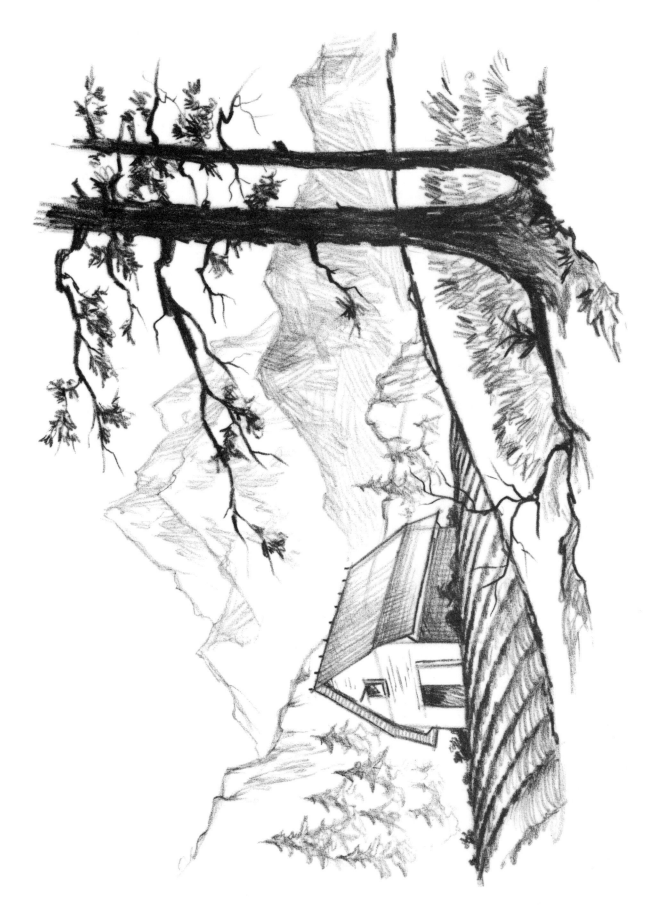

ALPINE BARN

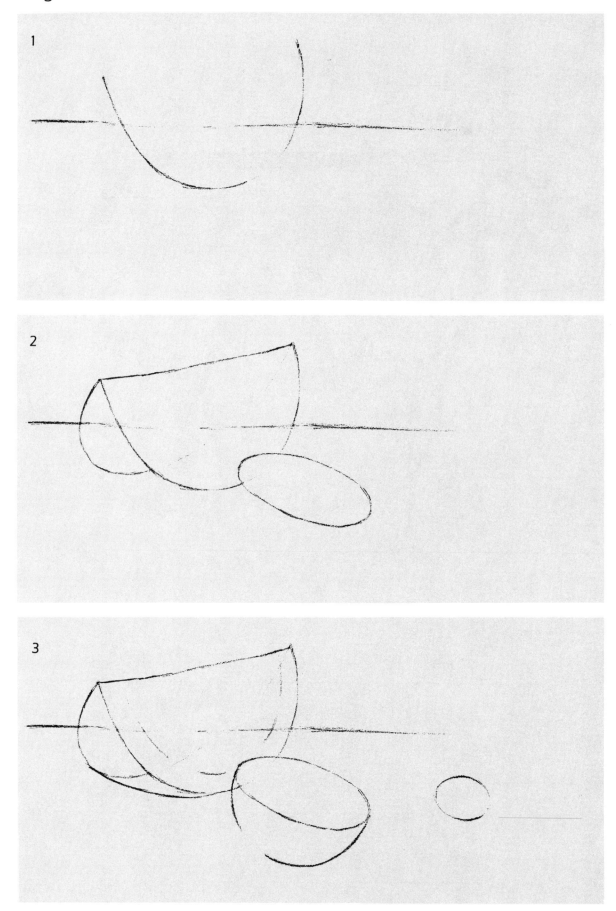

MELONS, AN ORANGE AND A LEMON

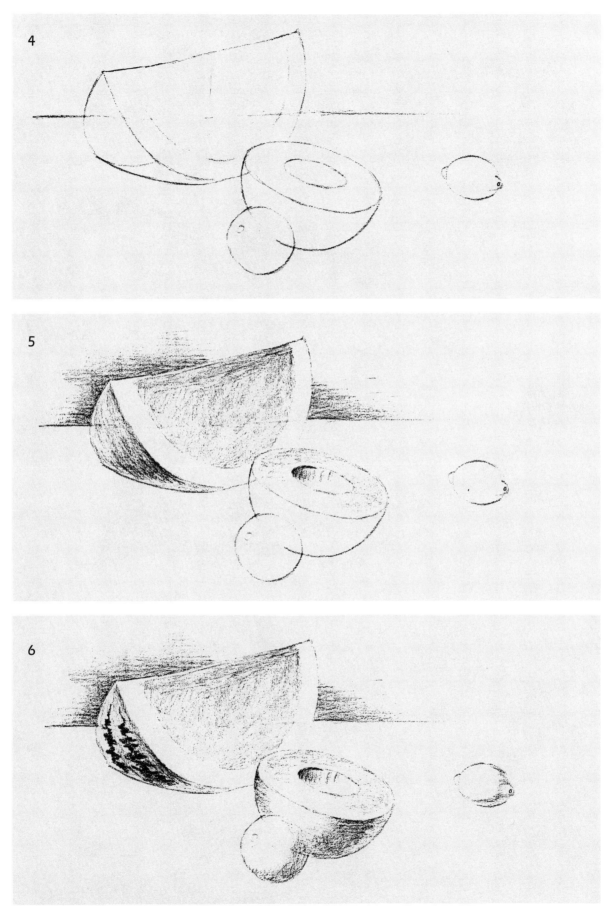

4

5

6

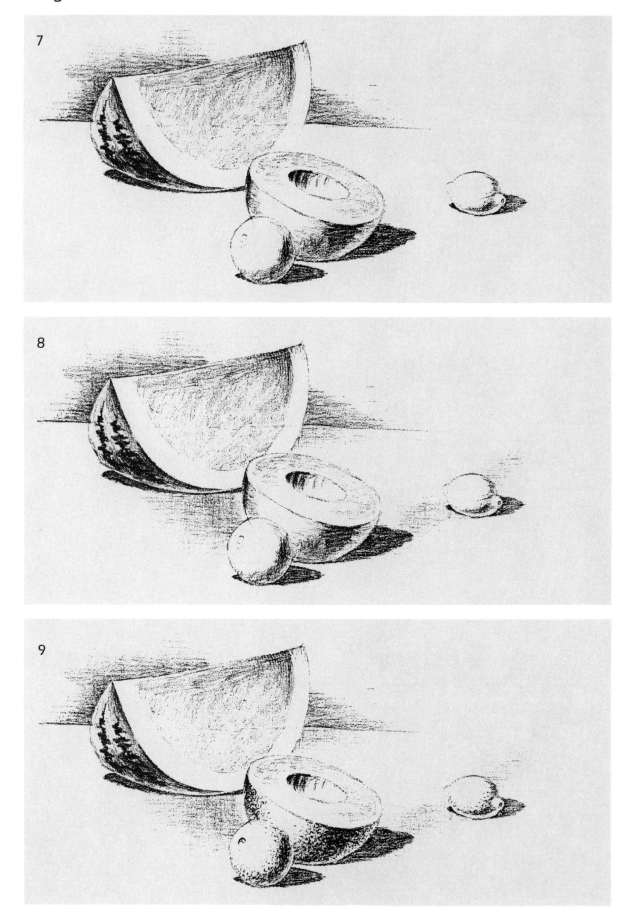

7

8

9

MELONS, AN ORANGE AND A LEMON

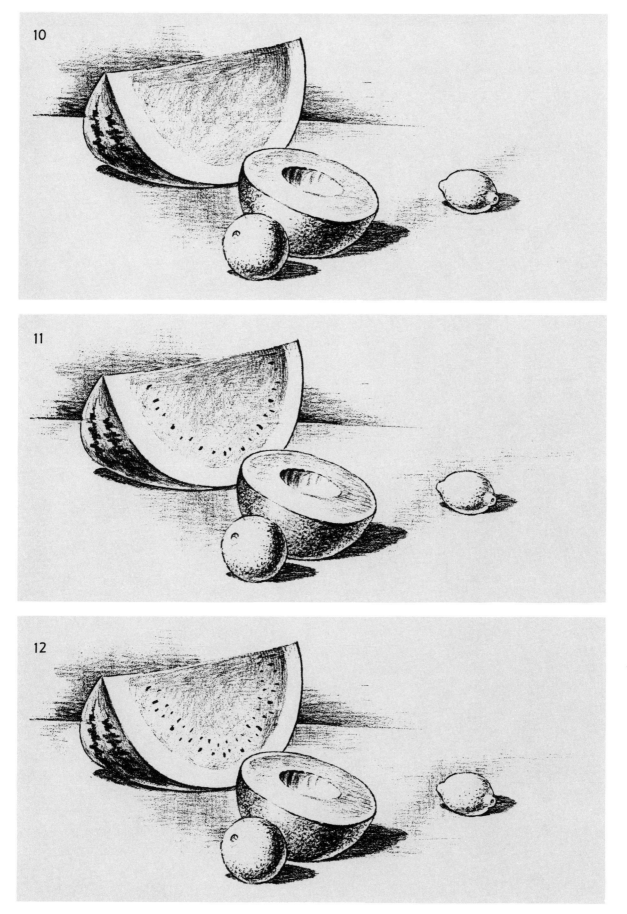

10

11

12

1

2

5

6

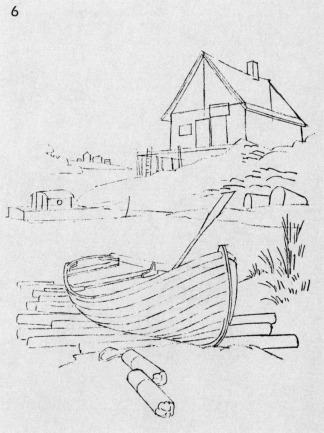

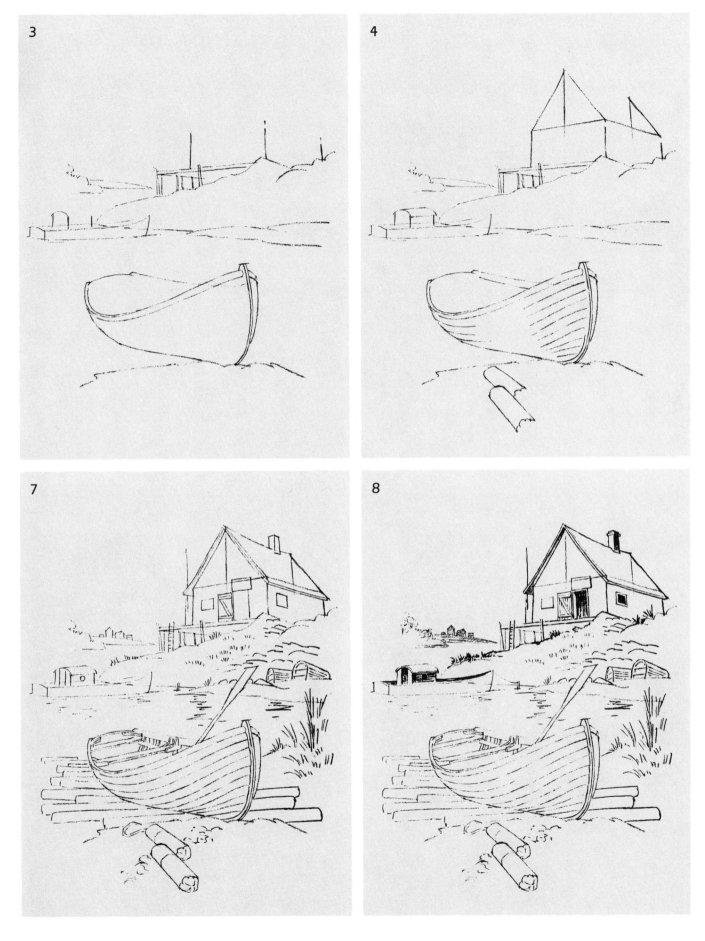

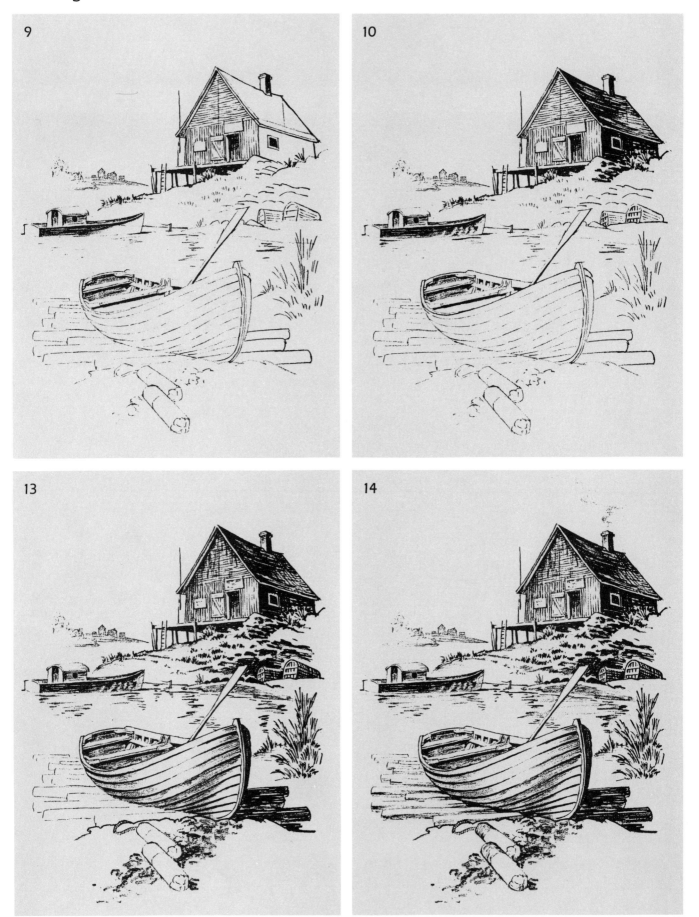

CAPE COD

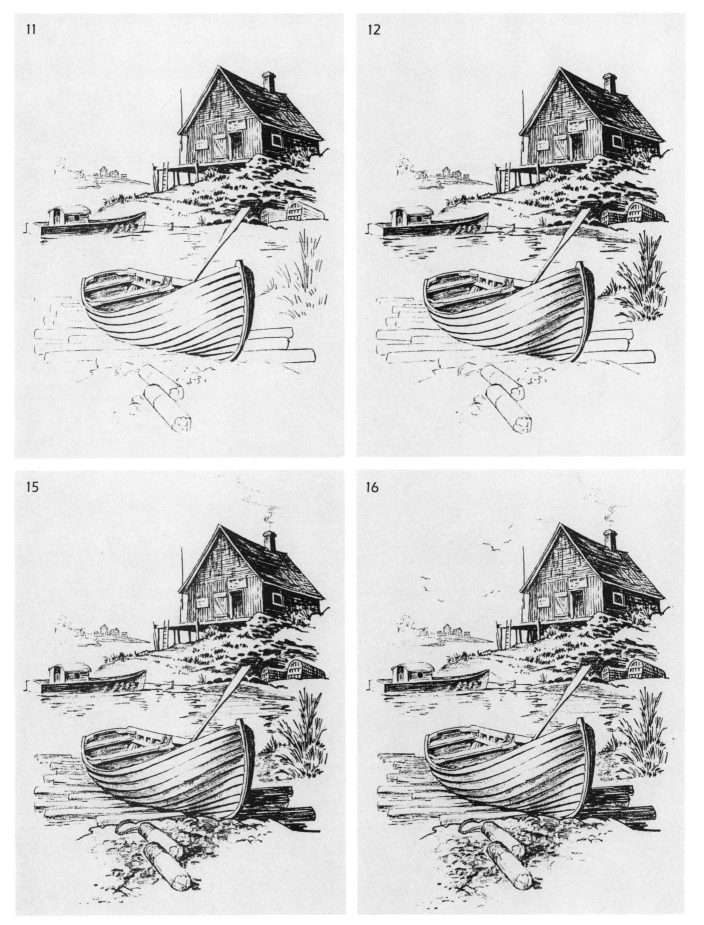

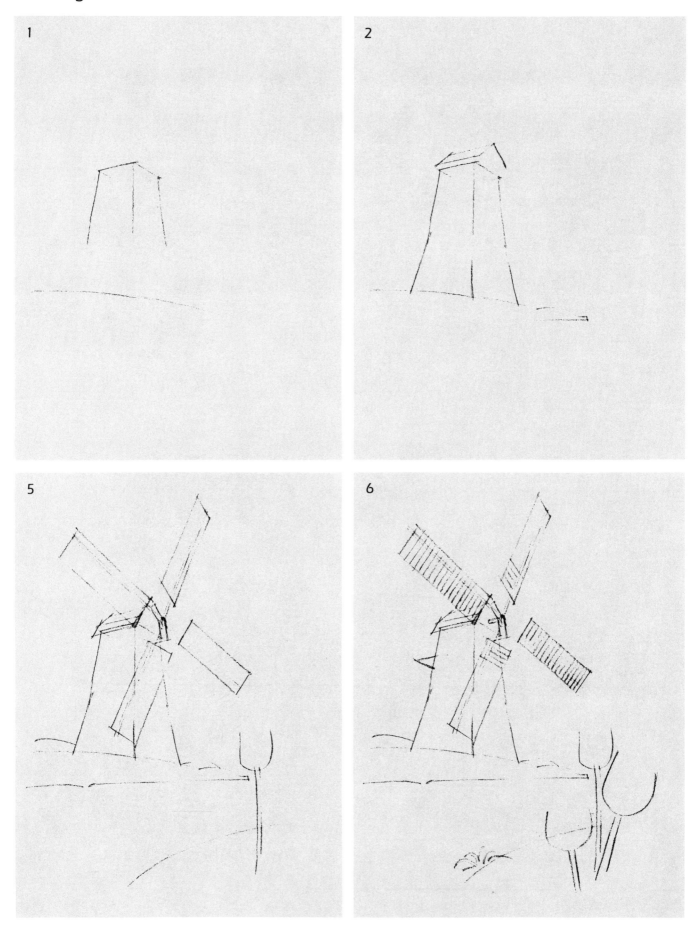

1

2

5

6

WINDMILL AND TULIPS

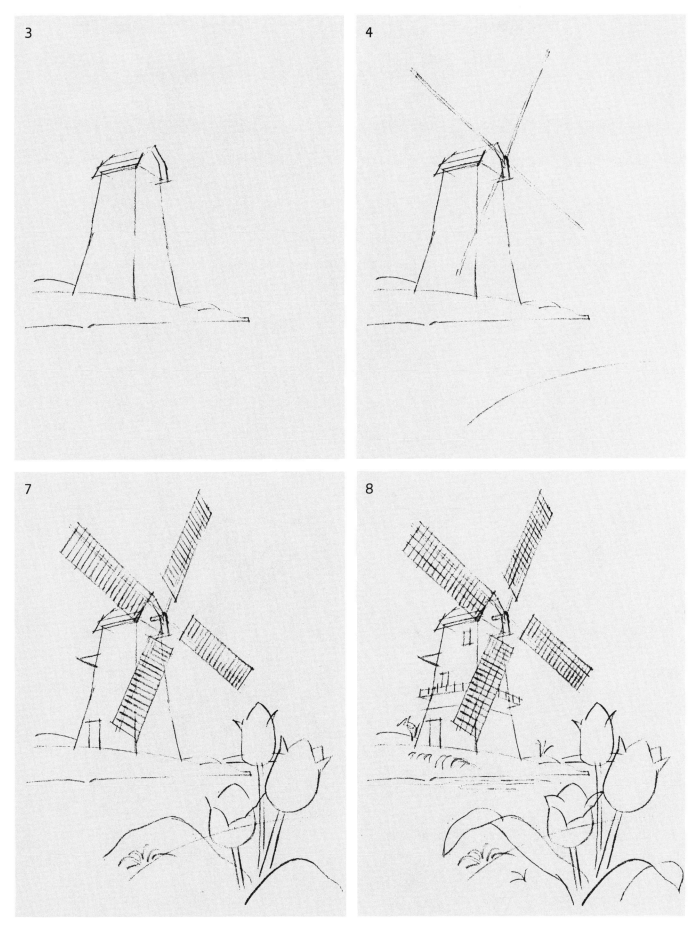

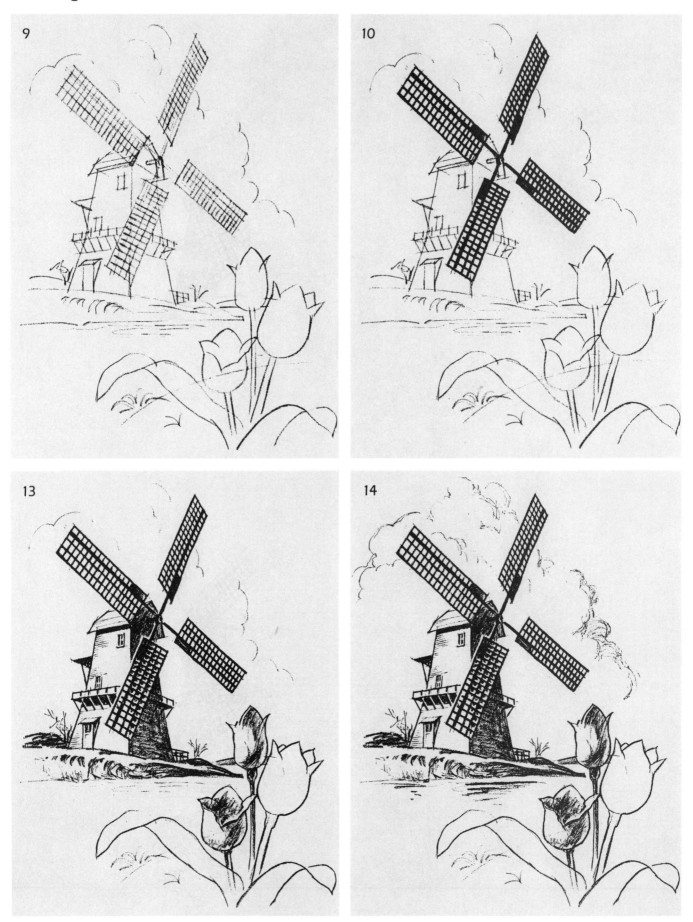

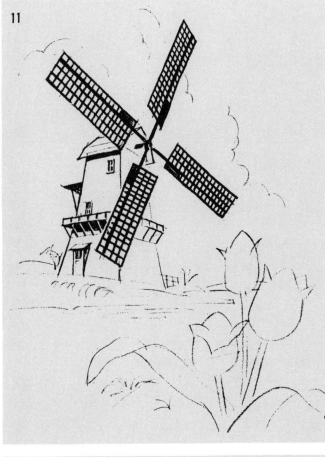

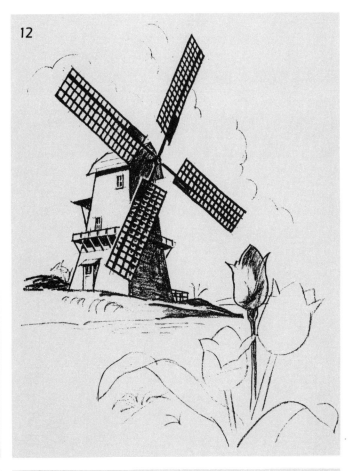

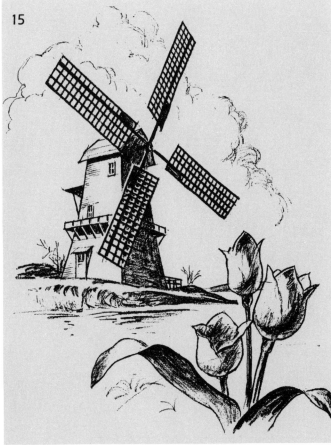

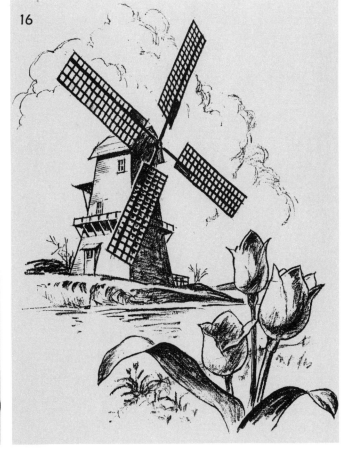

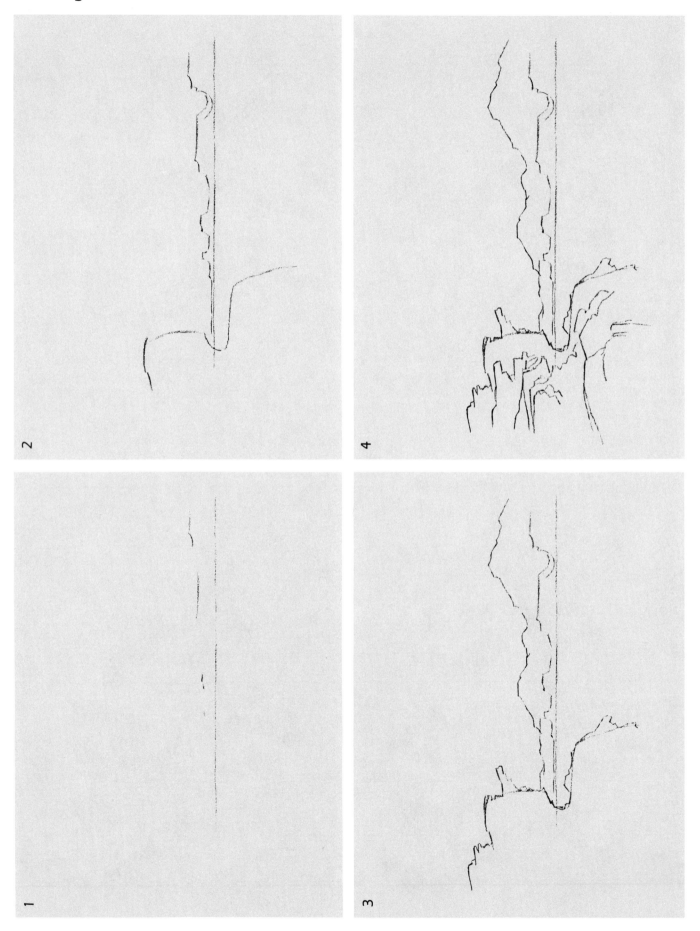

2

4

1

3

A HERD OF BISON

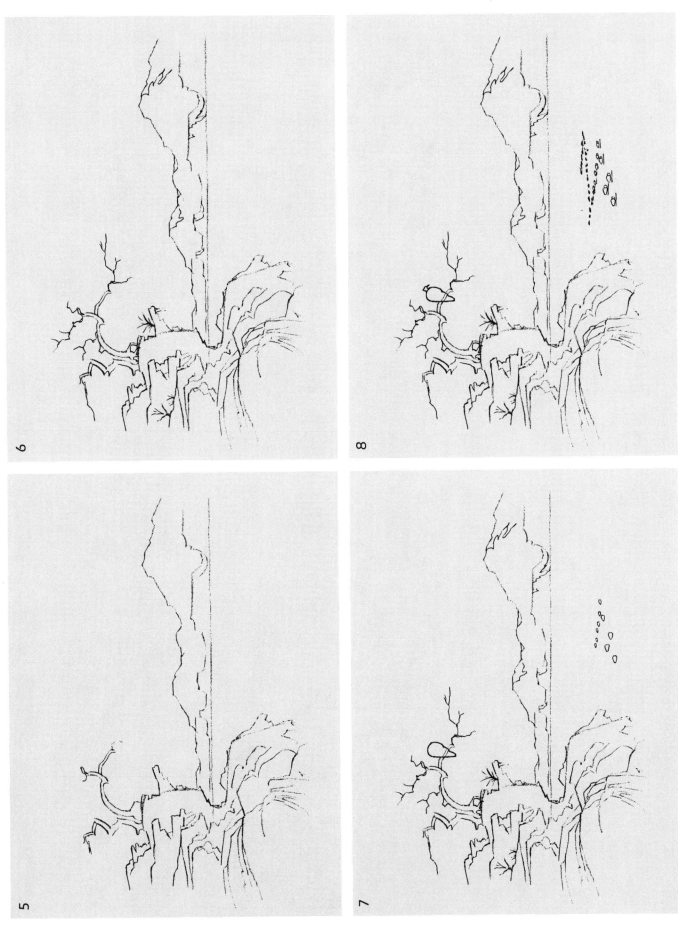

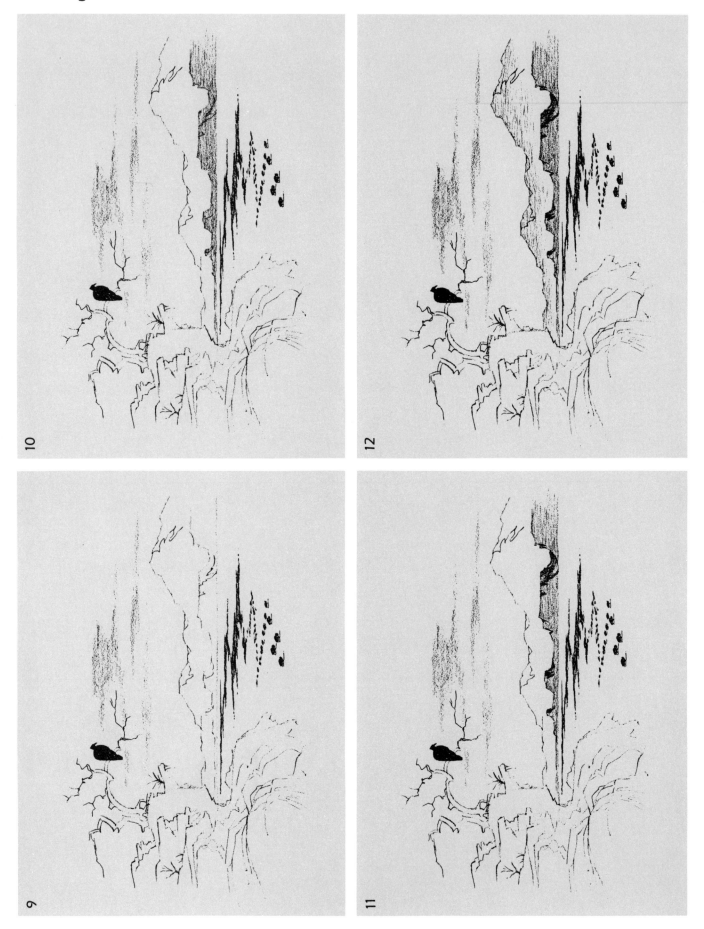

10

12

9

11

A HERD OF BISON

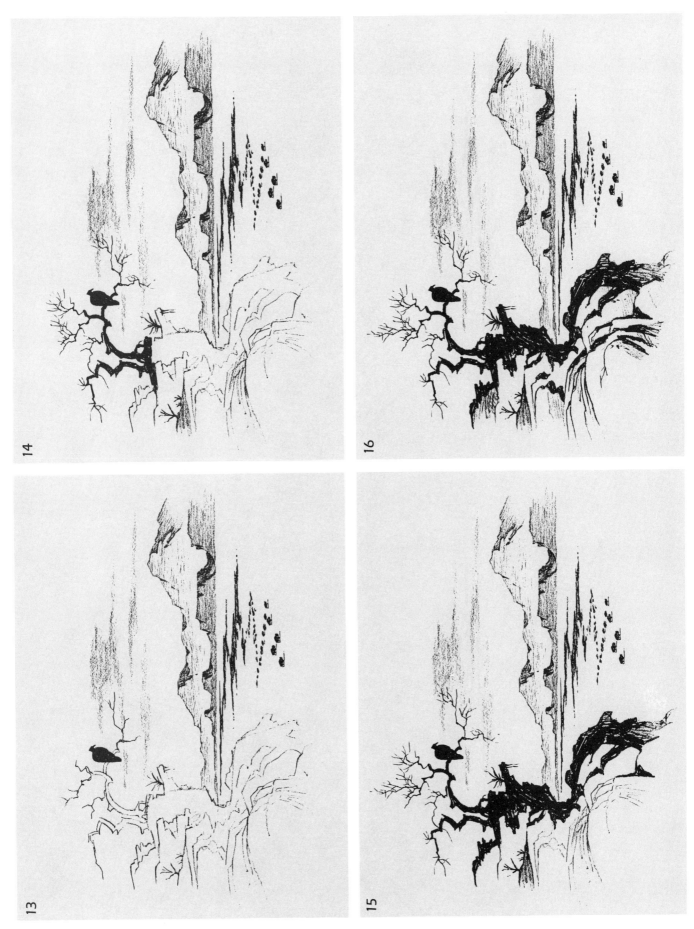

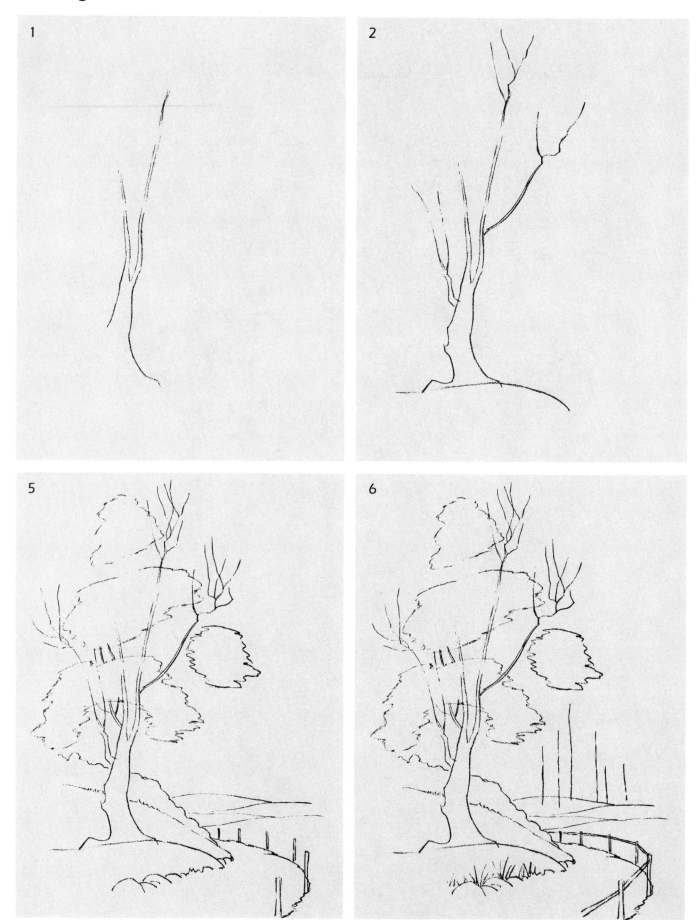

TREES AND FURROWS

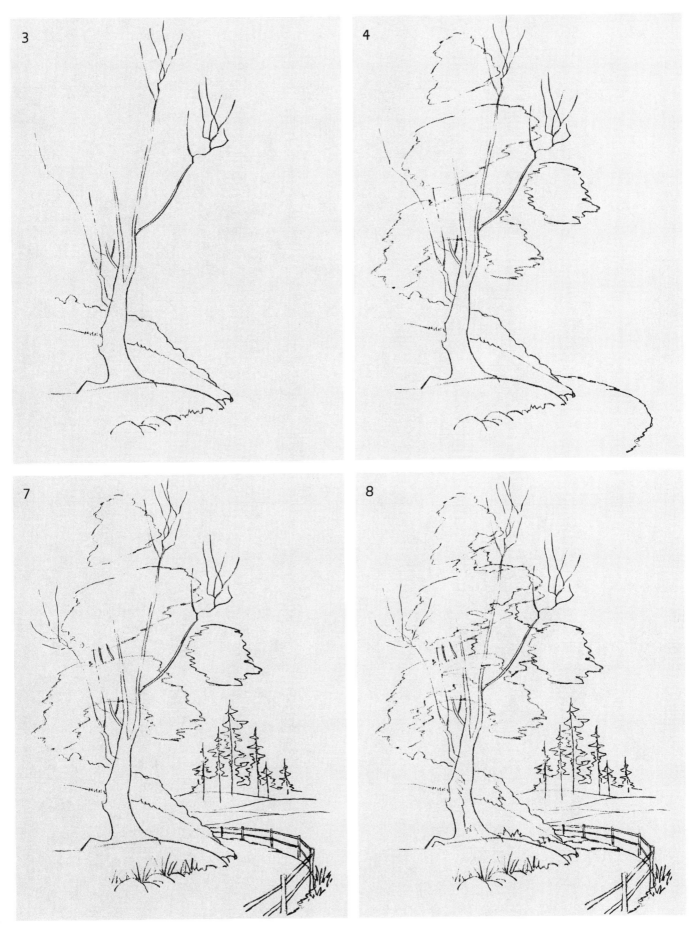

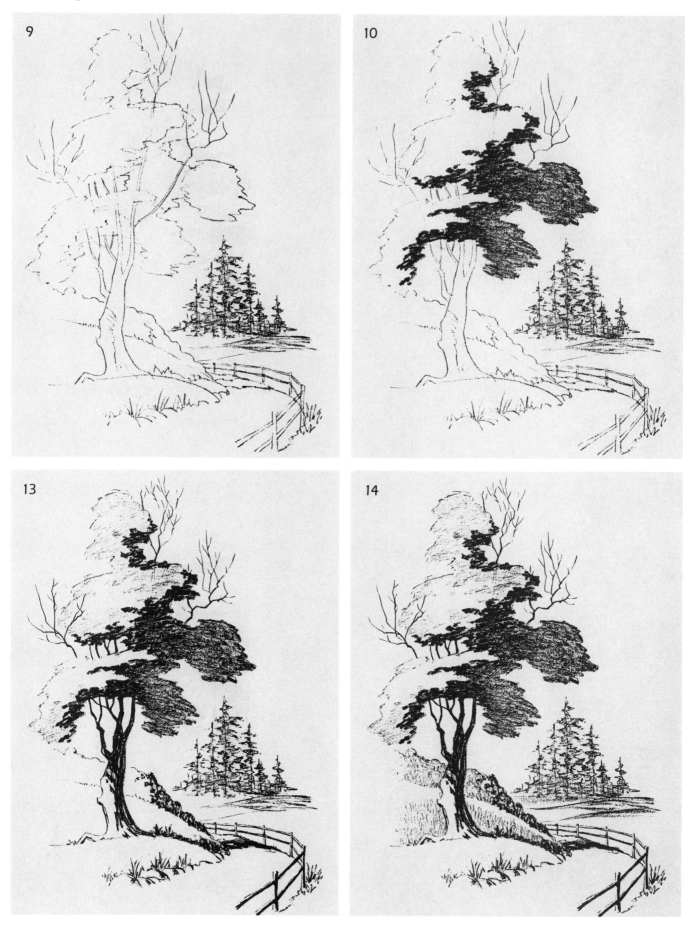

9

10

13

14

TREES AND FURROWS

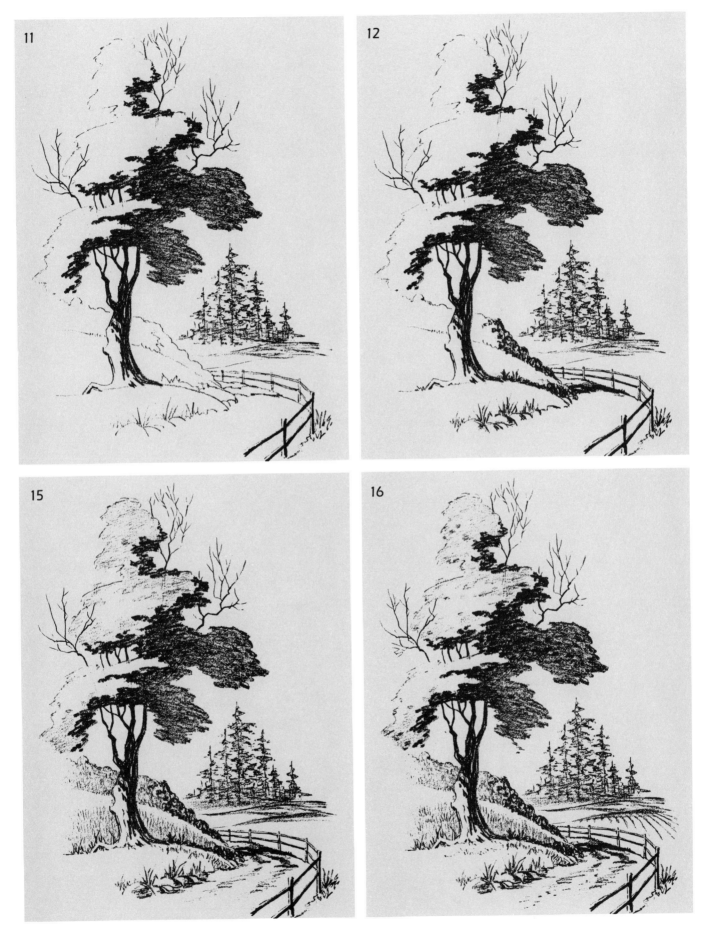

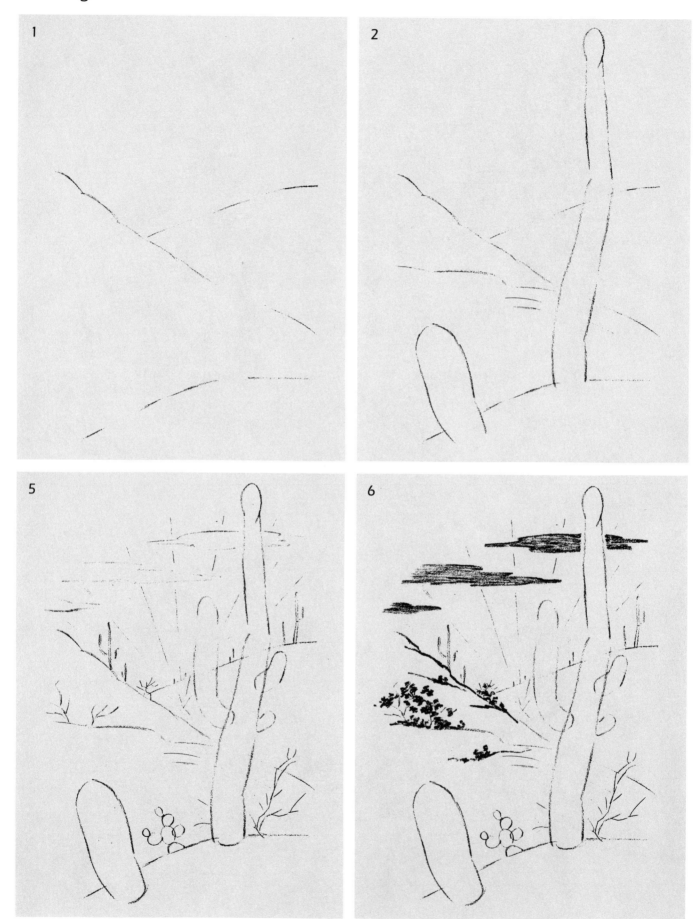

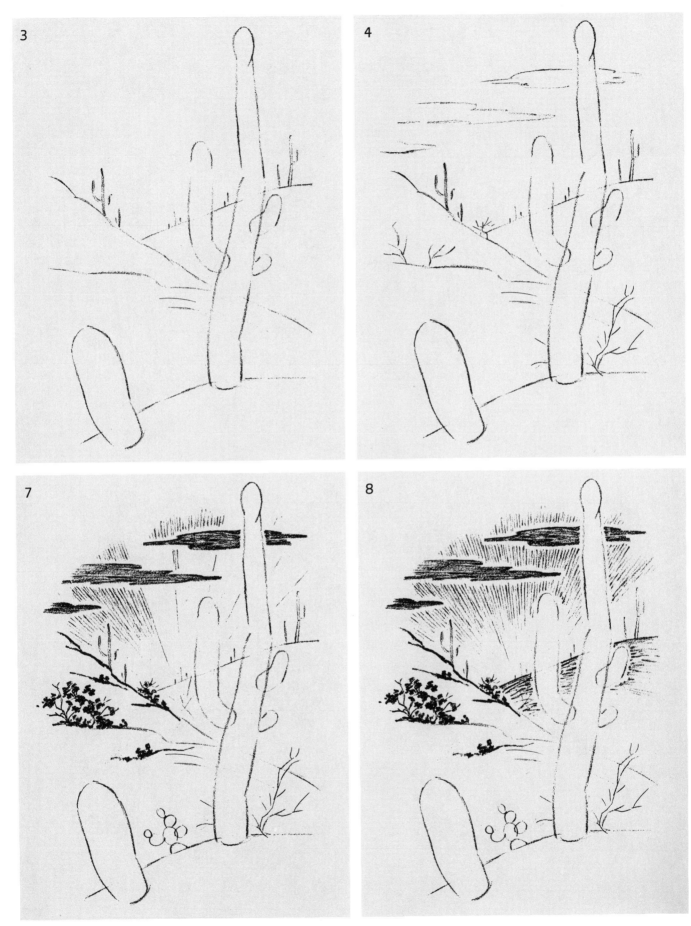

3

4

7

8

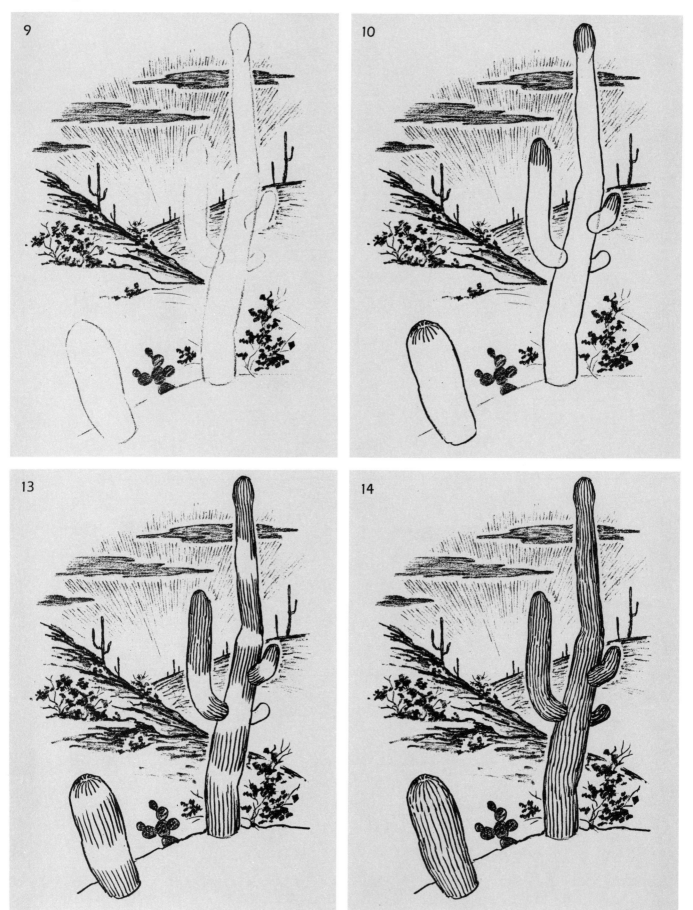

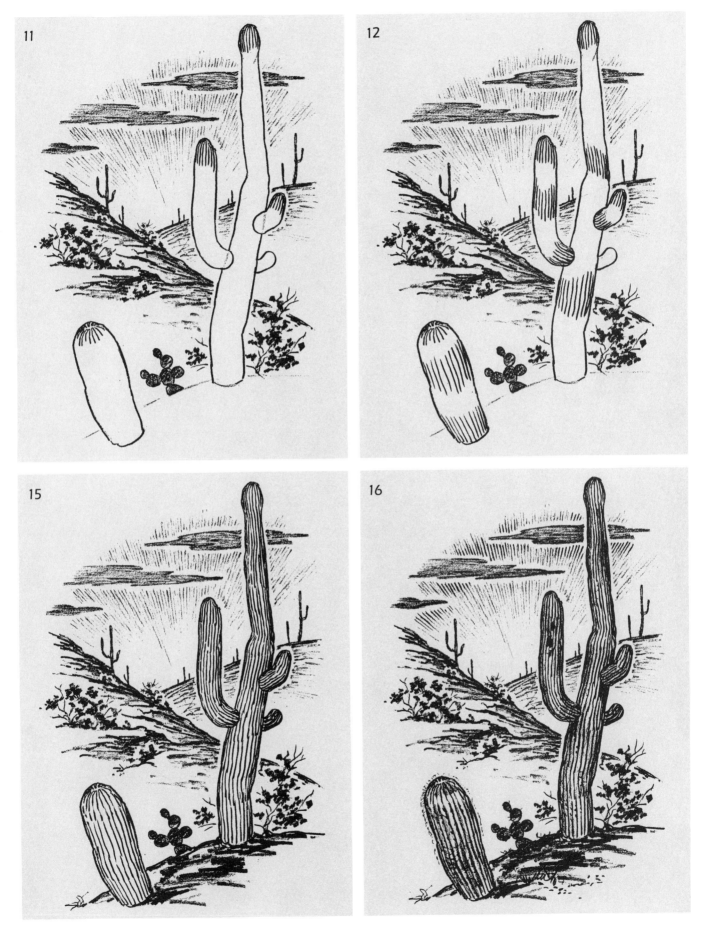

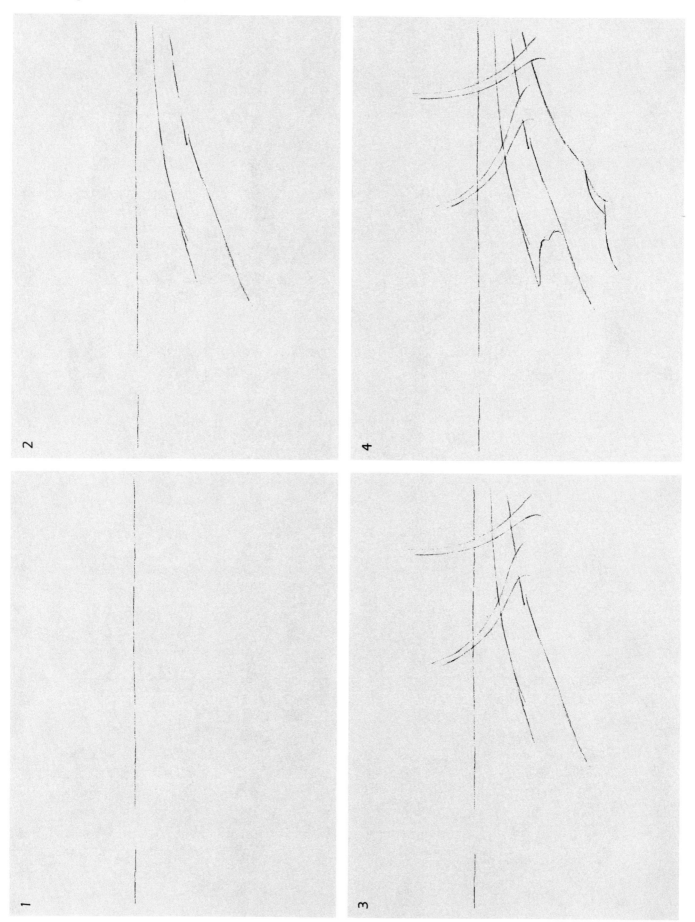

TROPICAL SHORE

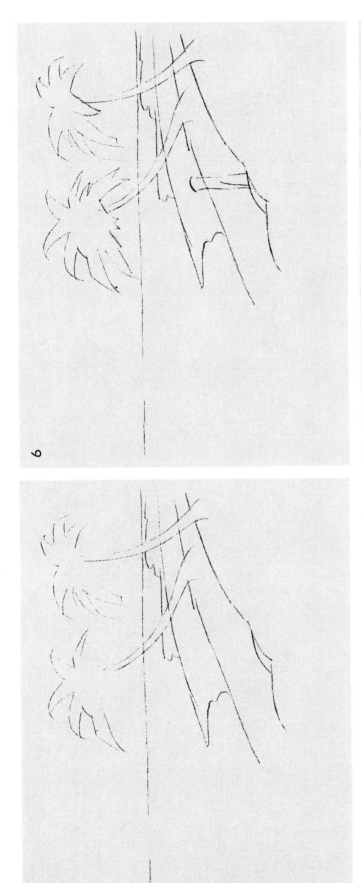

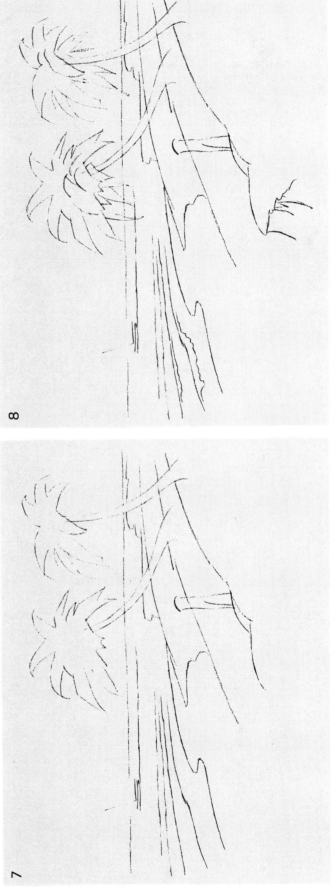

5

6

7

8

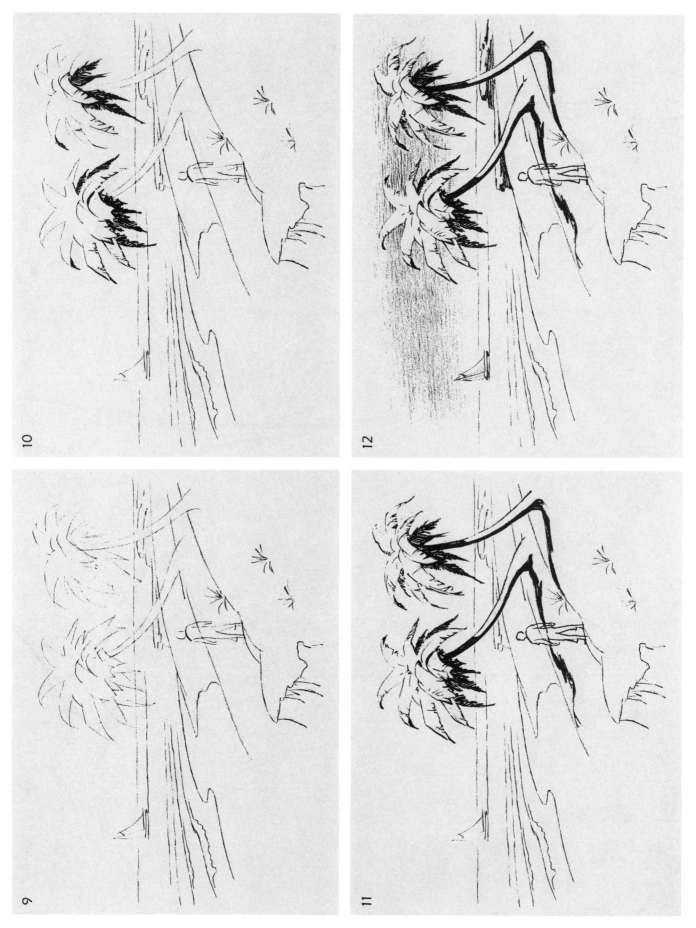

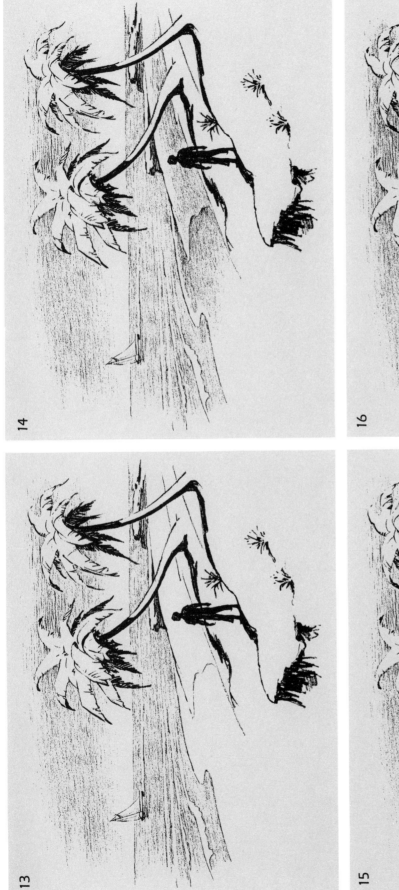

13

14

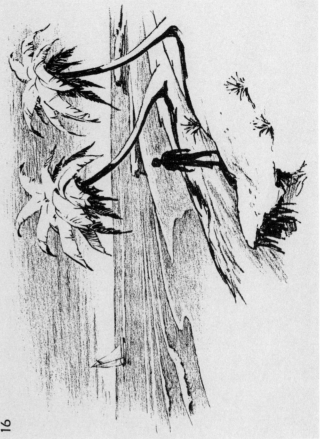

15

16

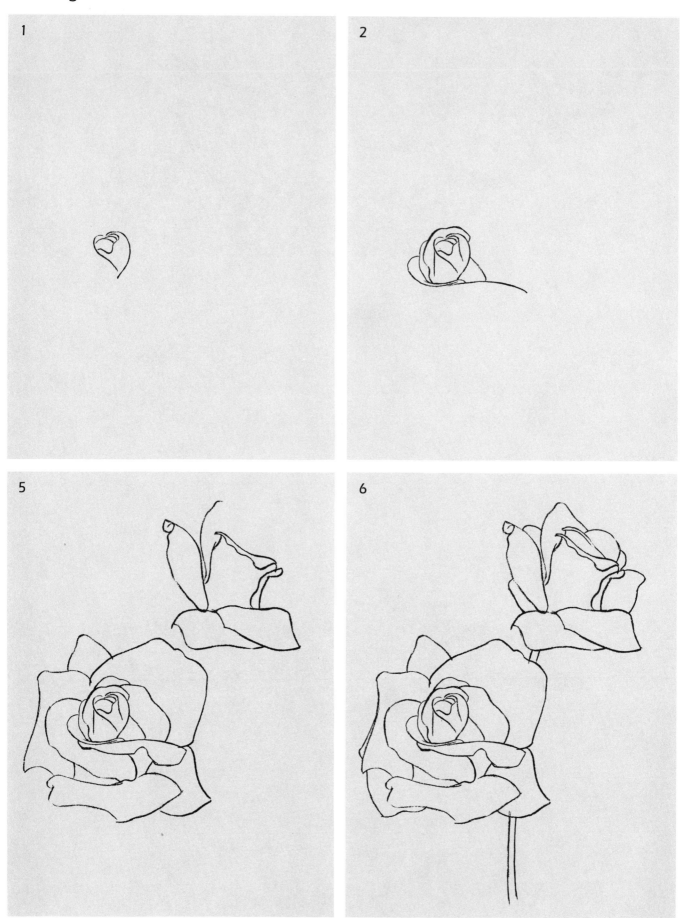

ROSES

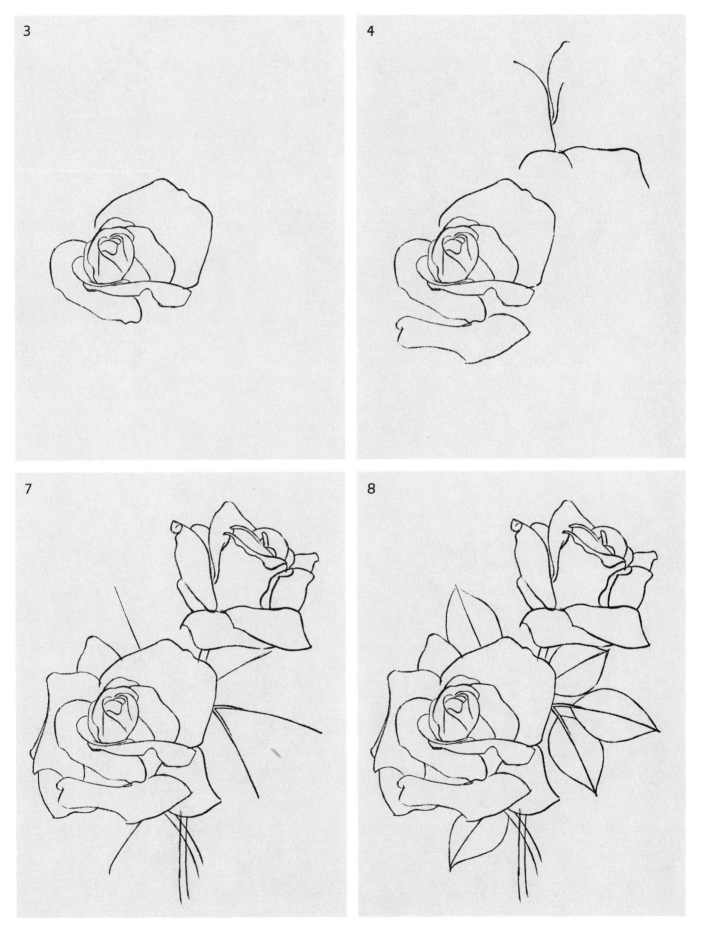

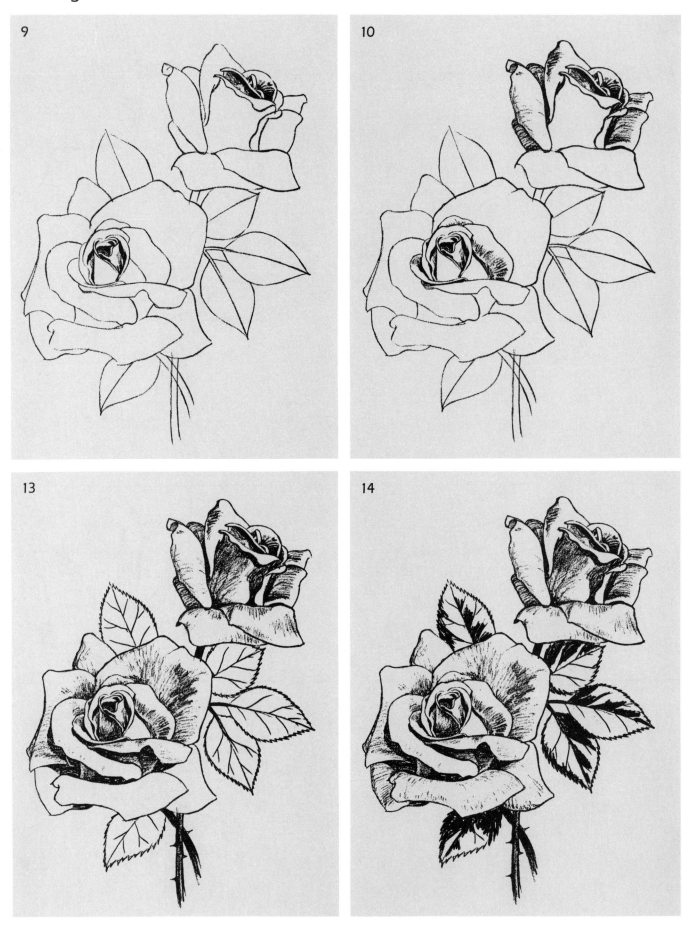

11

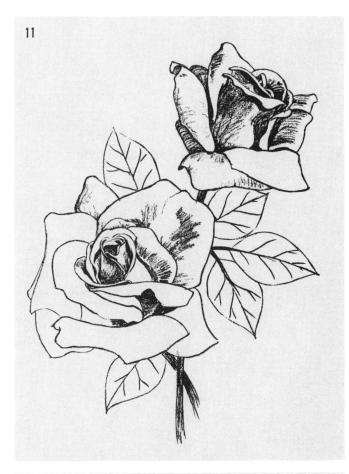

12

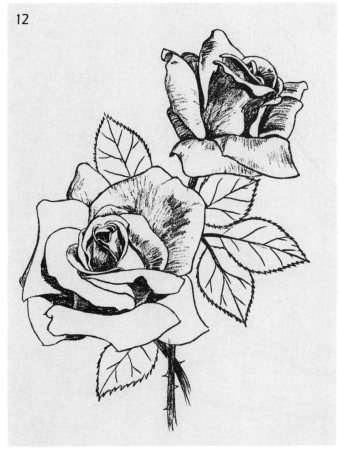

15

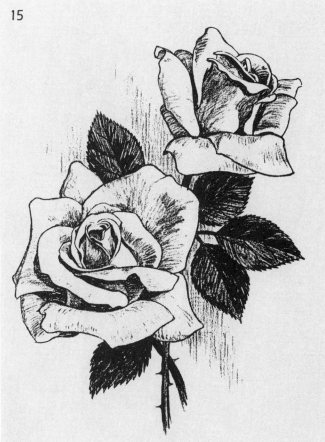

16

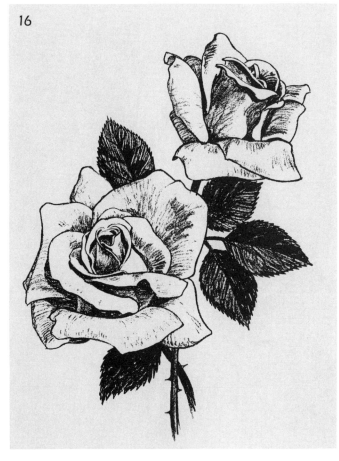

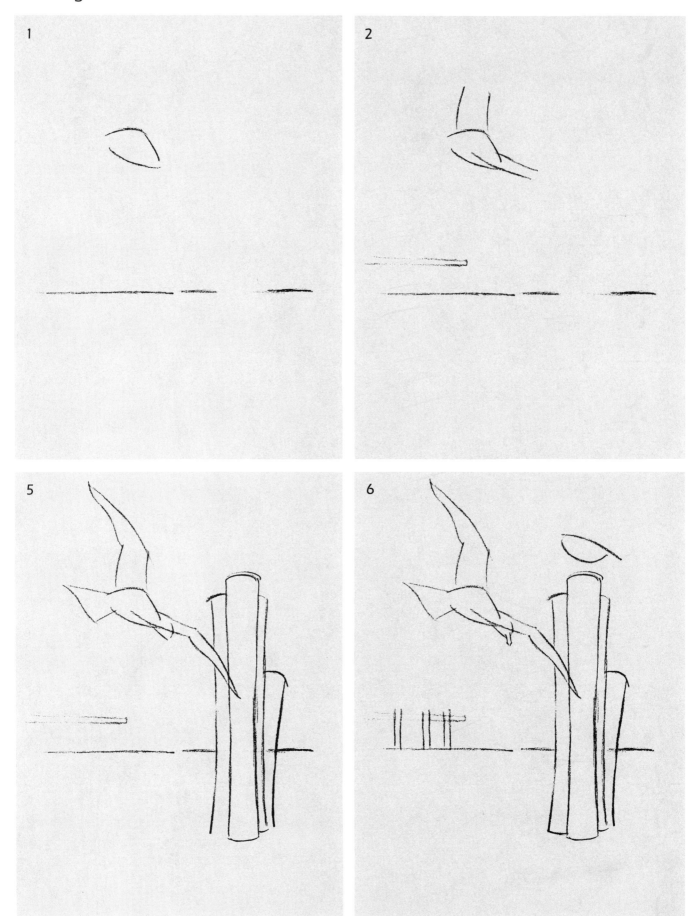

GULLS AND PILINGS

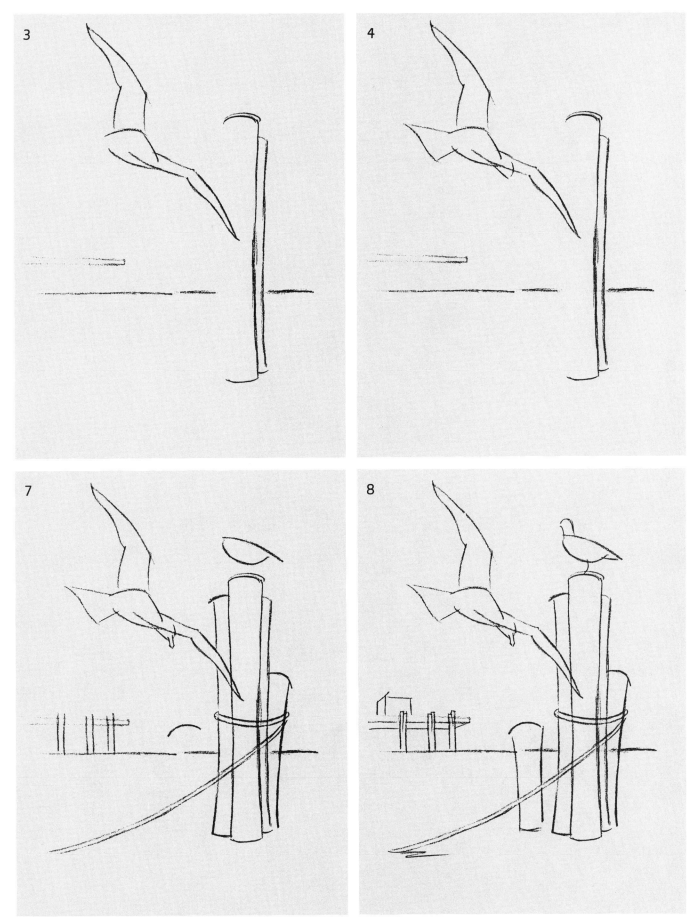

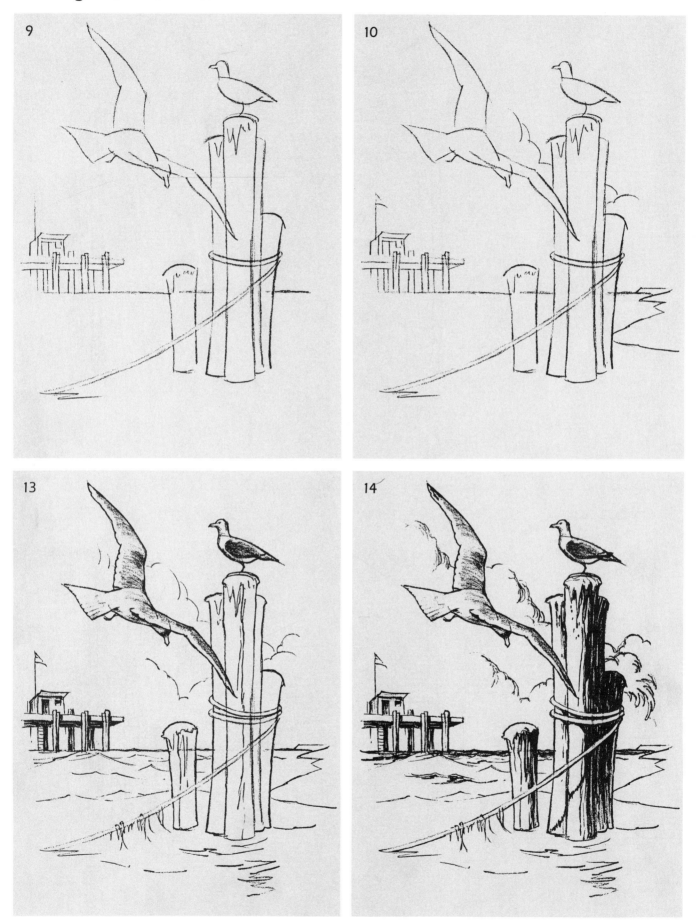

GULLS AND PILINGS

11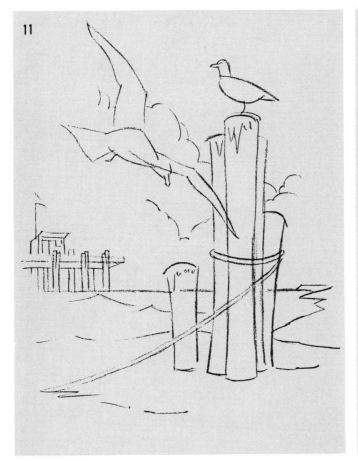

12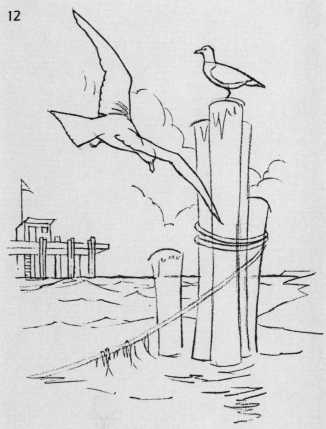

15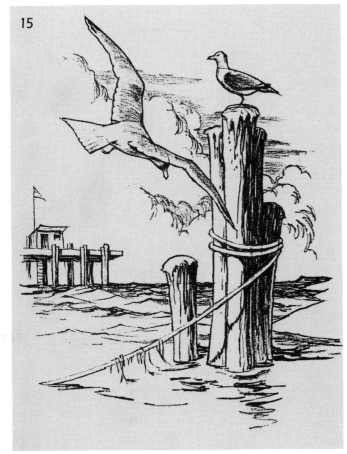

16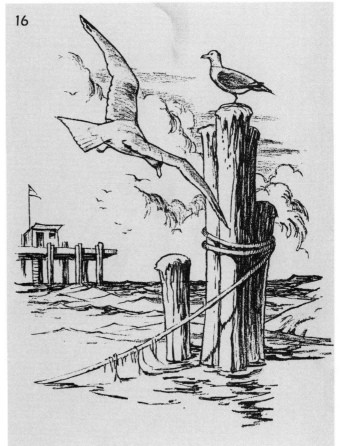

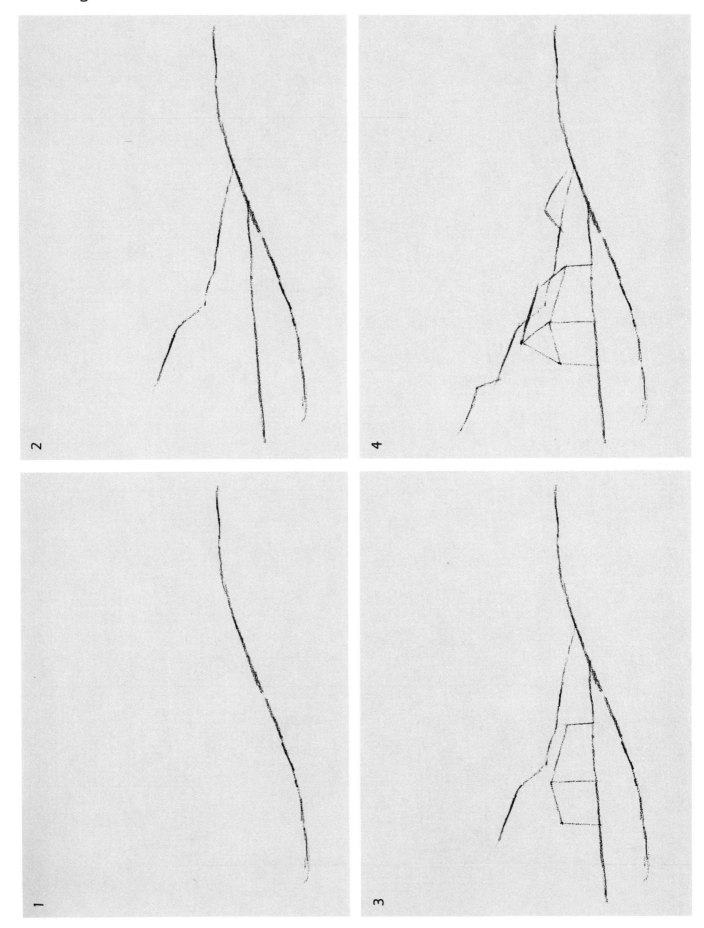

ALPINE BARN

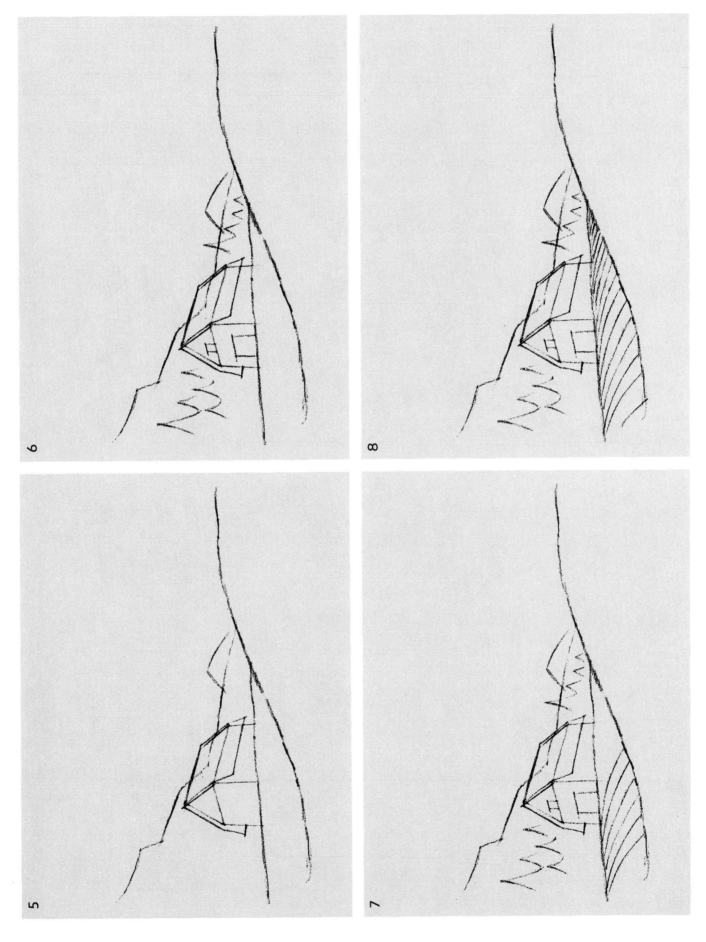

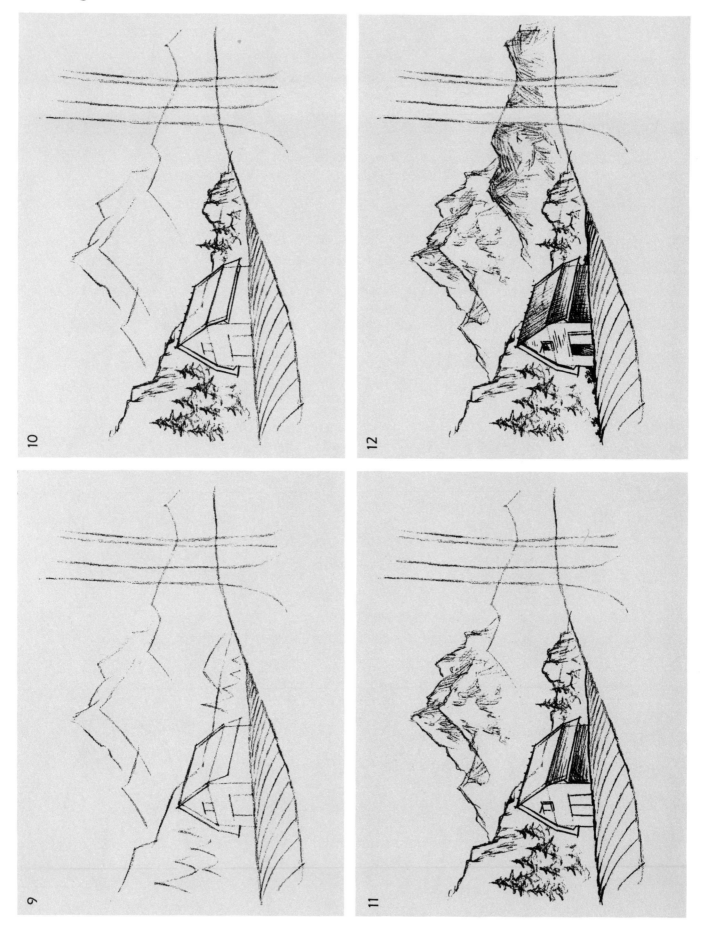

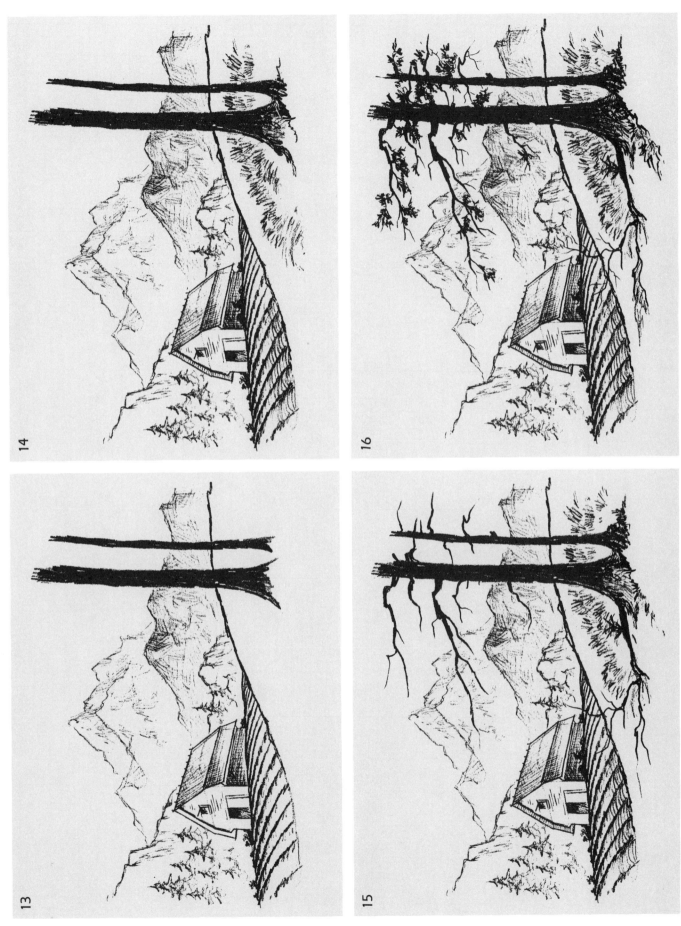

THE NUDE HUMAN FIGURE

The Mini-roughs for the Nude Human Figure

I had considered including a section on classical, general proportions of the human torso; the proportions of the average male, the average female, and children of various ages. Since these are available in many other excellent works, it seems more appropriate to stick with the original intention: a hands-on, step-by-step successful achievement of drawings; learning by intelligent mimicking.

Here are thumbnails for the drawings of the nudes. In developing these tiny roughs I used models, photographs, or my imagination.

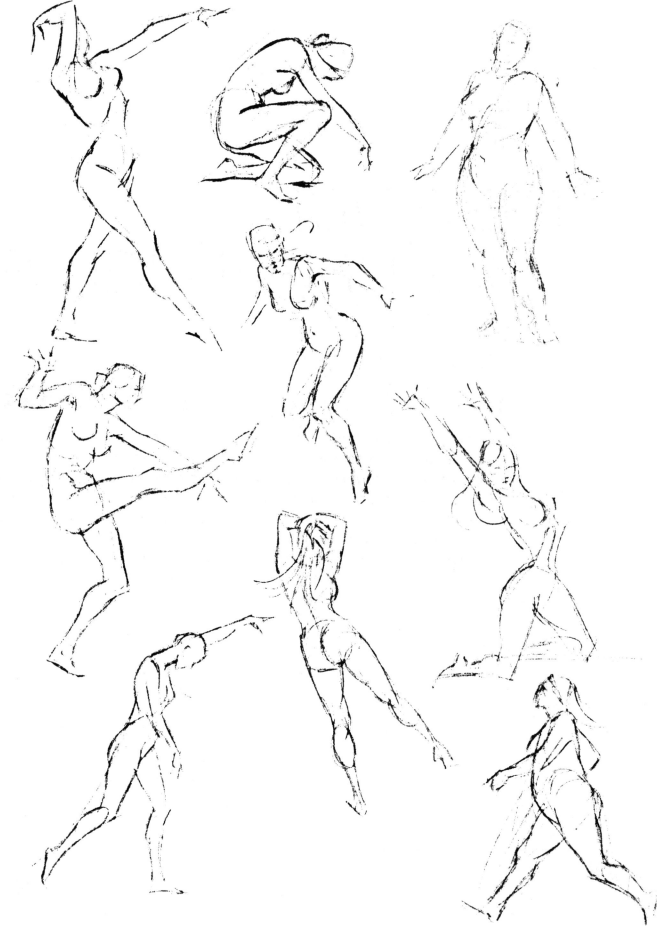

The Mini-roughs

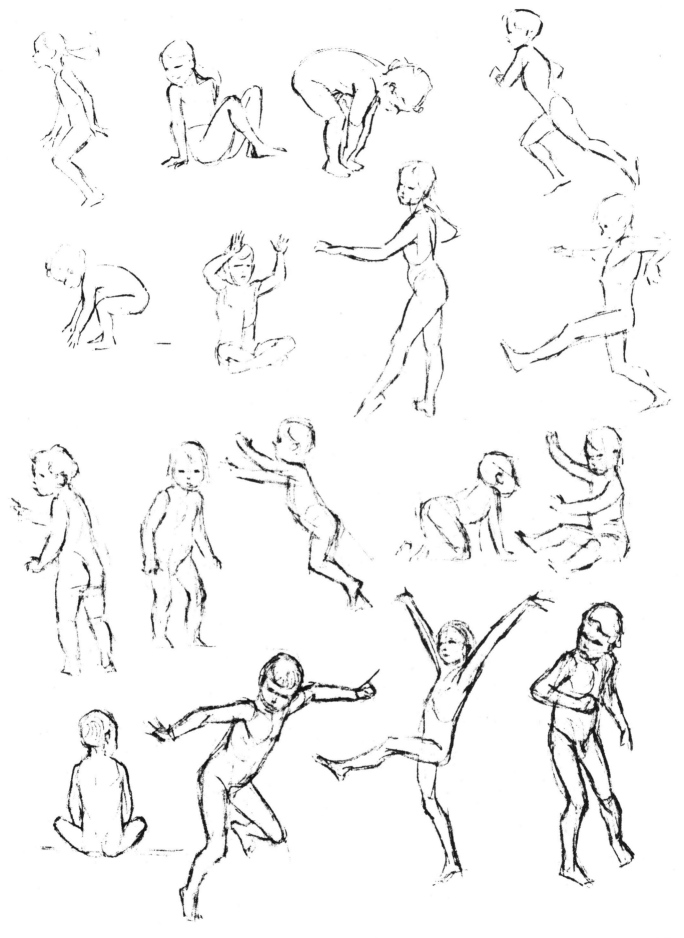

The Mini-roughs

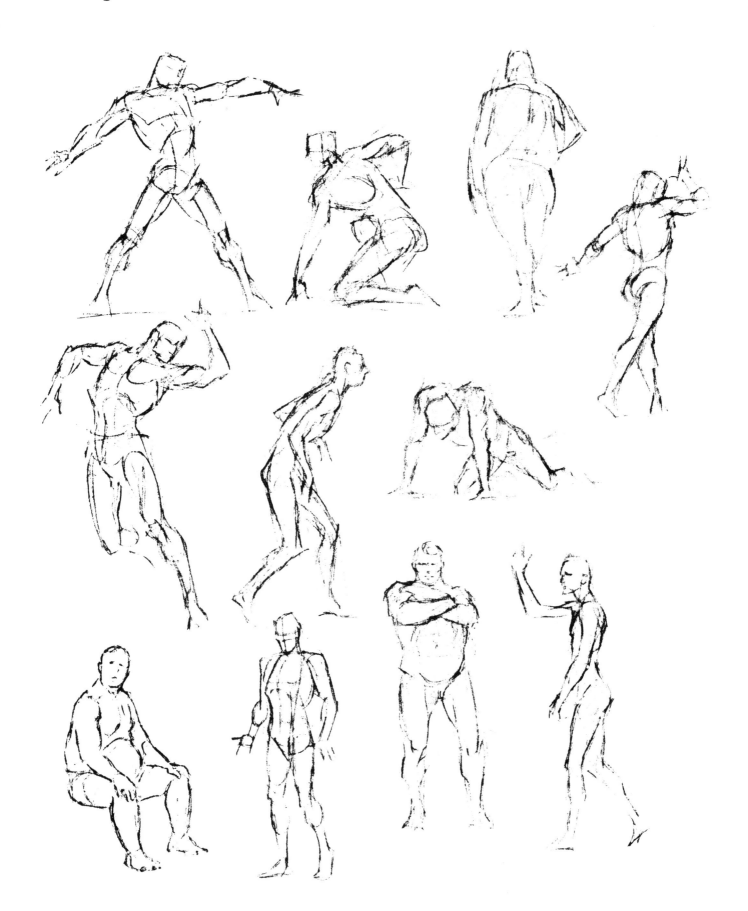

The Mini-roughs

Drawing the Nude Human Figure

The time-tested, classical approach to teaching drawing involves studying the nude. This is true because the human subject is obviously closest to us. It is one of us! It is traditionally accepted that he who masters the drawing of the nude has, indeed, become the master. ''Here are fourteen human nude figures, male and female, old and young. When you've completed them you will have become familiar with conventional human proportions.

First, however, study the models on the next fourteen pages. Make a selection, start drawing, step-by-step. Remember, lightly and carefully, and enjoy doing it!

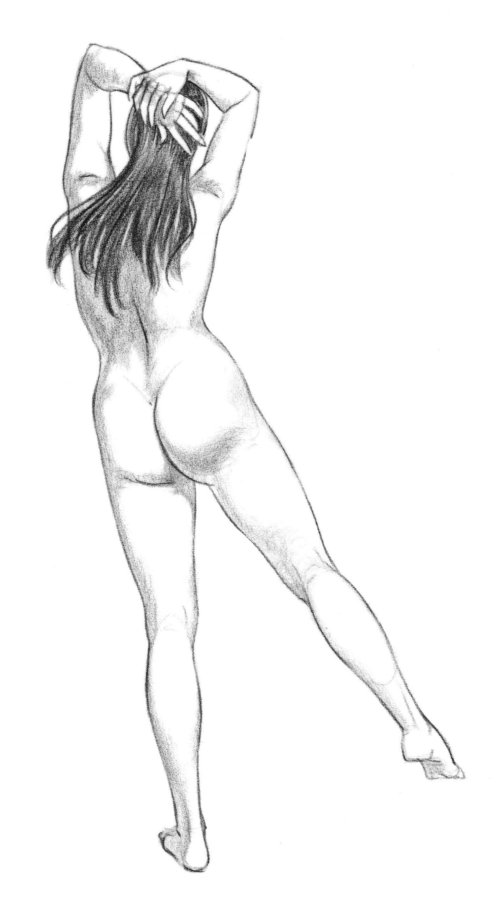

FEMALE NO. 1

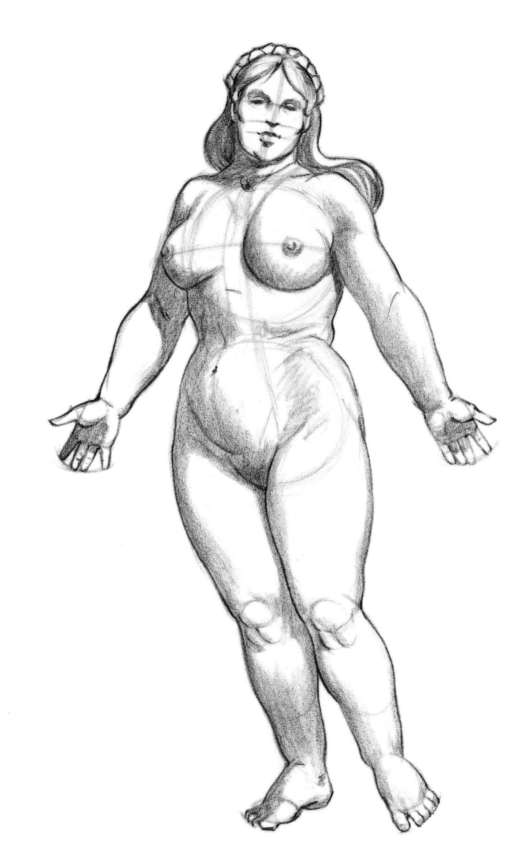

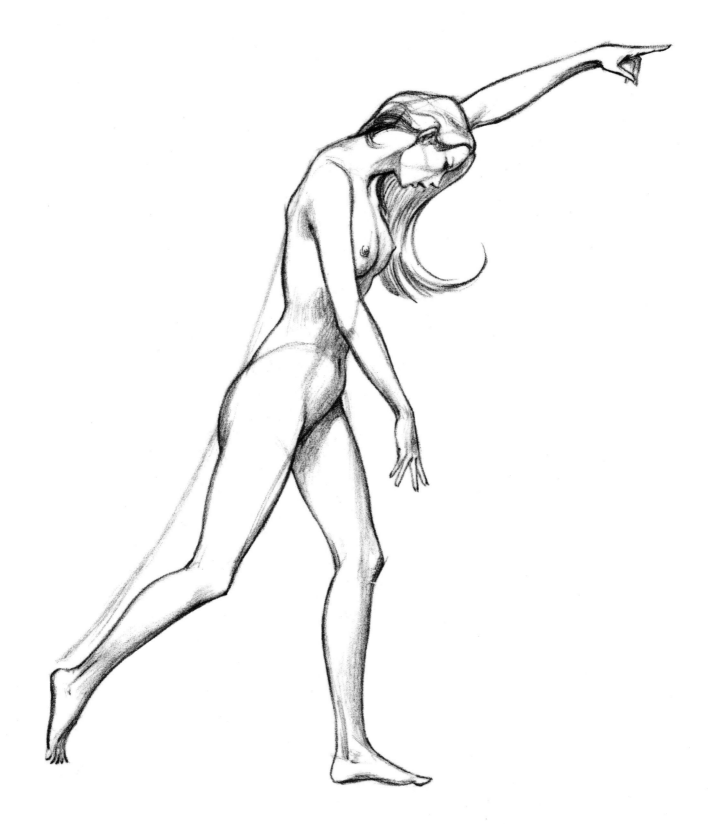

FEMALE NO. 3

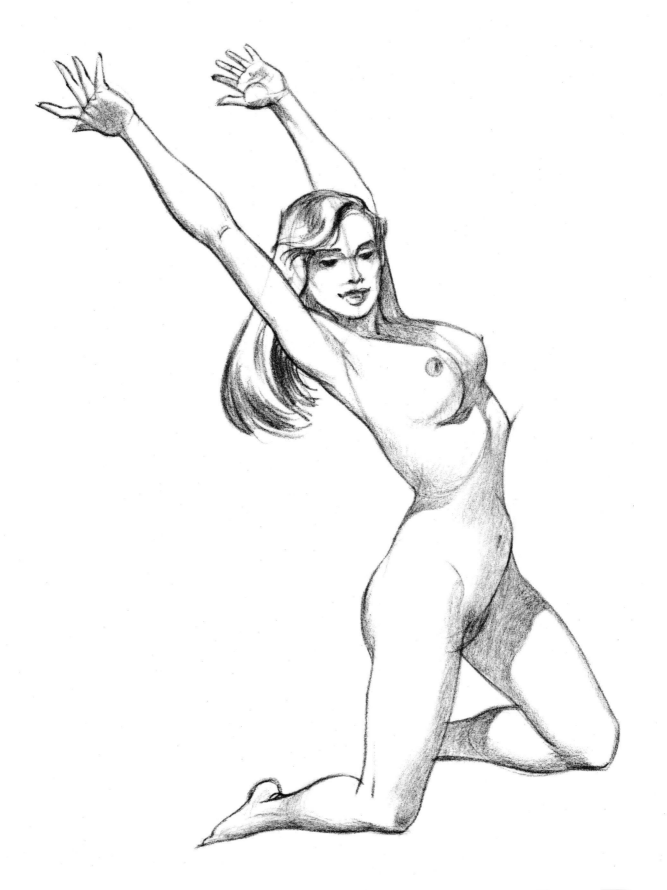

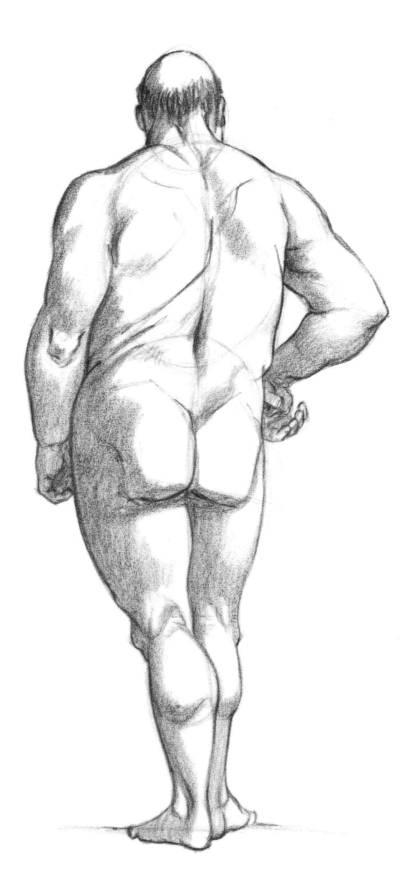

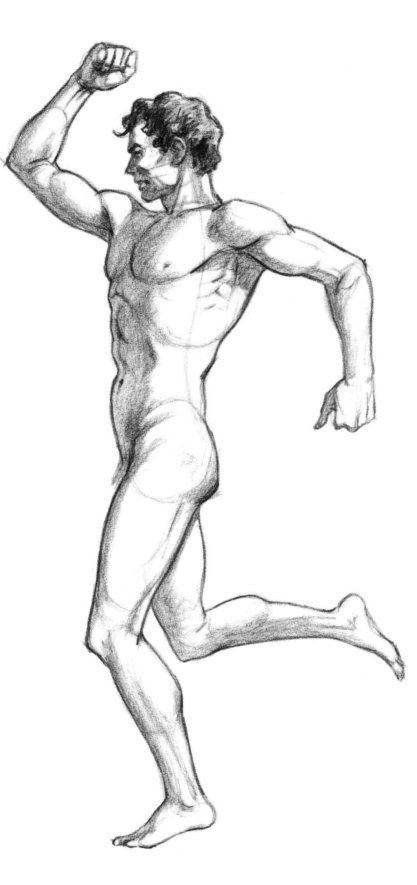

MALE NO. 2 The Models **101**

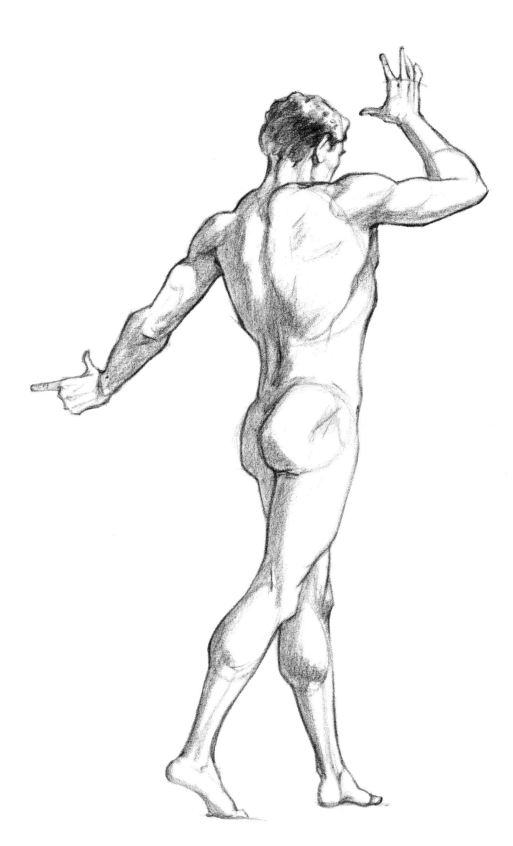

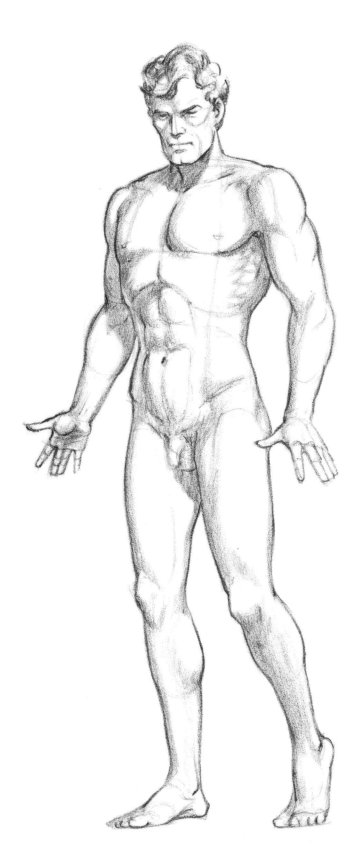

MALE NO. 4 The Models **103**

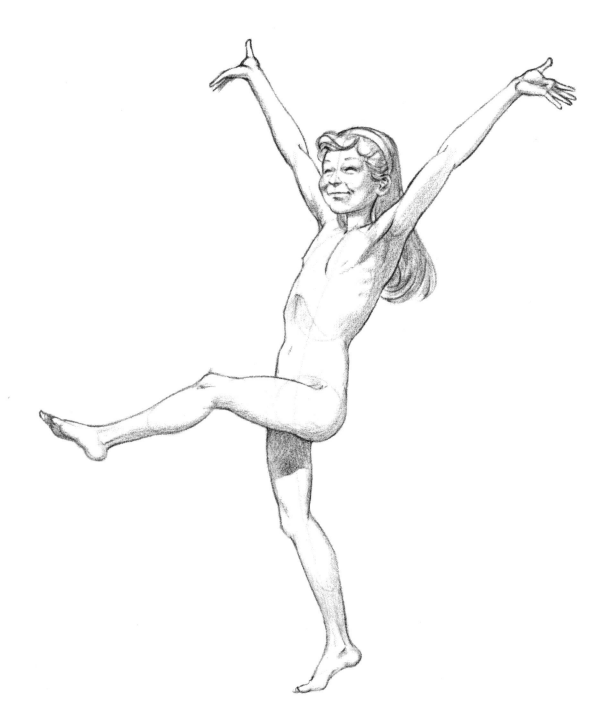

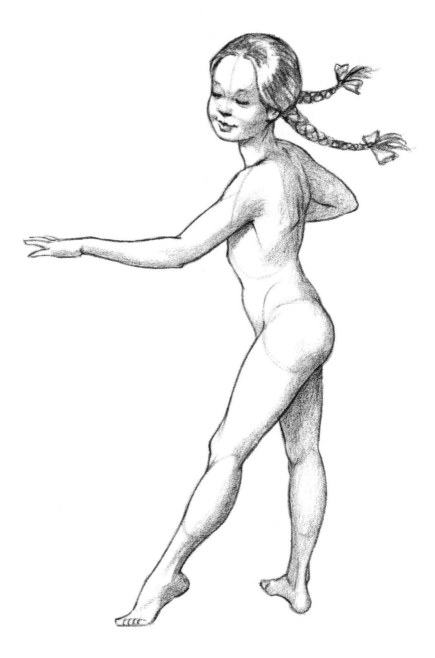

ADOLESCENT NO. 2 The Models **105**

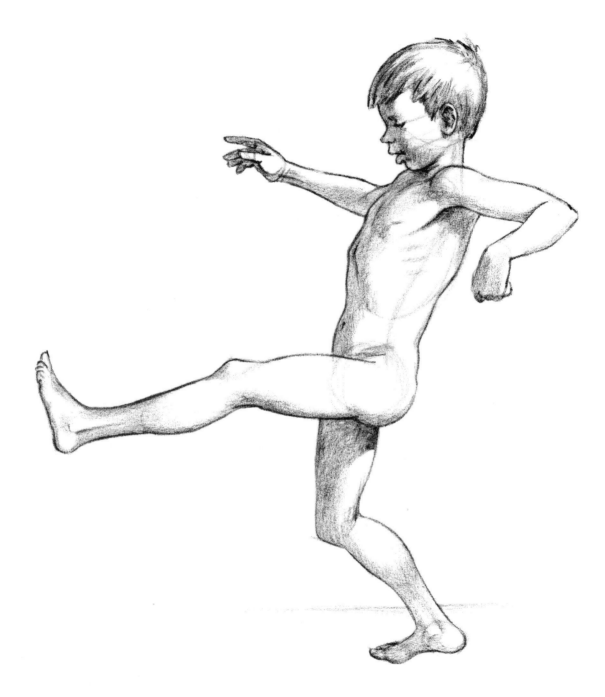

ADOLESCENT NO. 3

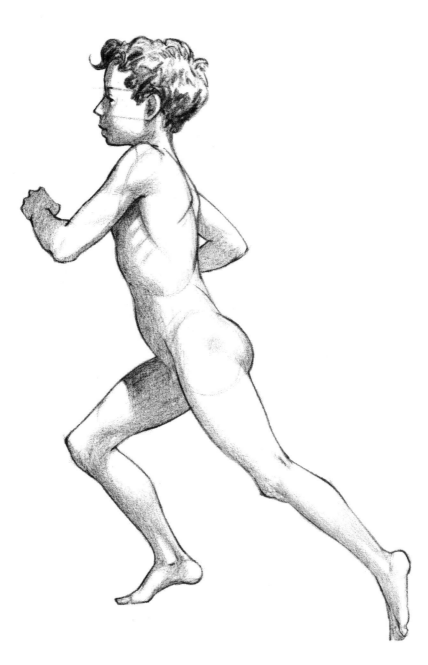

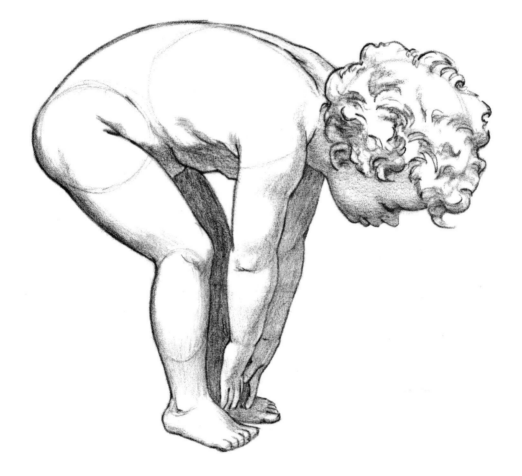

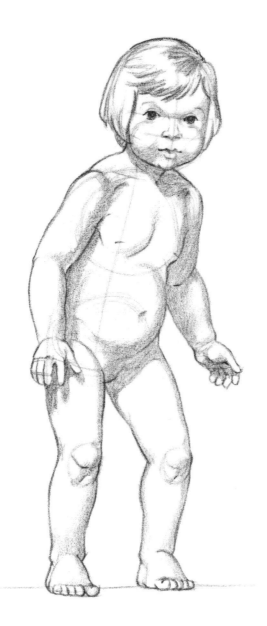

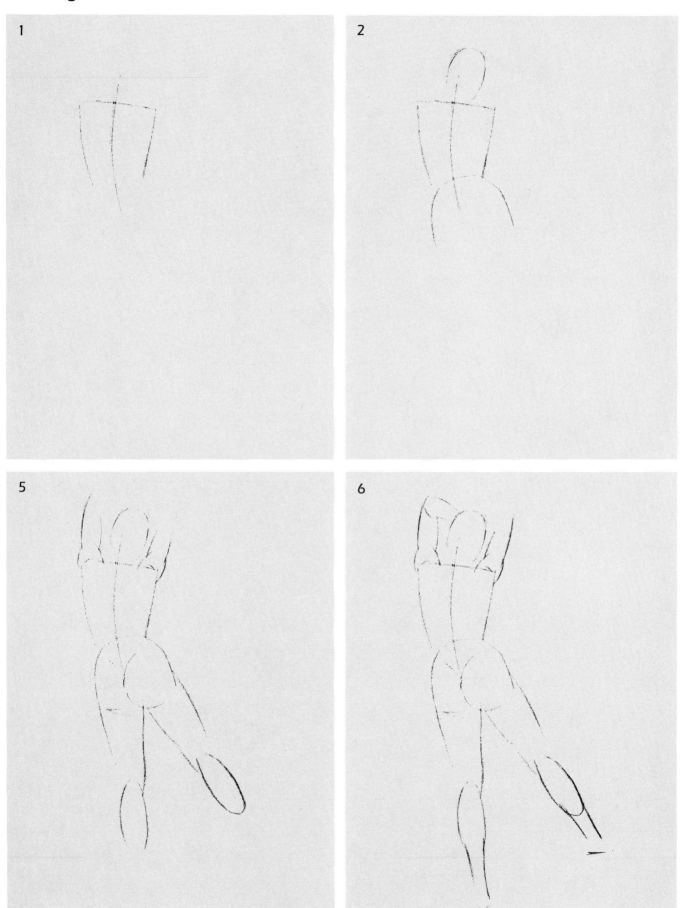

1

2

5

6

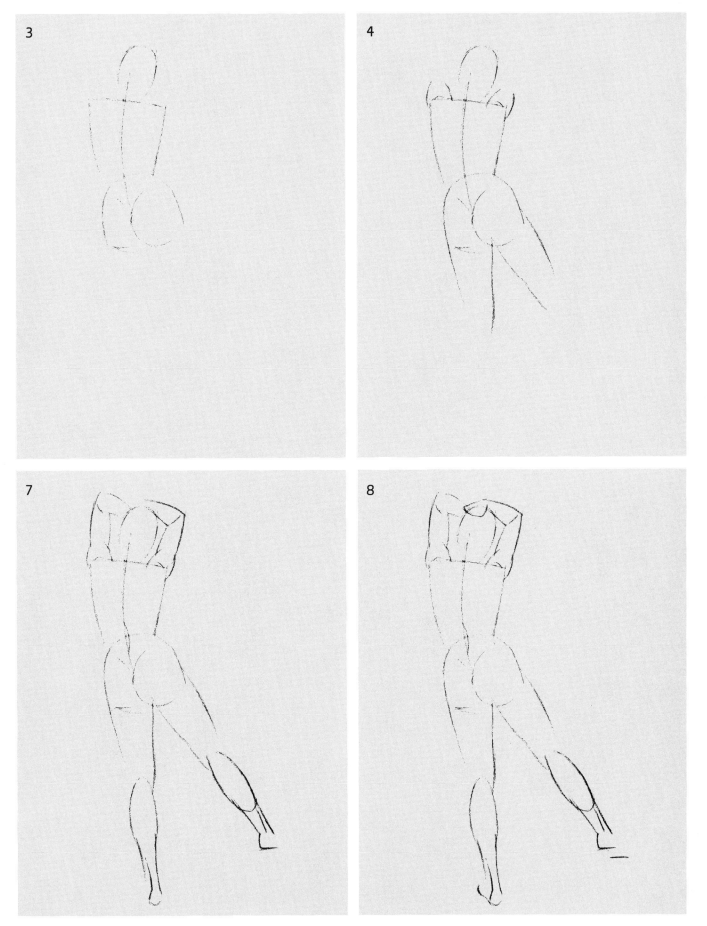

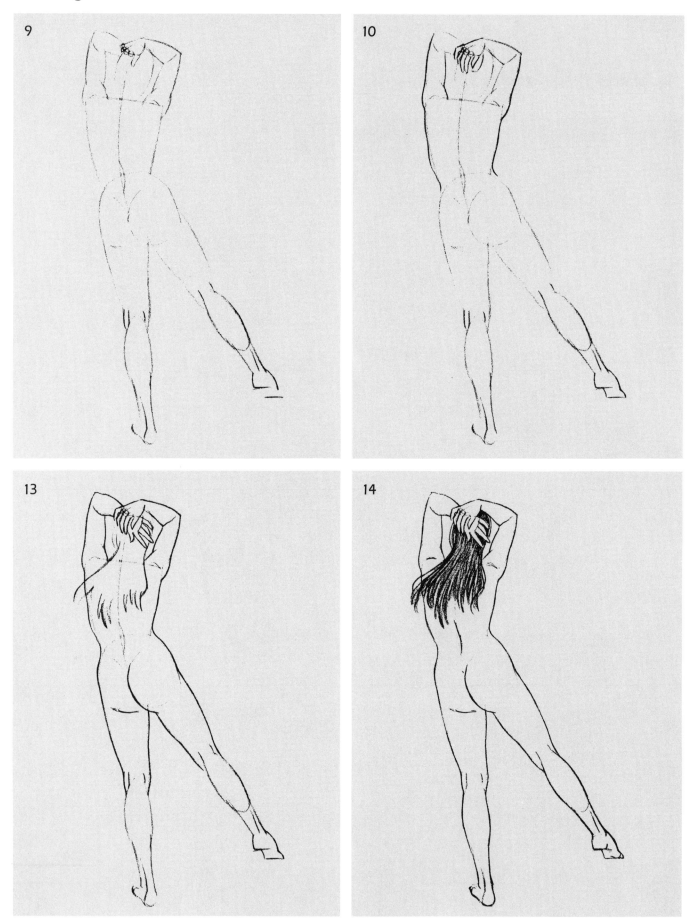

9

10

13

14

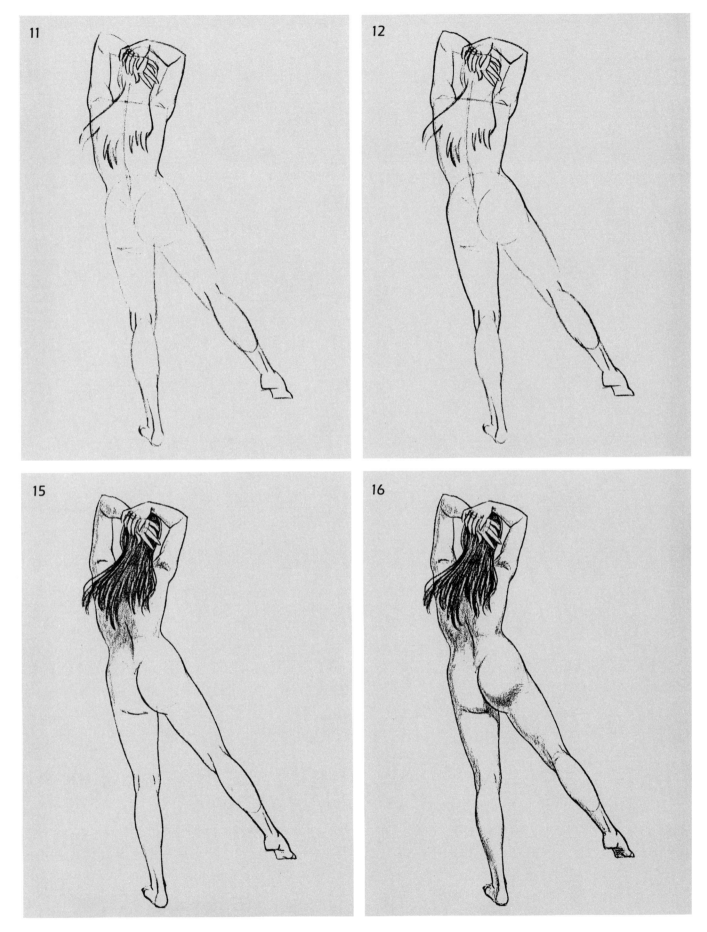

11

12

15

16

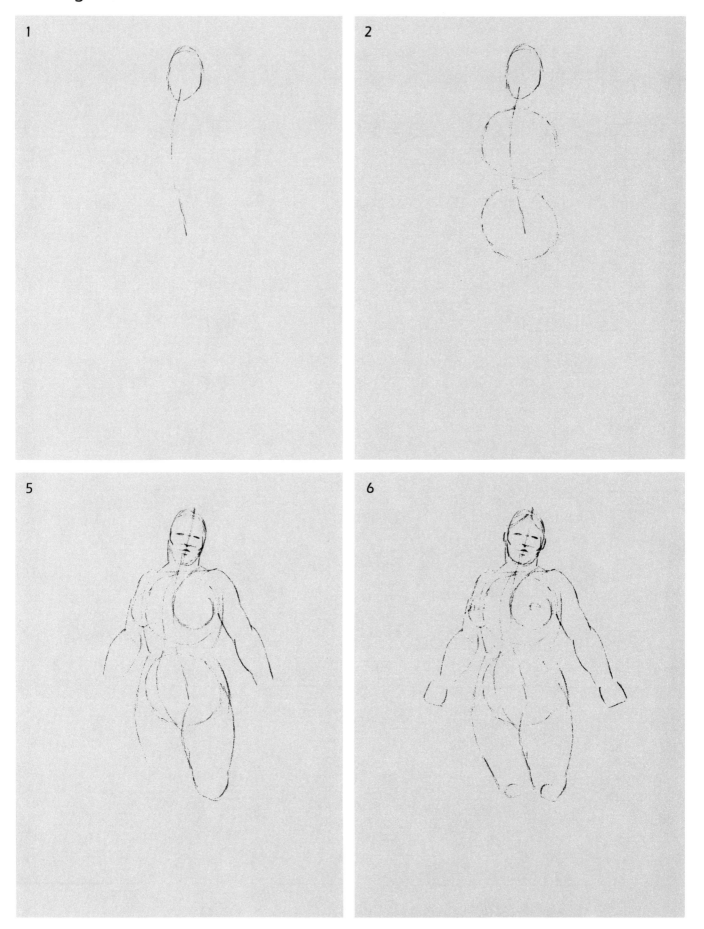

1

2

5

6

FEMALE NO. 2

3

4

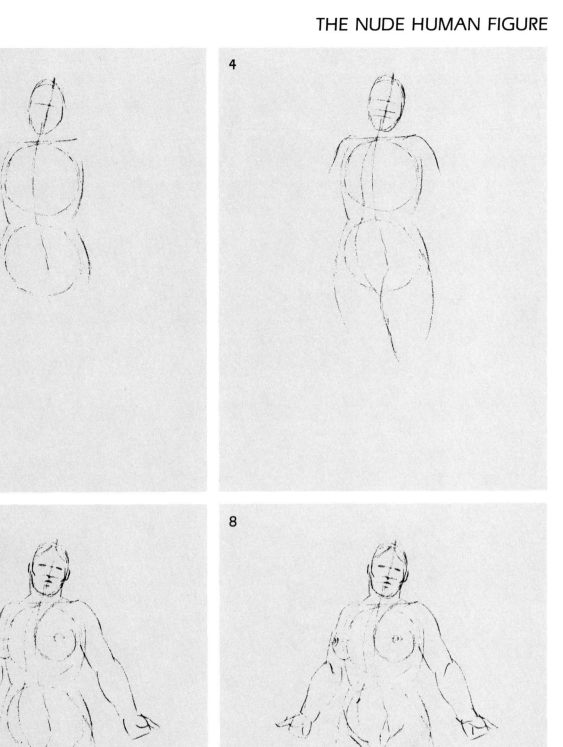

7

8

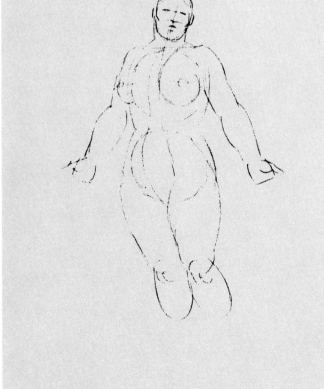

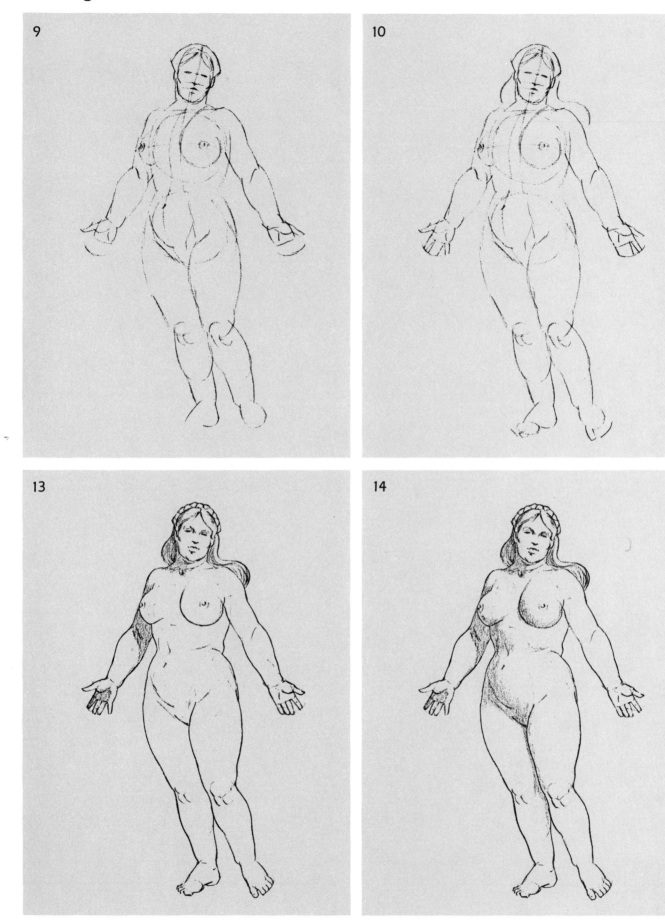

9

10

13

14

FEMALE NO. 2

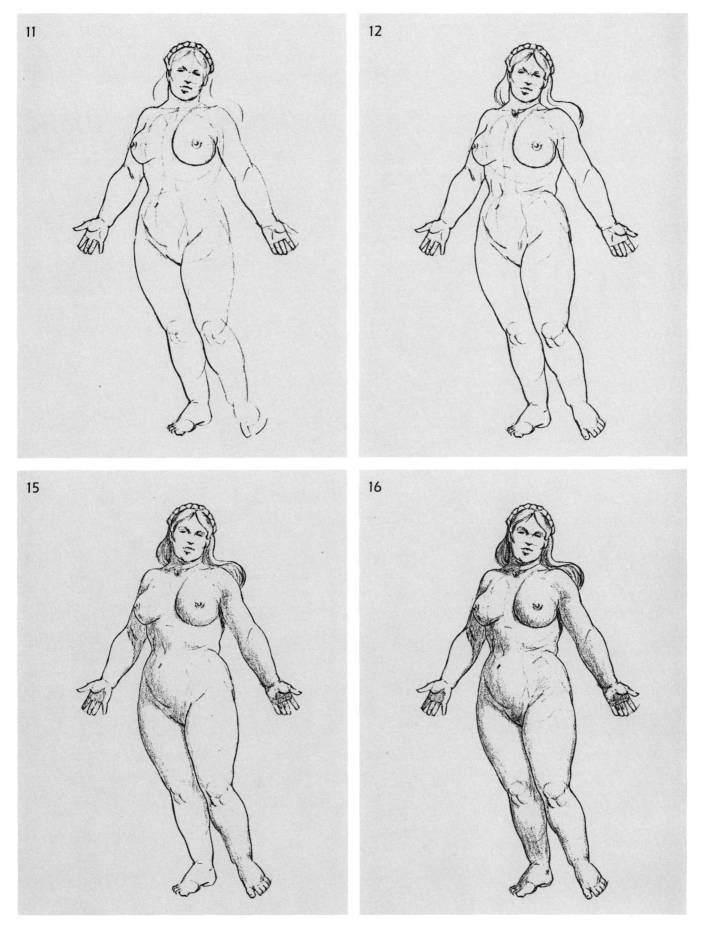

11

12

15

16

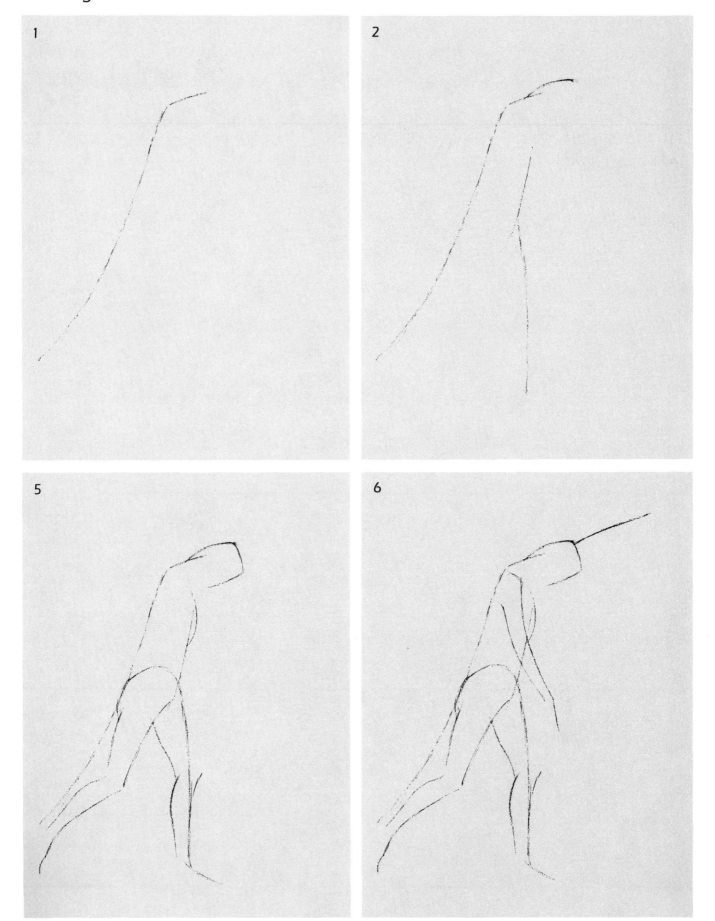

FEMALE NO. 3

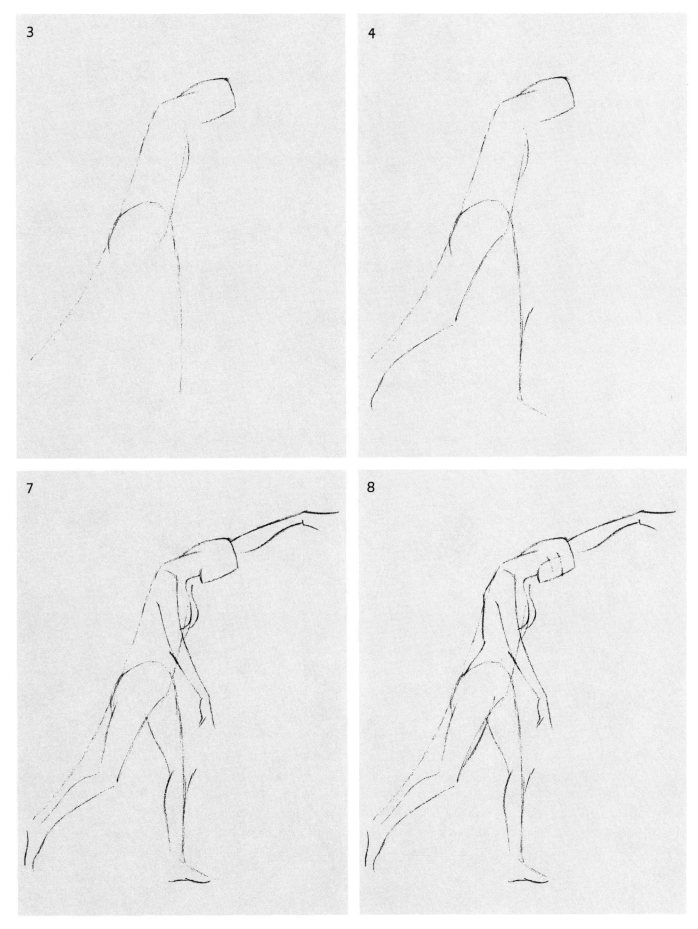

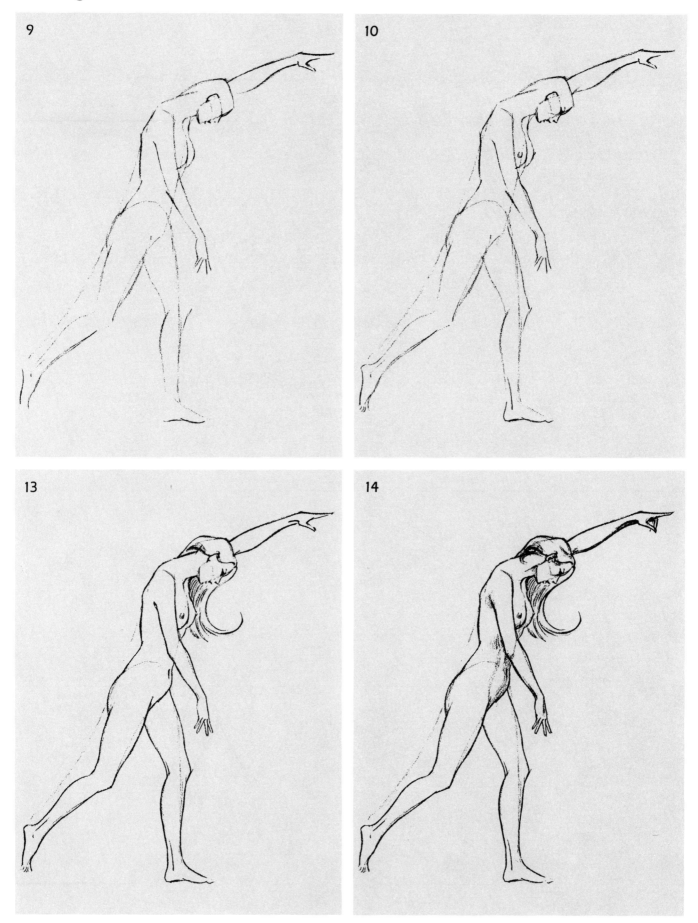

9

10

13

14

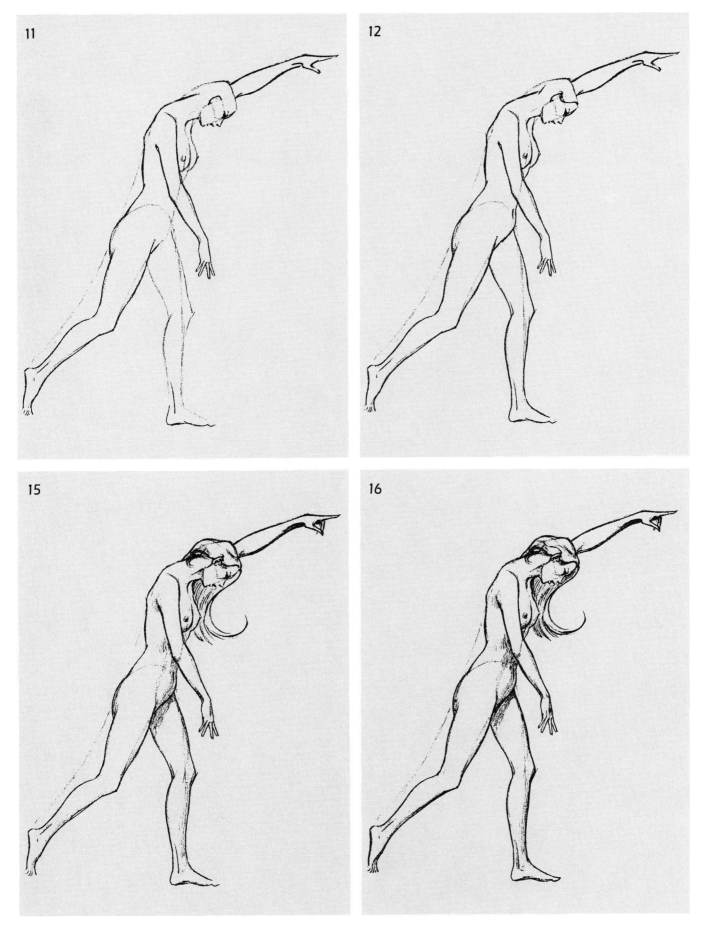

11

12

15

16

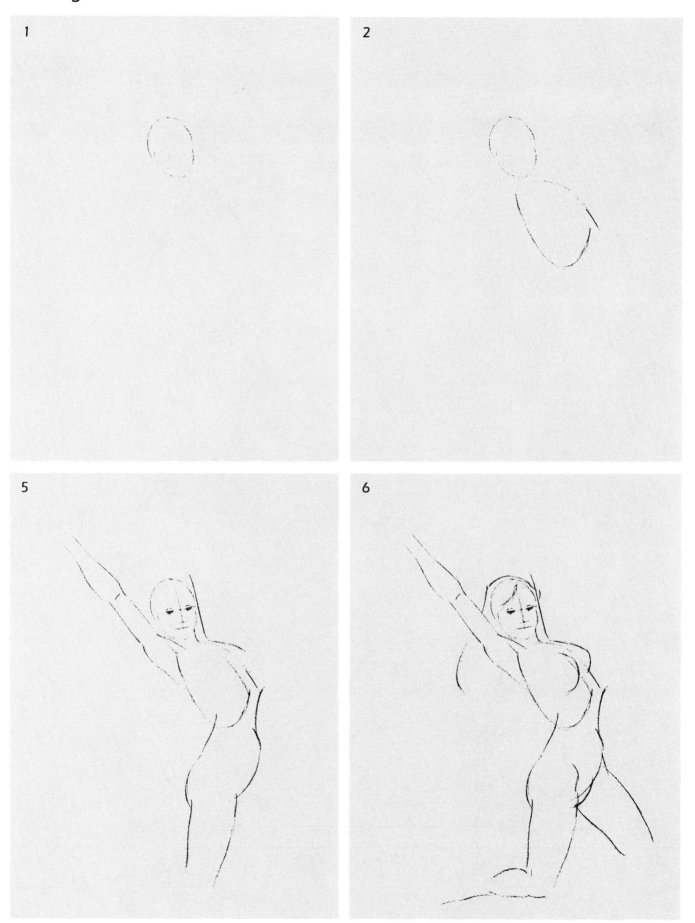

1

2

5

6

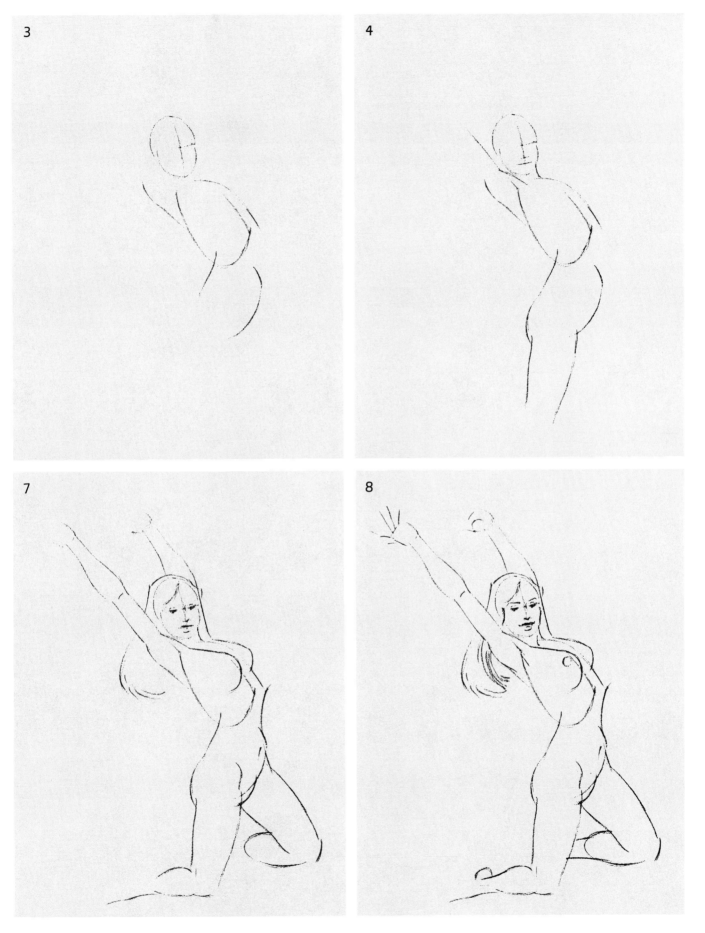

3

4

7

8

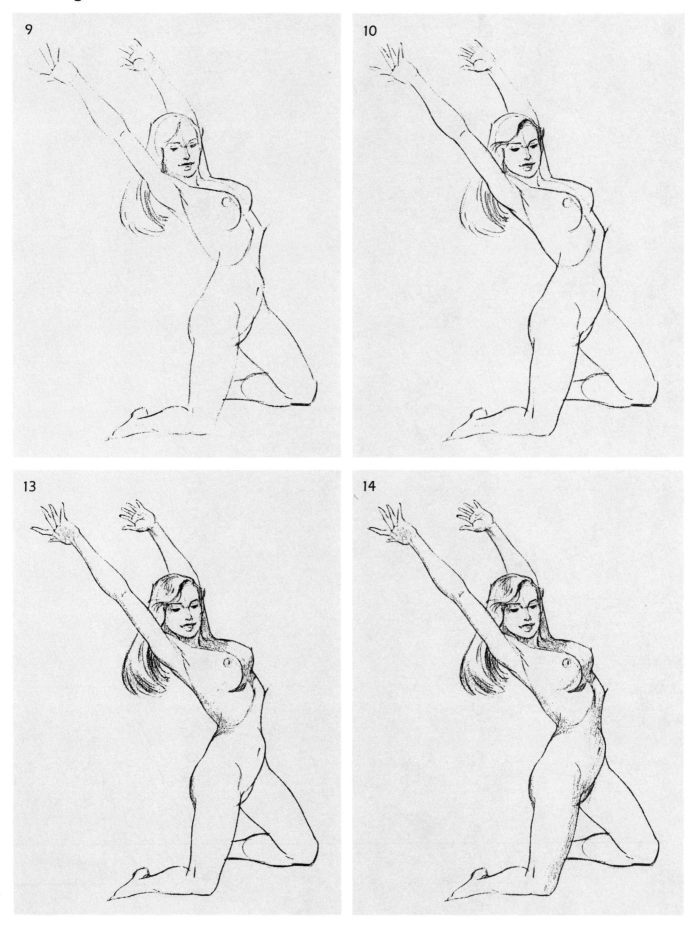

9

10

13

14

FEMALE NO. 4

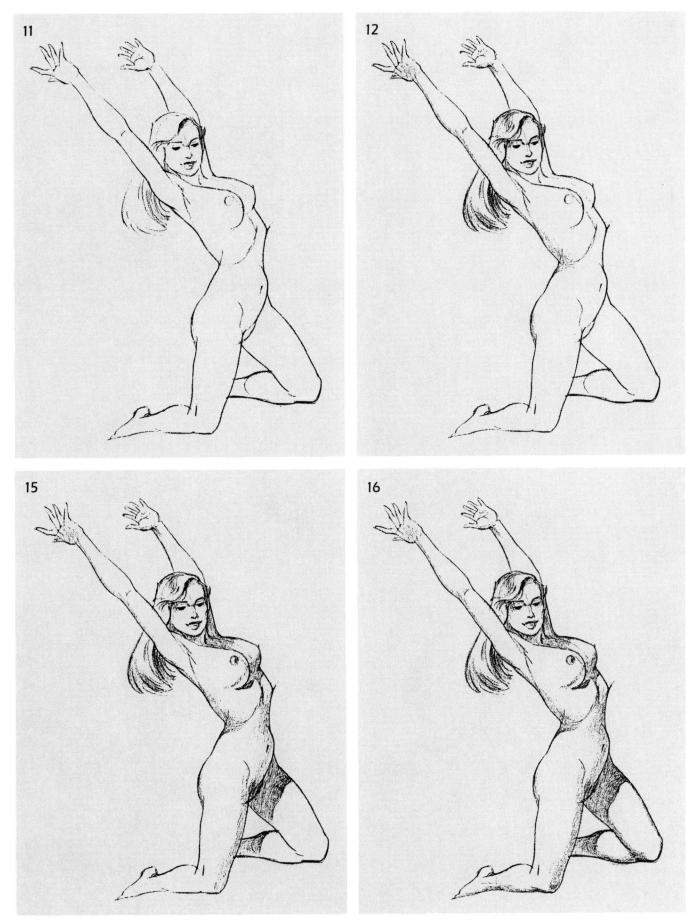

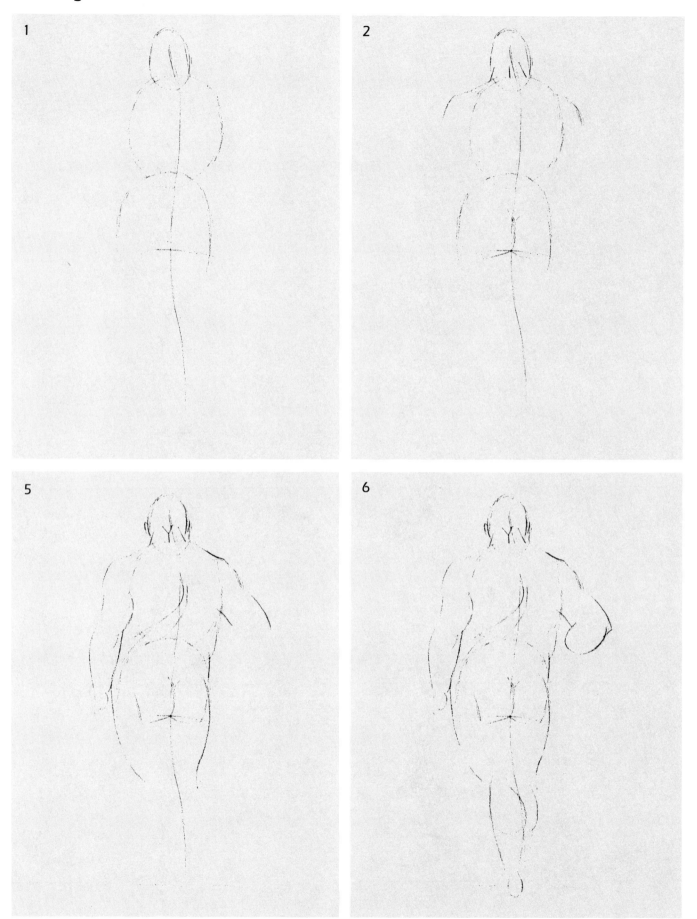

1

2.

5

6

MALE NO. 1

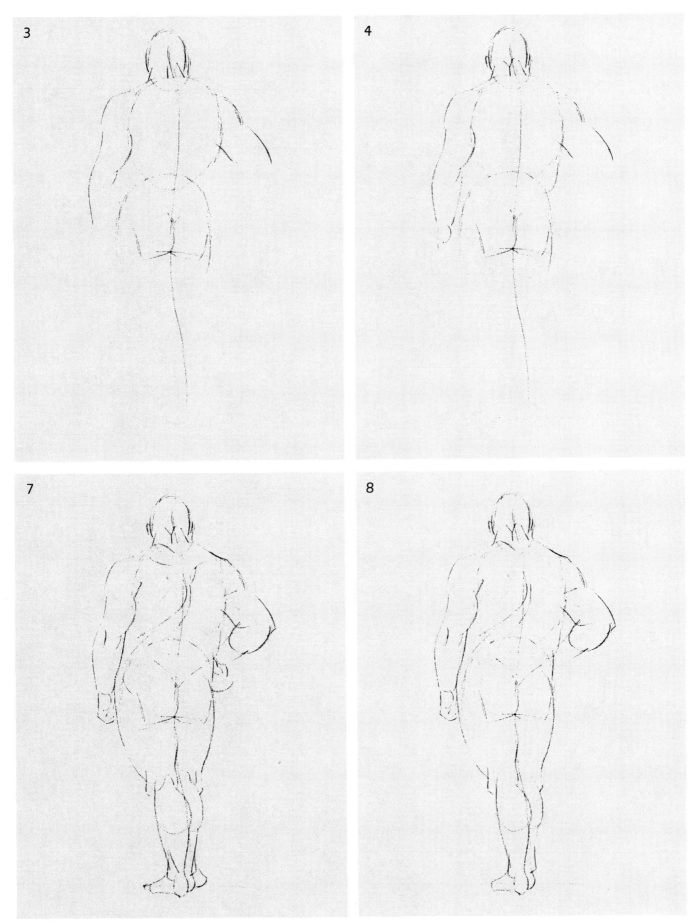

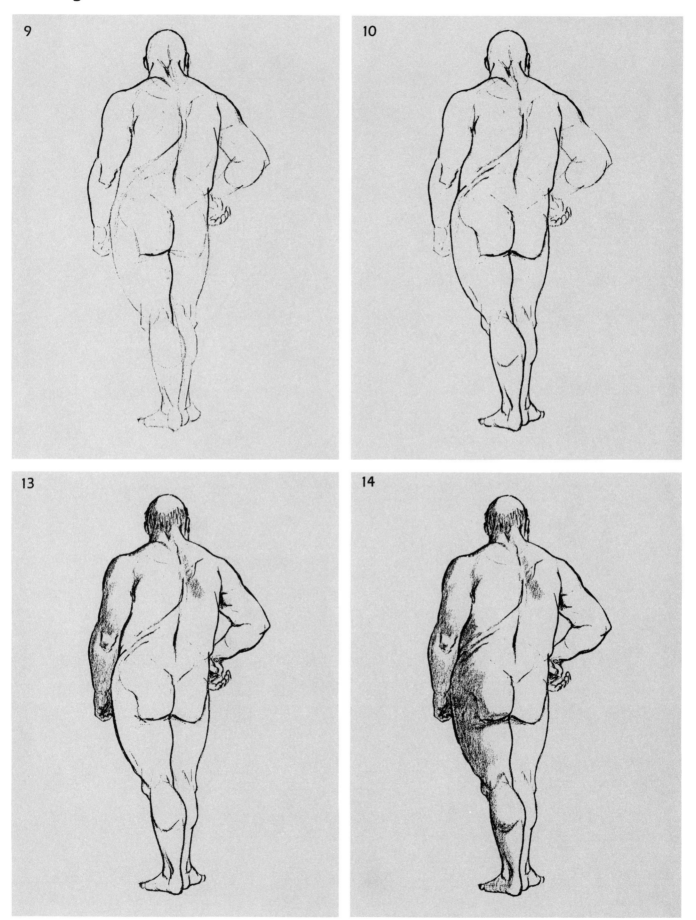

9

10

13

14

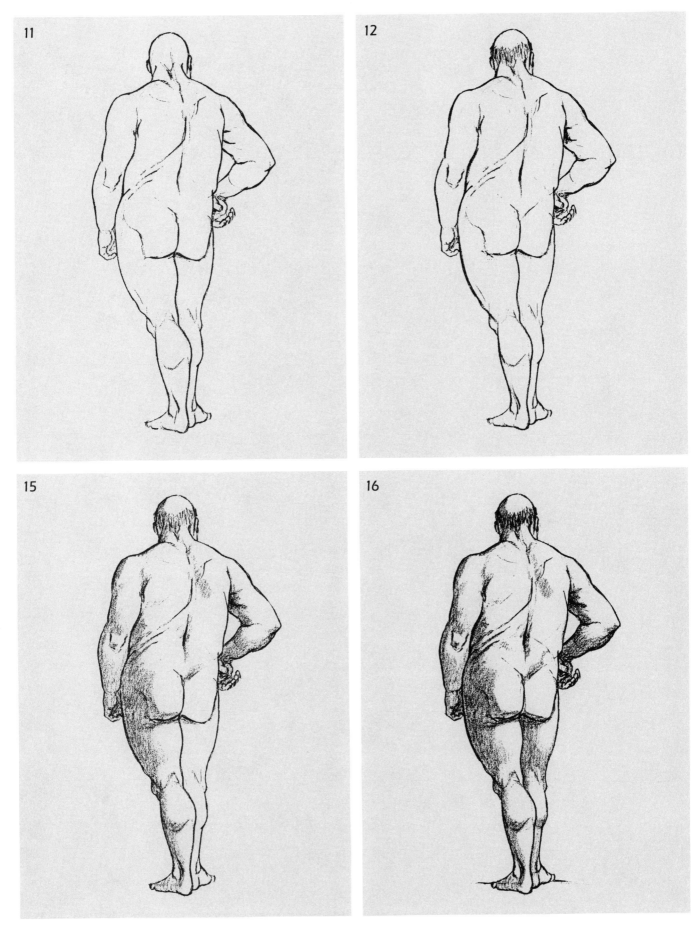

11

12

15

16

1

2

5

6

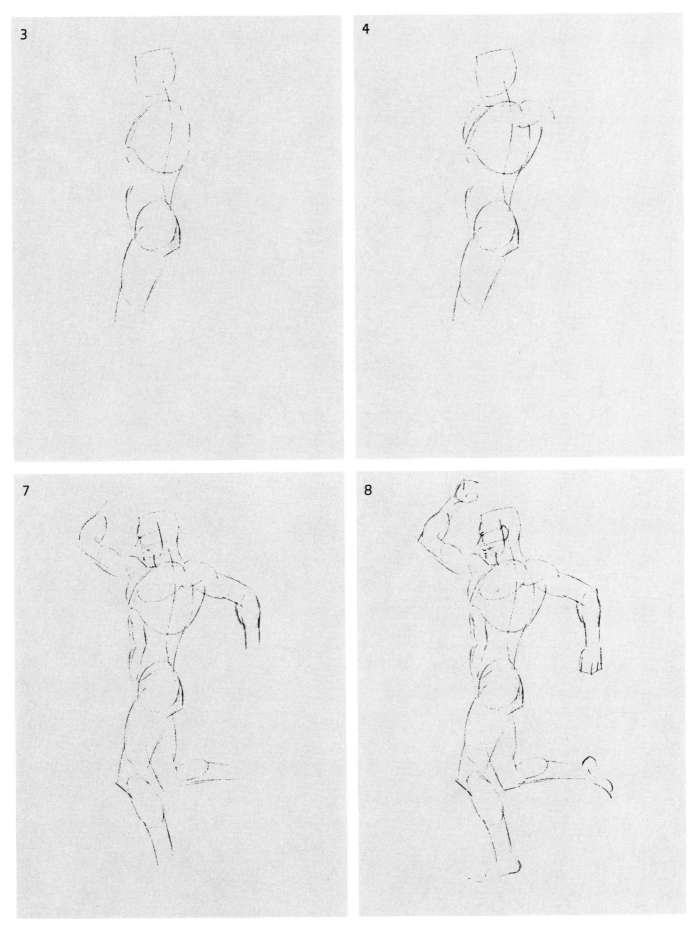

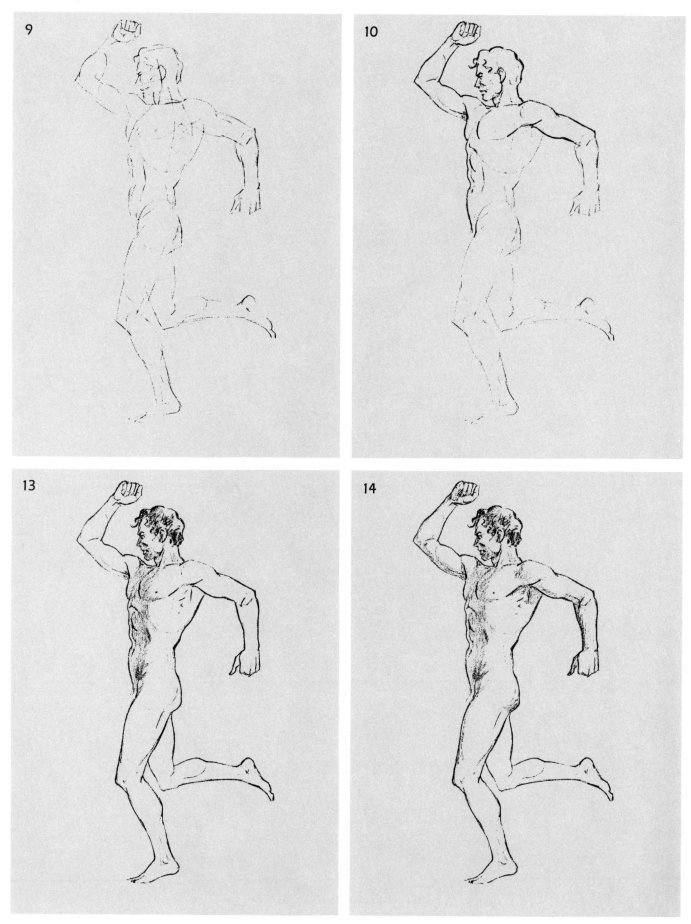

MALE NO. 2

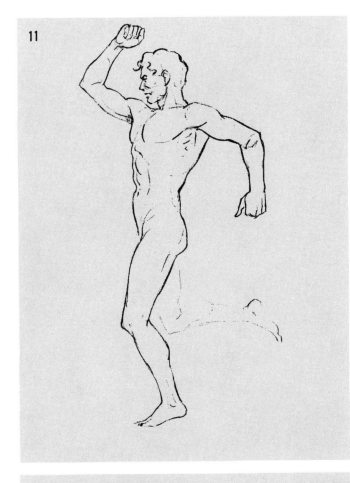

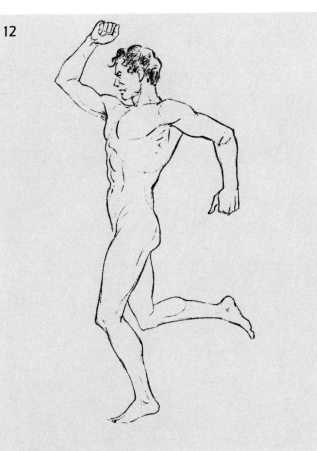

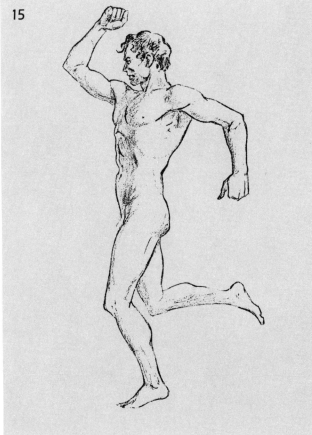

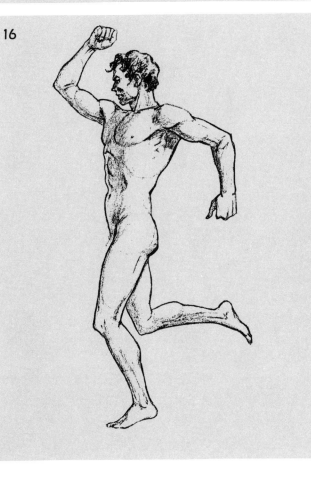

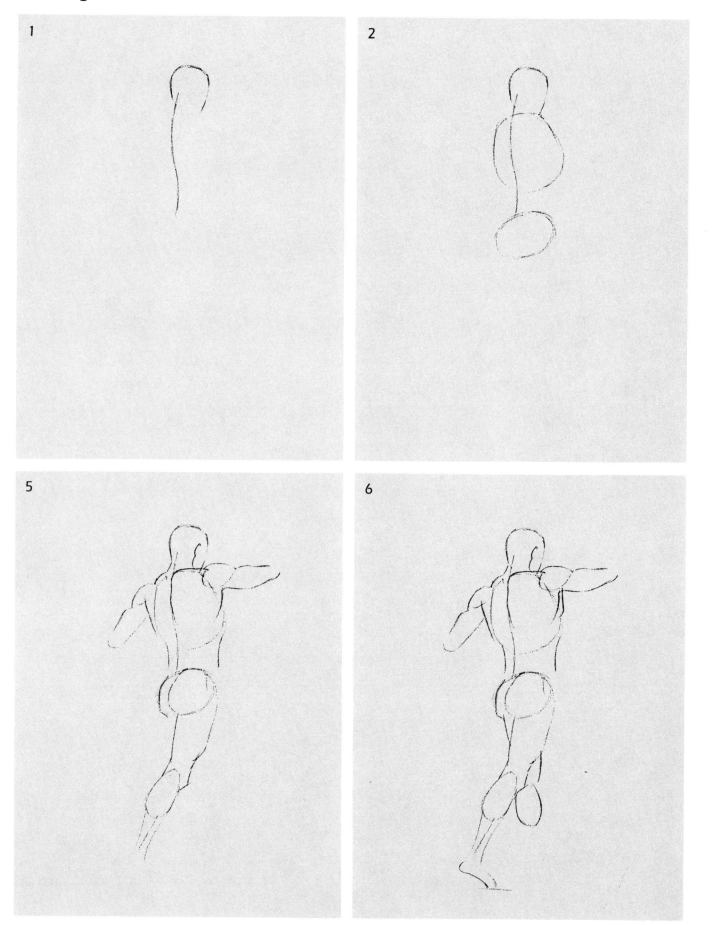

1

2

5

6

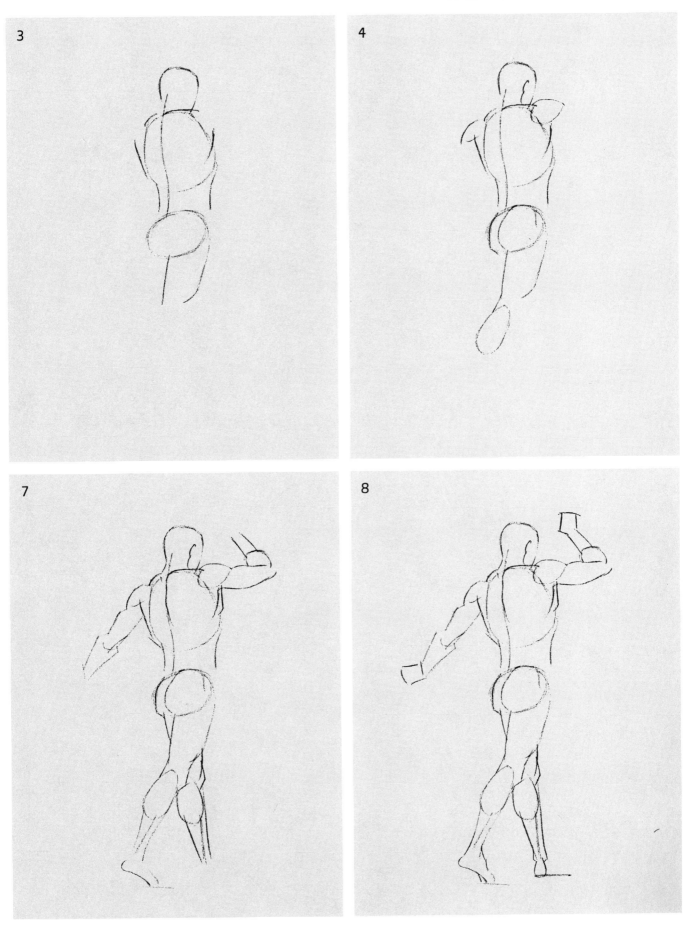

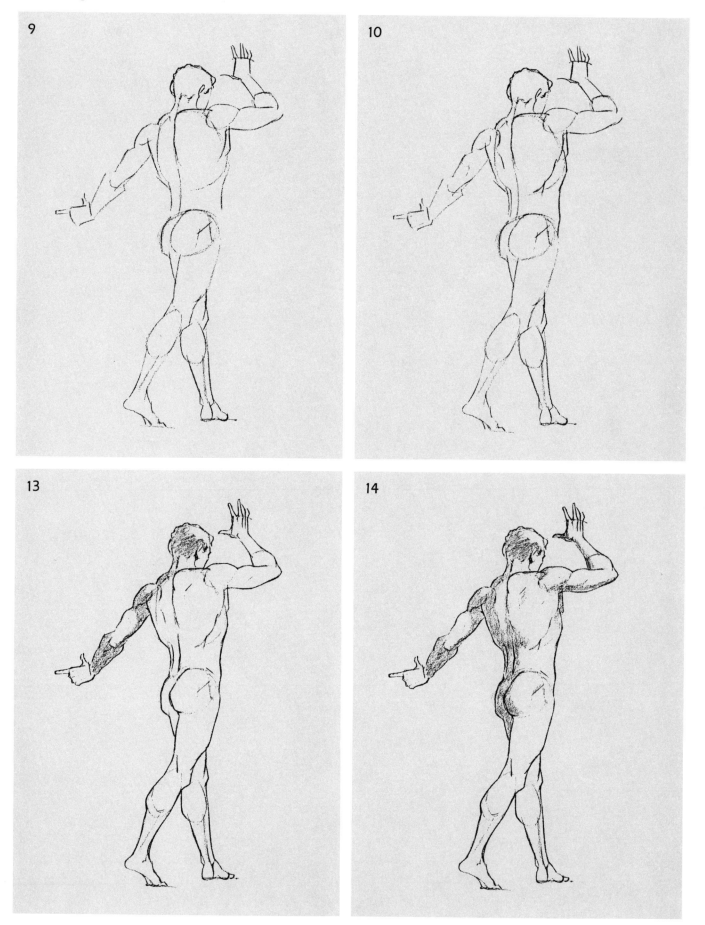

MALE NO. 3

11

12

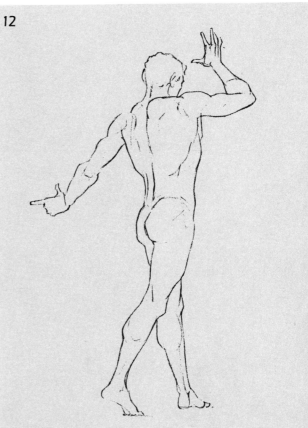

15

16

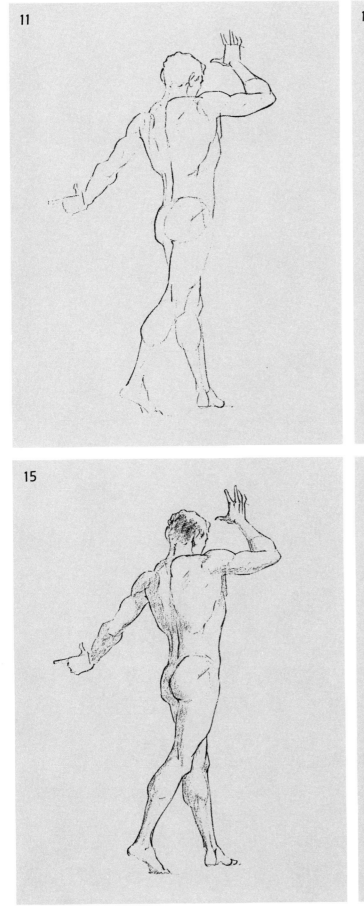

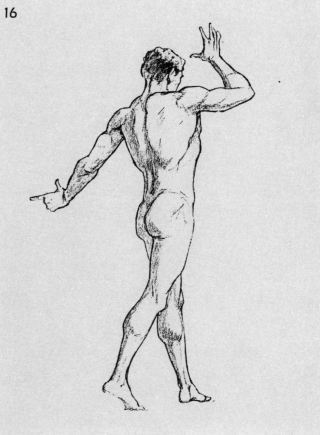

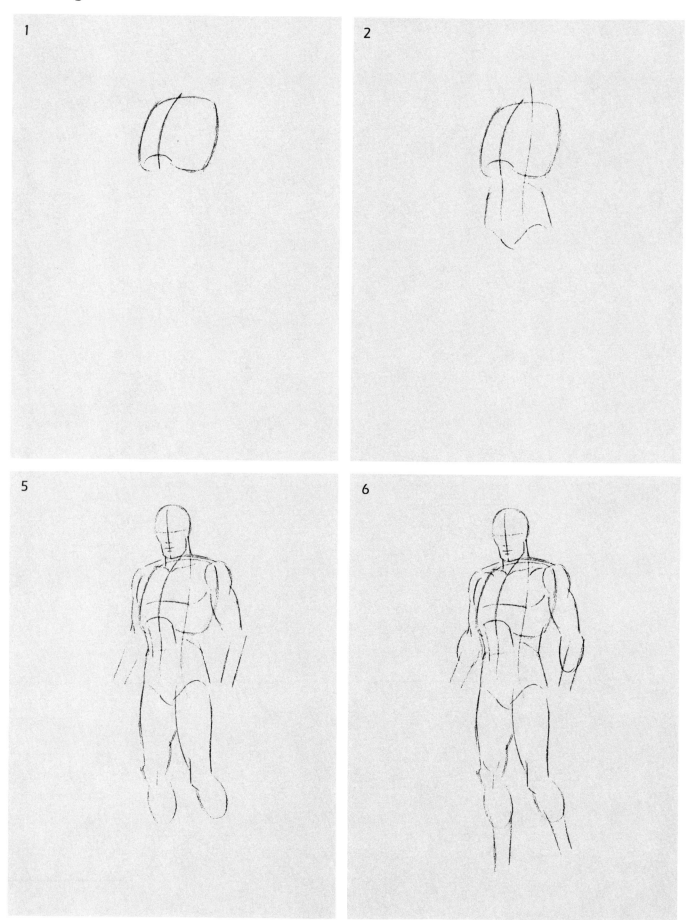

1

2

5

6

MALE NO. 4

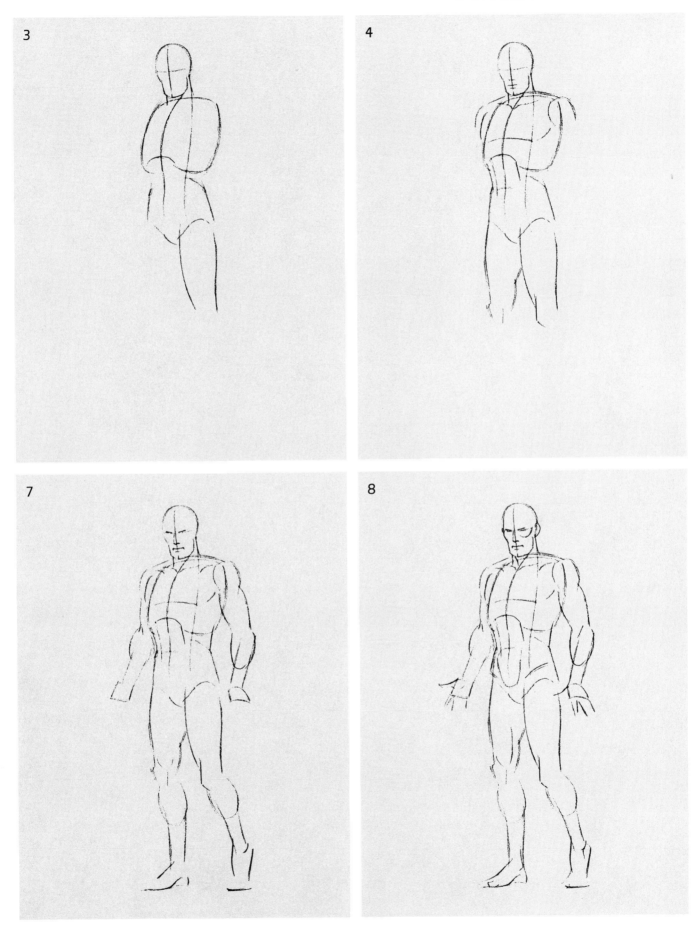

3

4

7

8

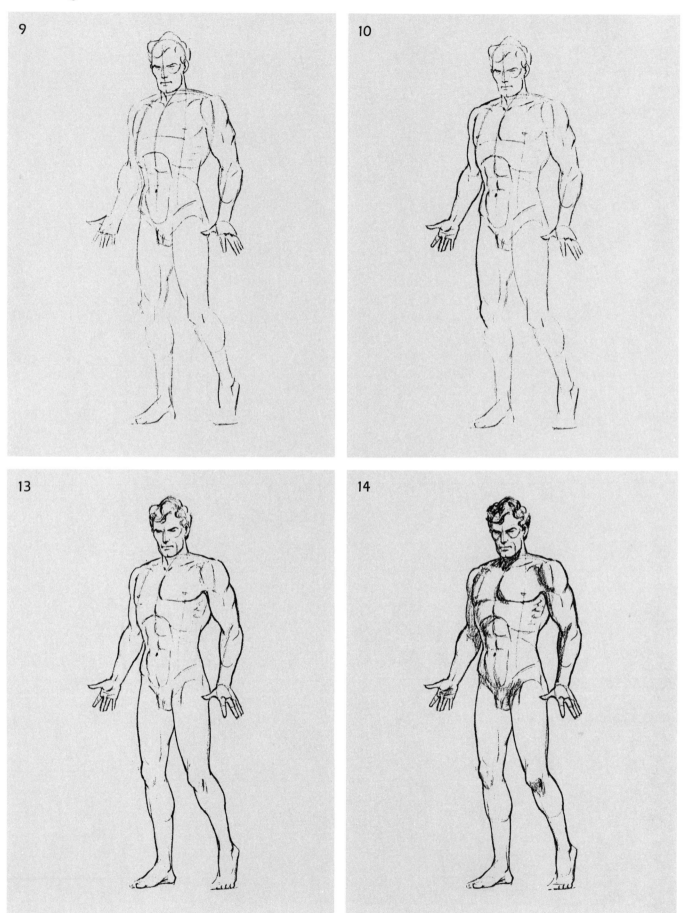

MALE NO. 4

11
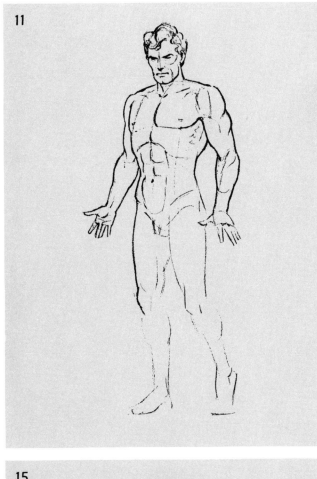

12
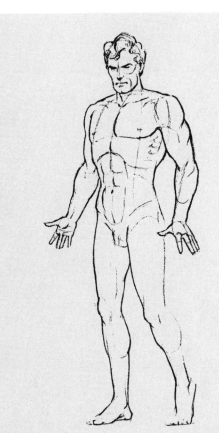

15
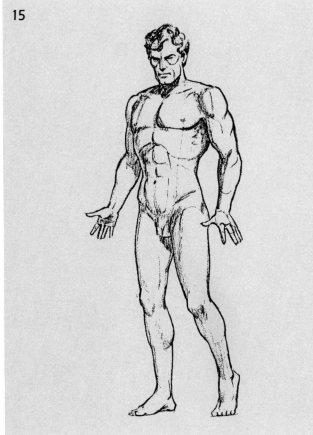

16
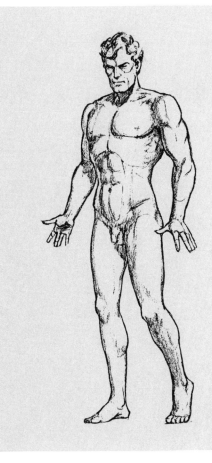

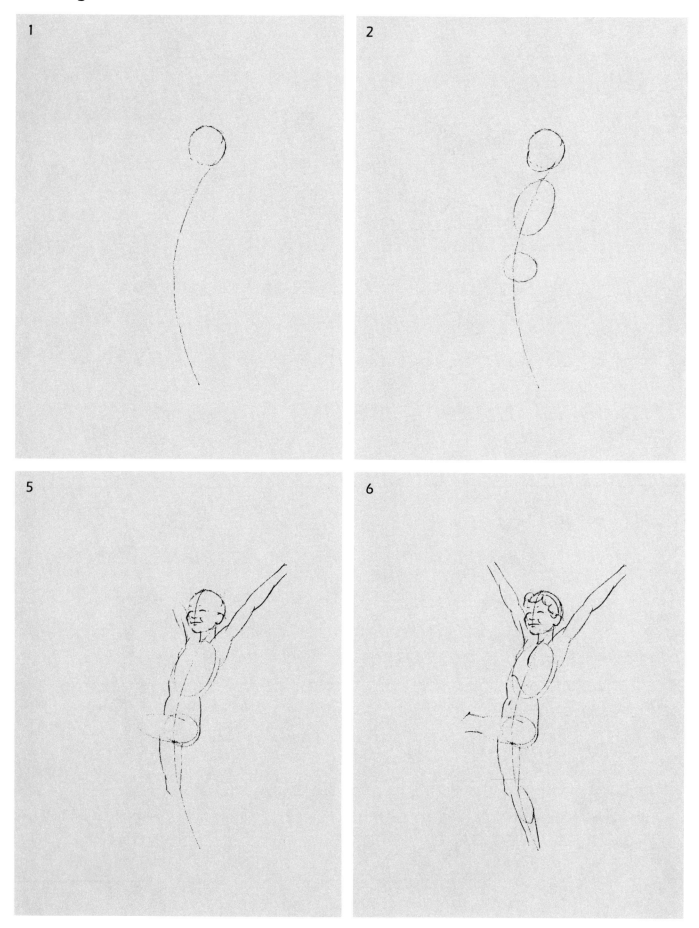

1

2

5

6

ADOLESCENT NO. 1

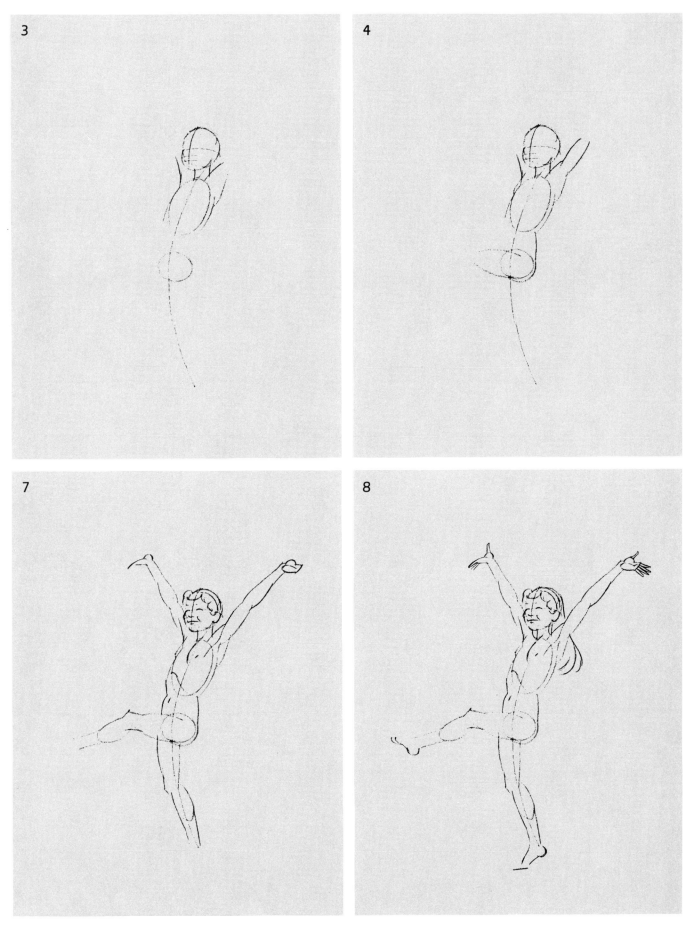

3

4

7

8

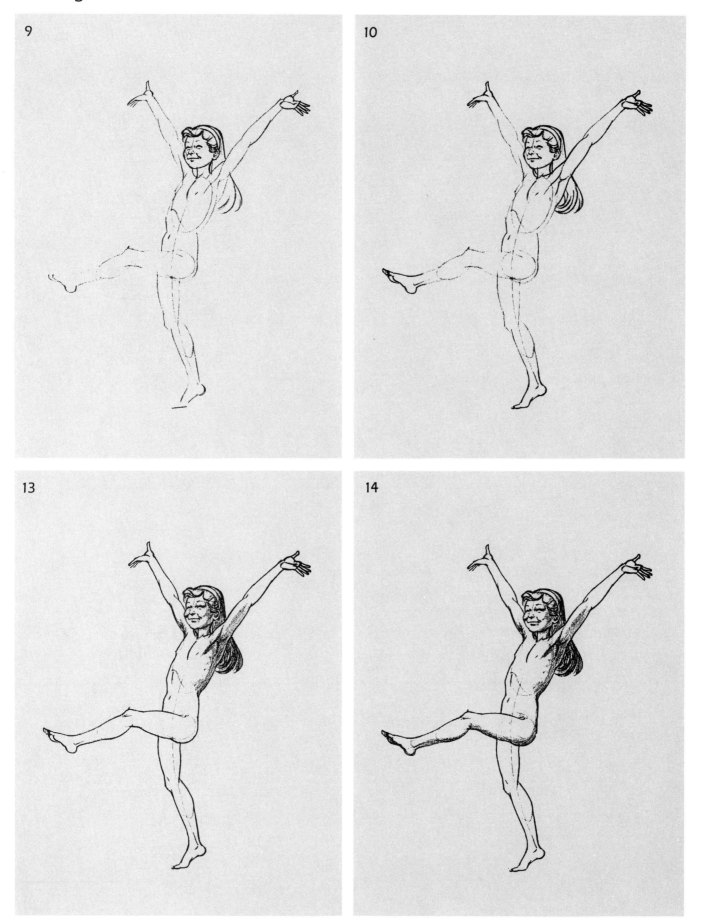

9

10

13

14

ADOLESCENT NO. 1

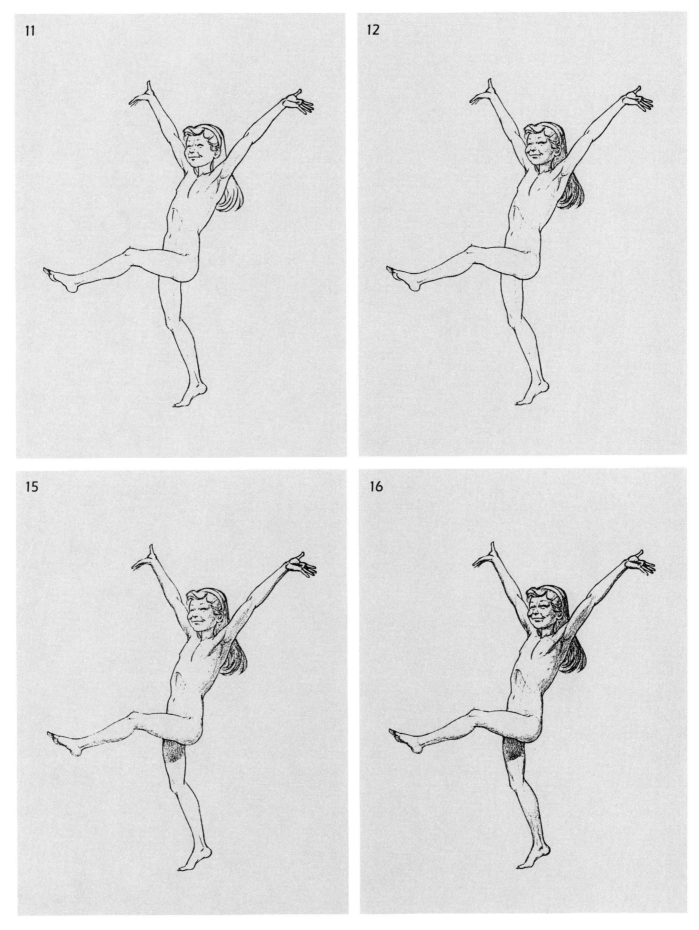

11

12

15

16

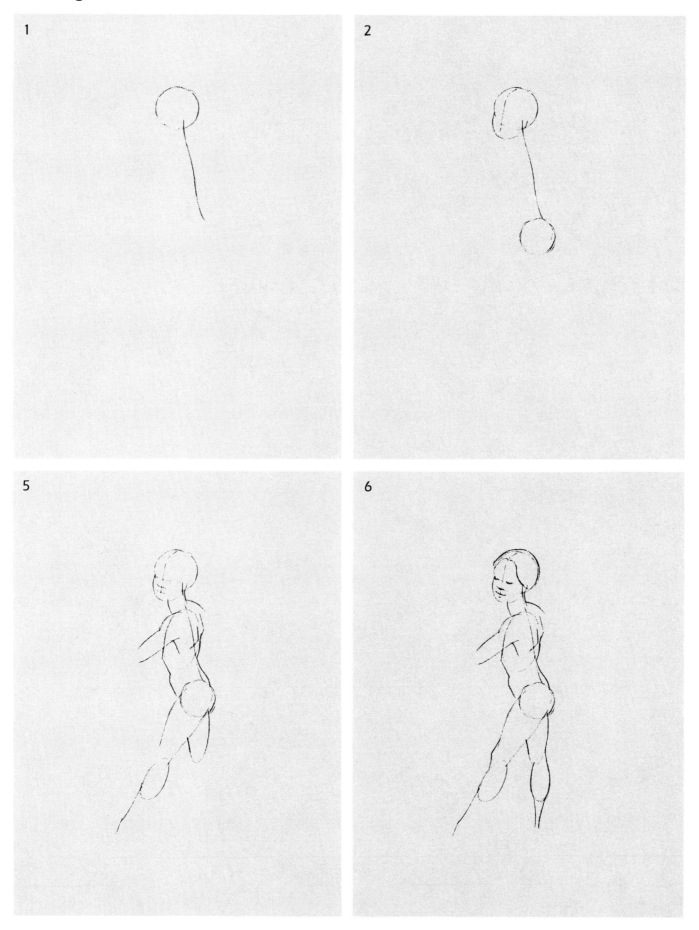

1

2

5

6

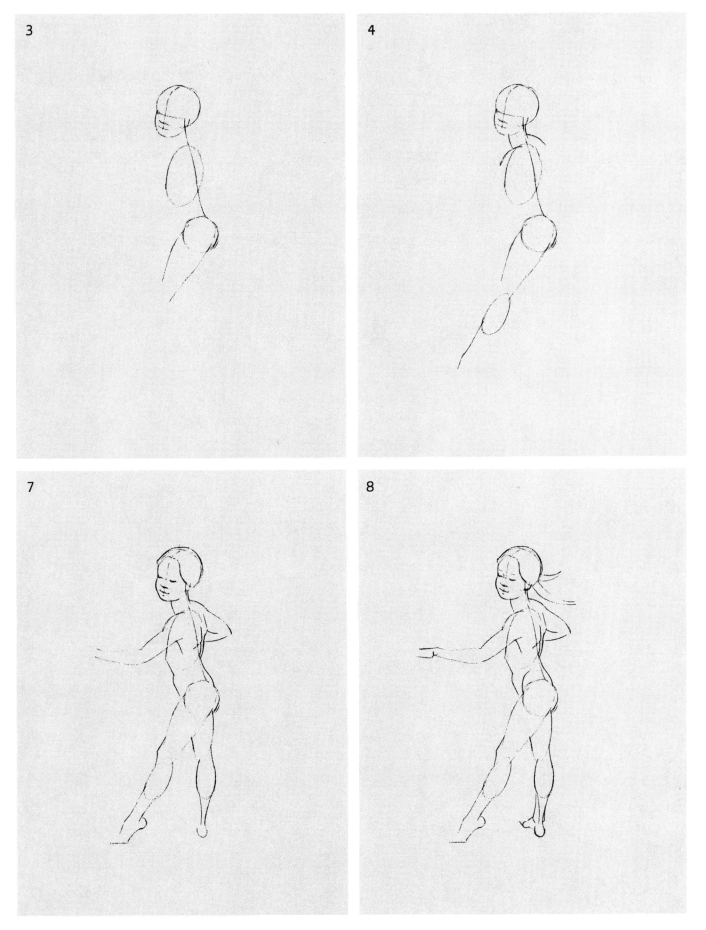

3

4

7

8

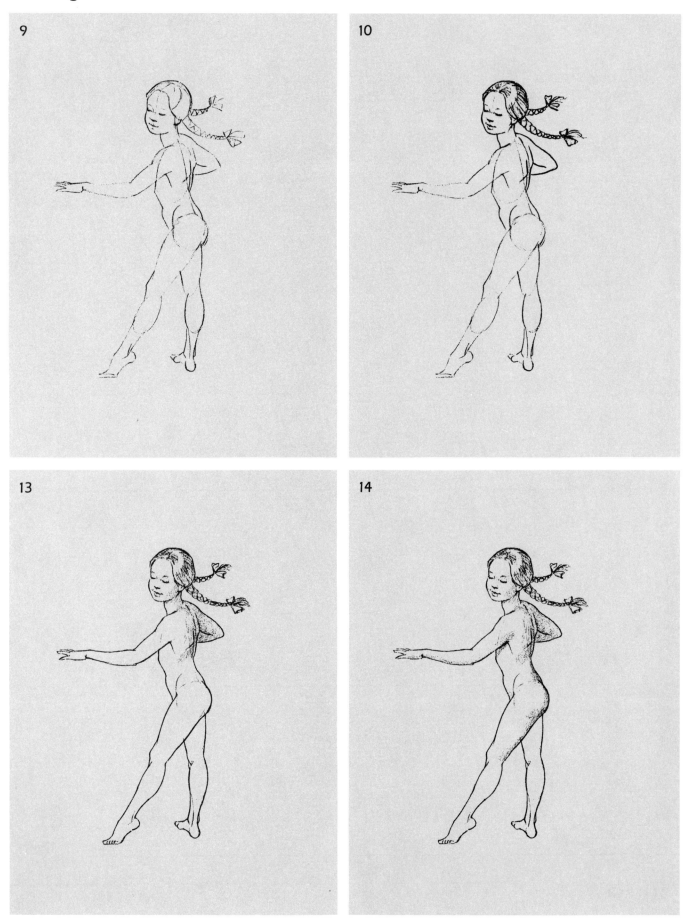

ADOLESCENT NO. 2

11

12

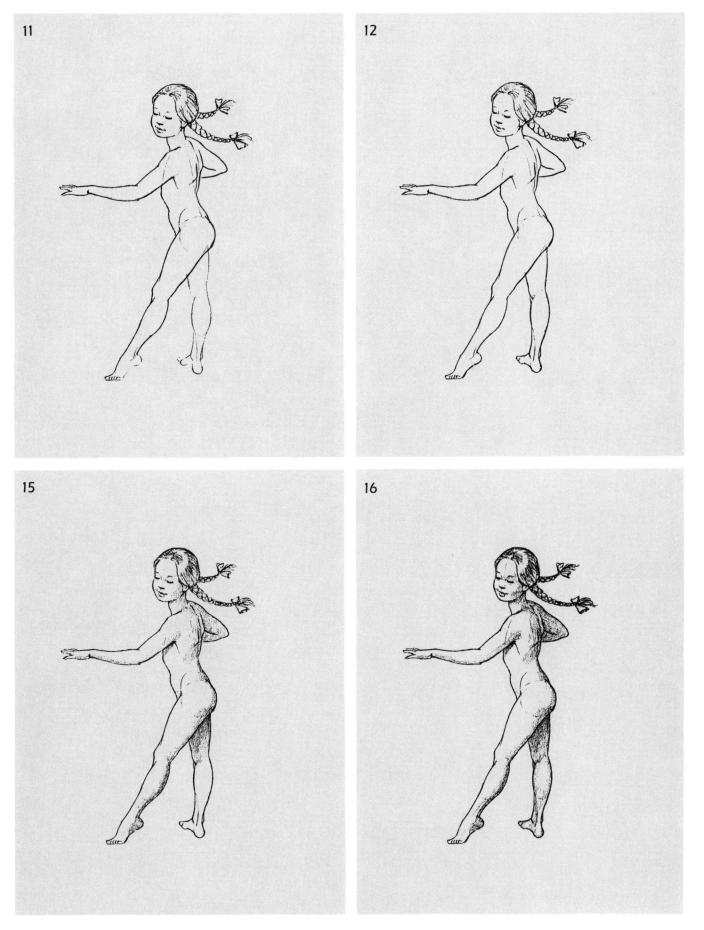

15

16

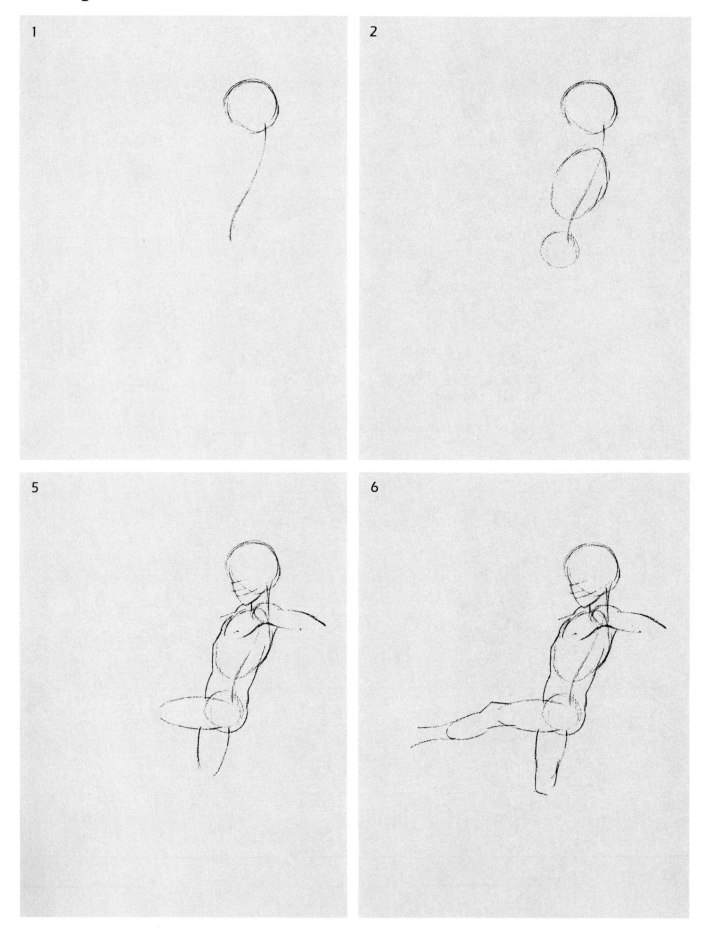

1

2

5

6

ADOLESCENT NO. 3

3

4

7

8

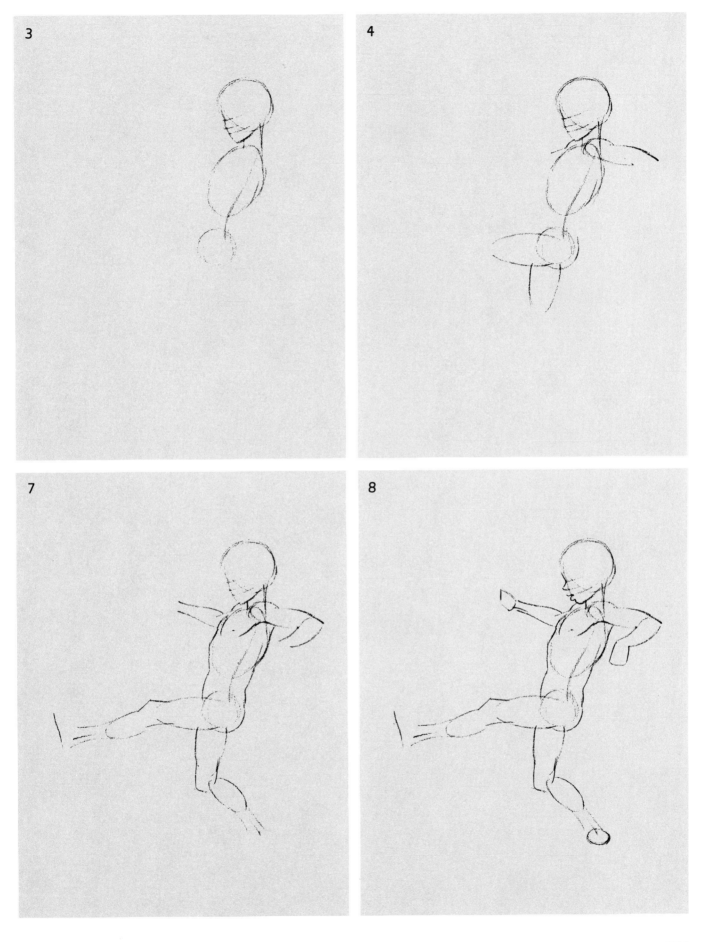

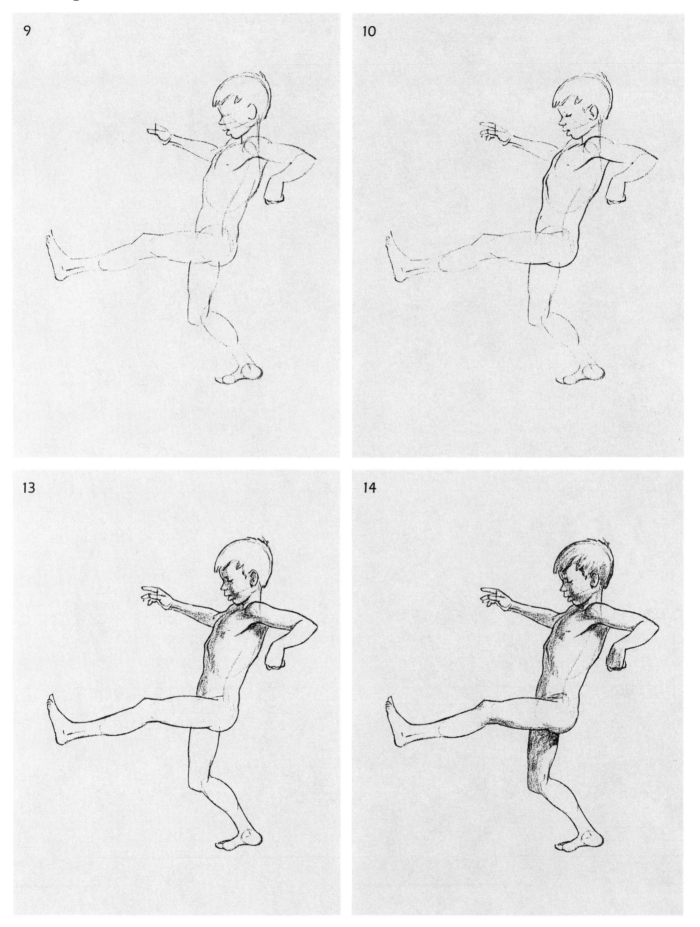

9

10

13

14

ADOLESCENT NO. 3

11

12

15

16

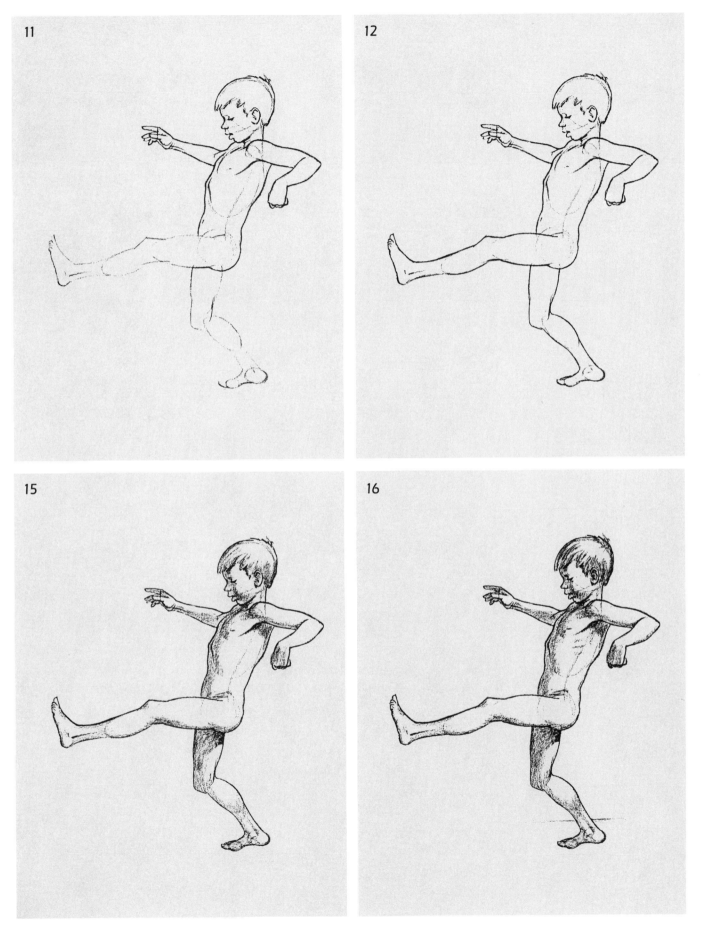

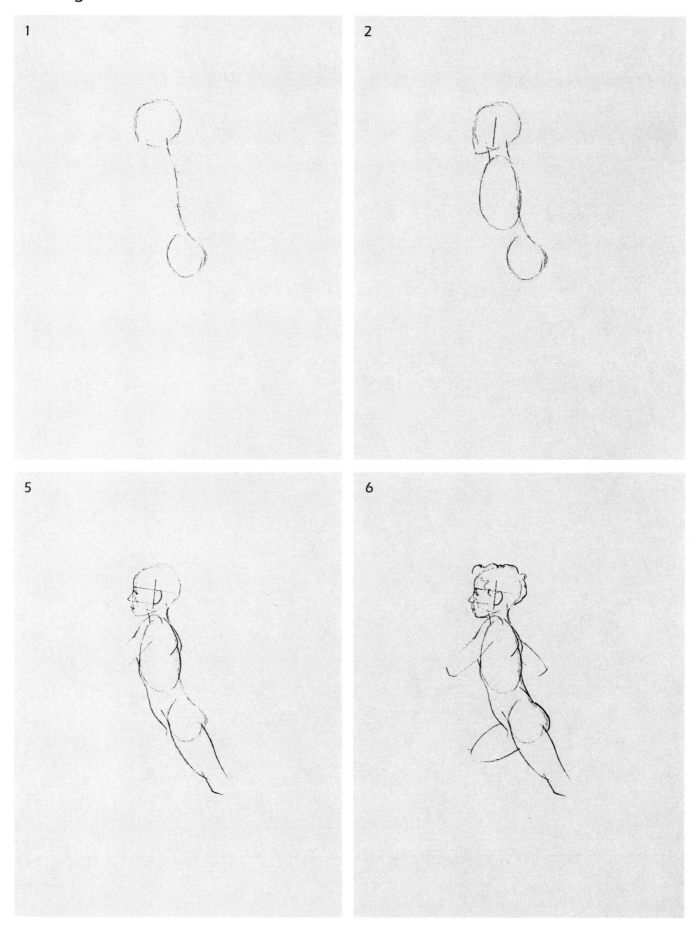

1

2

5

6

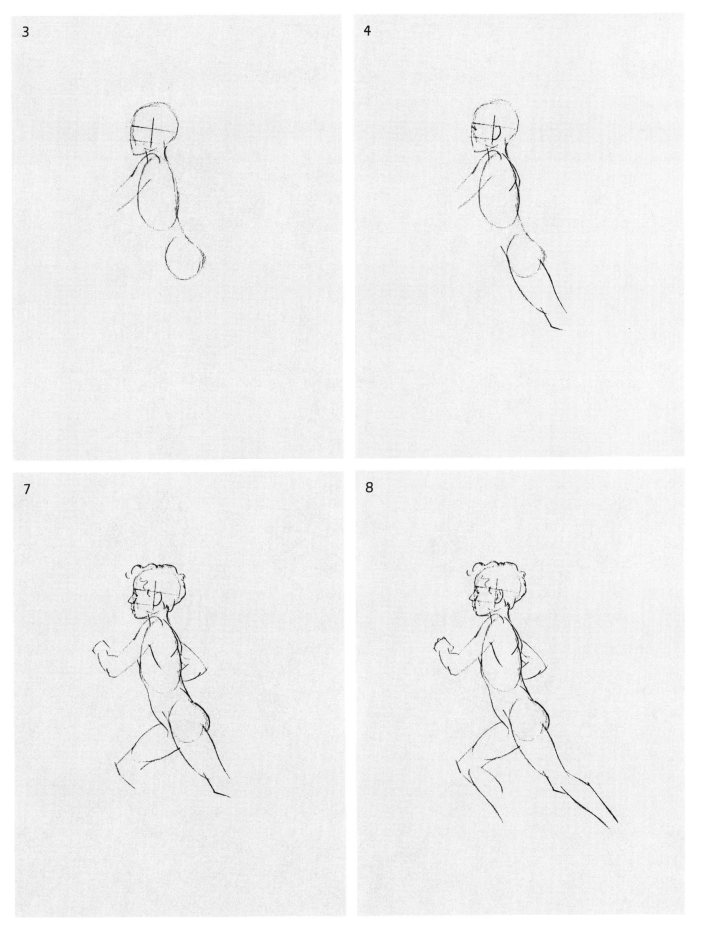

3

4

7

8

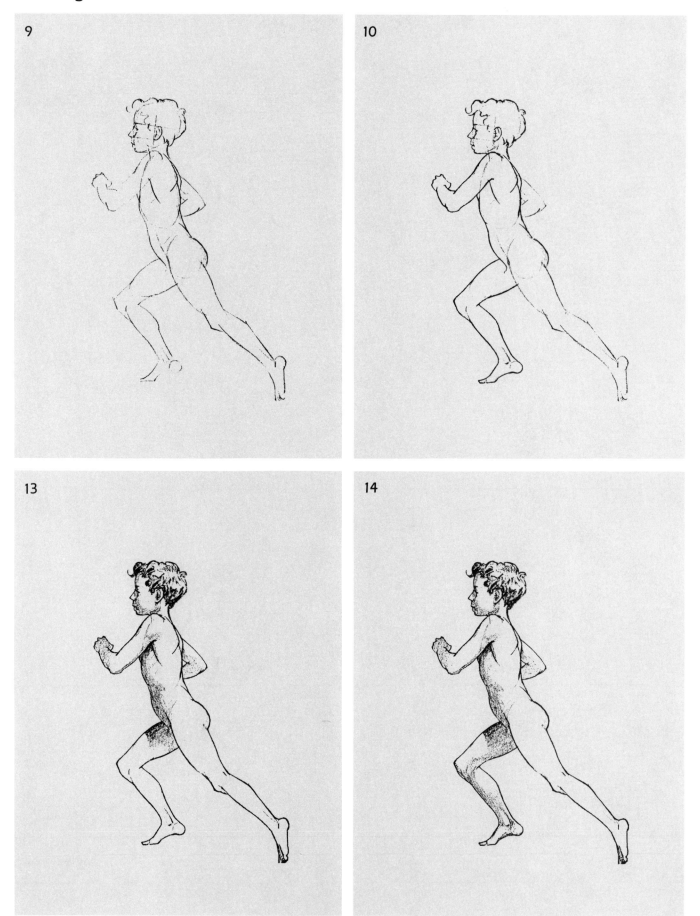

9

10

13

14

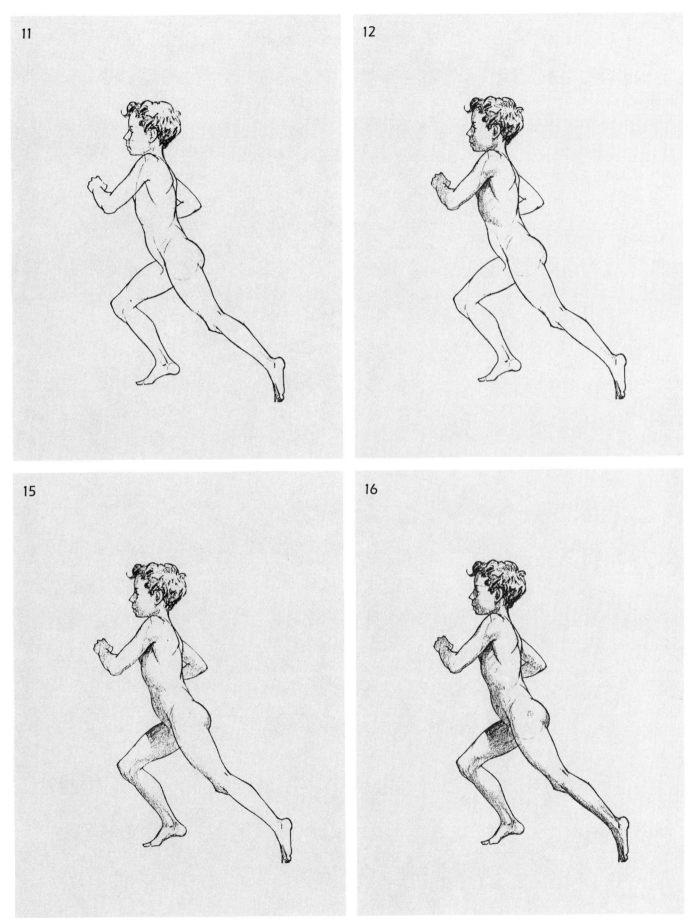

11

12

15

16

1

2

5

6

CHILD NO. 1

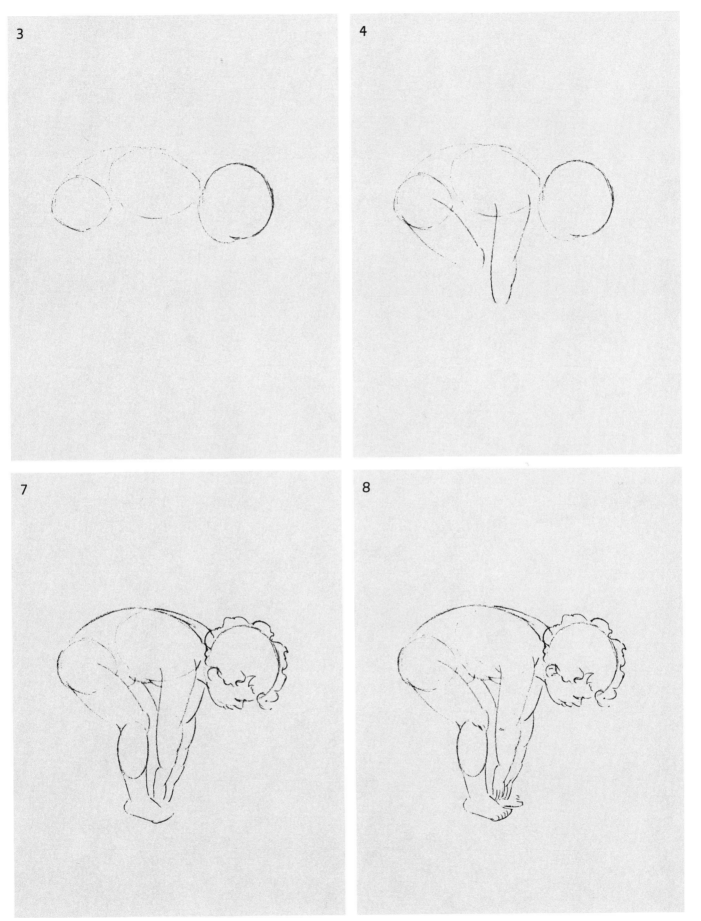

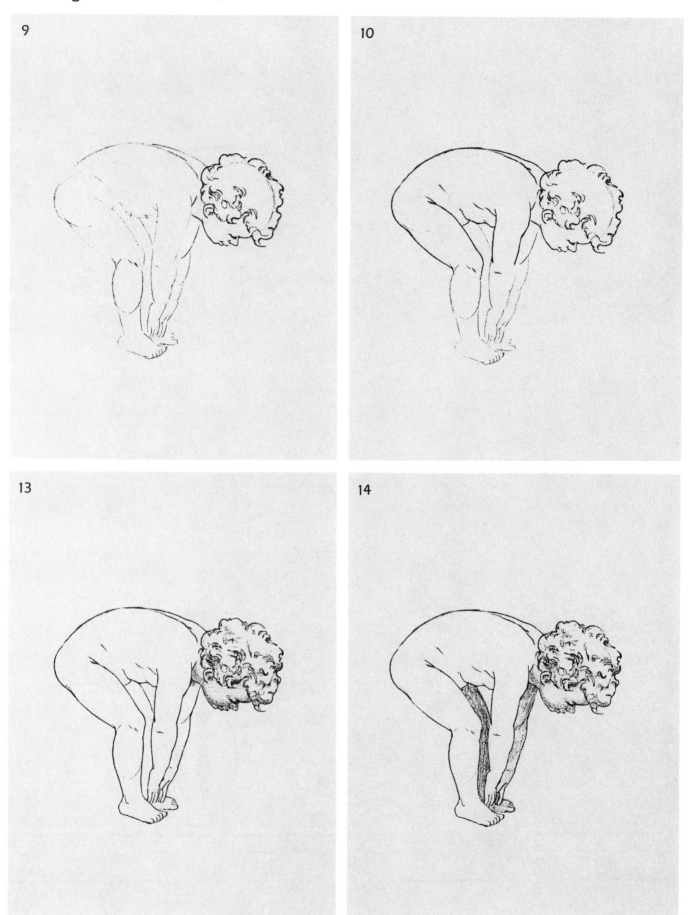

9

10

13

14

CHILD NO. 1

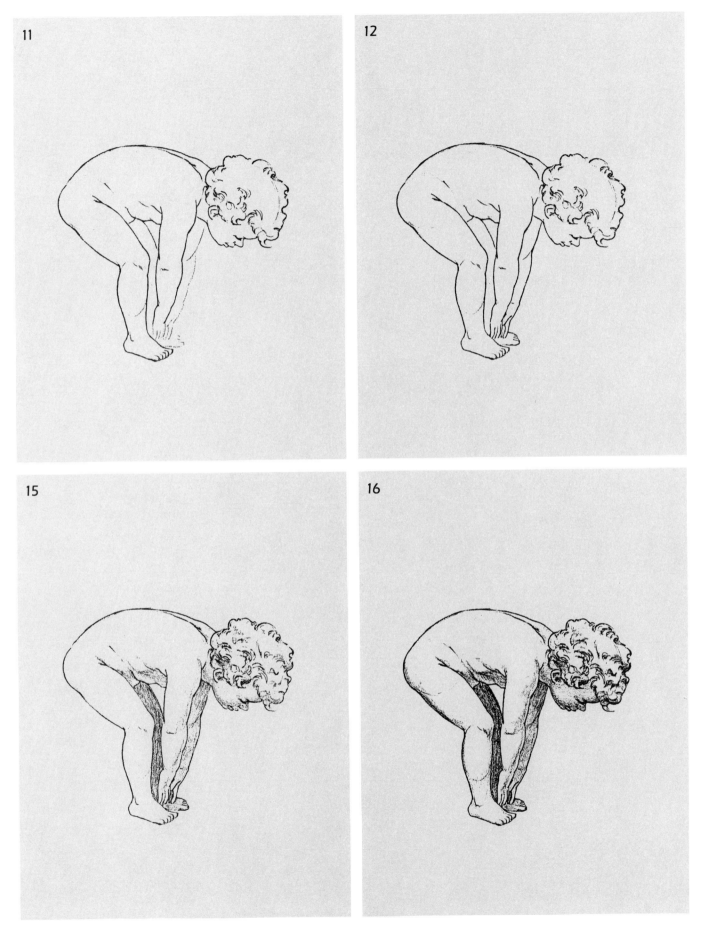

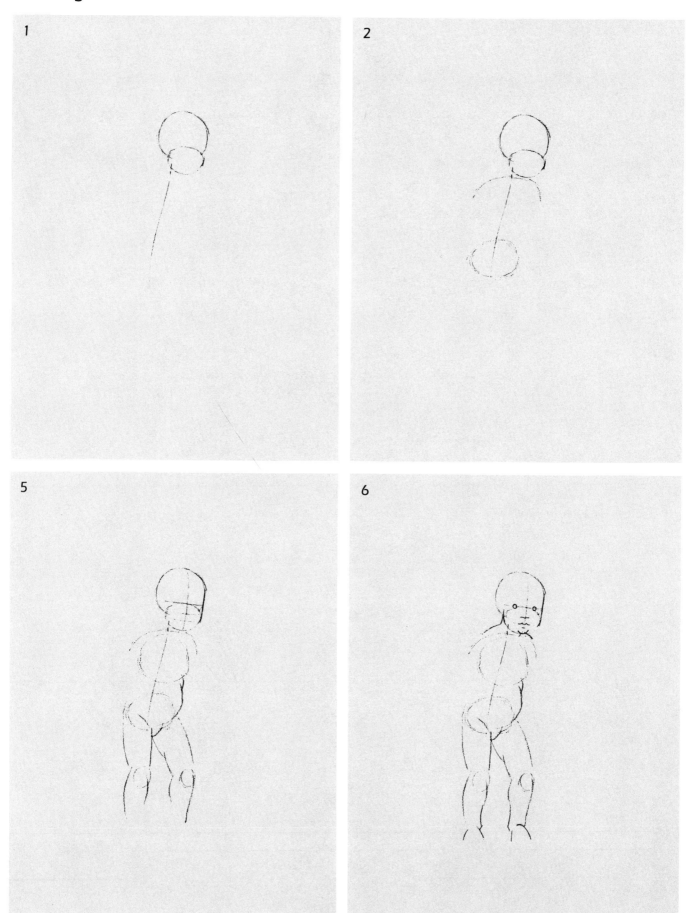

1

2

5

6

CHILD NO. 2

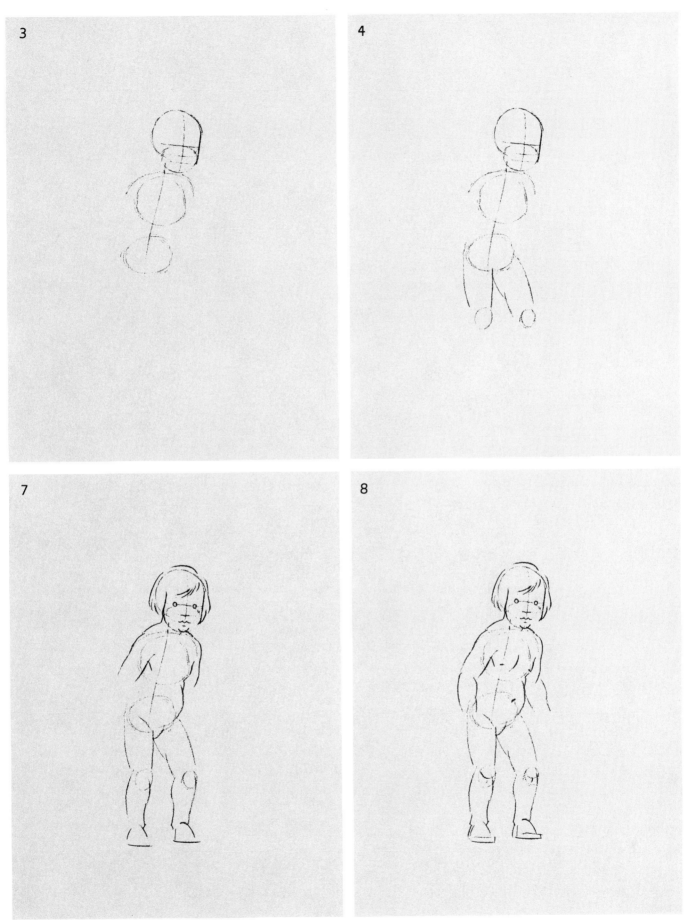

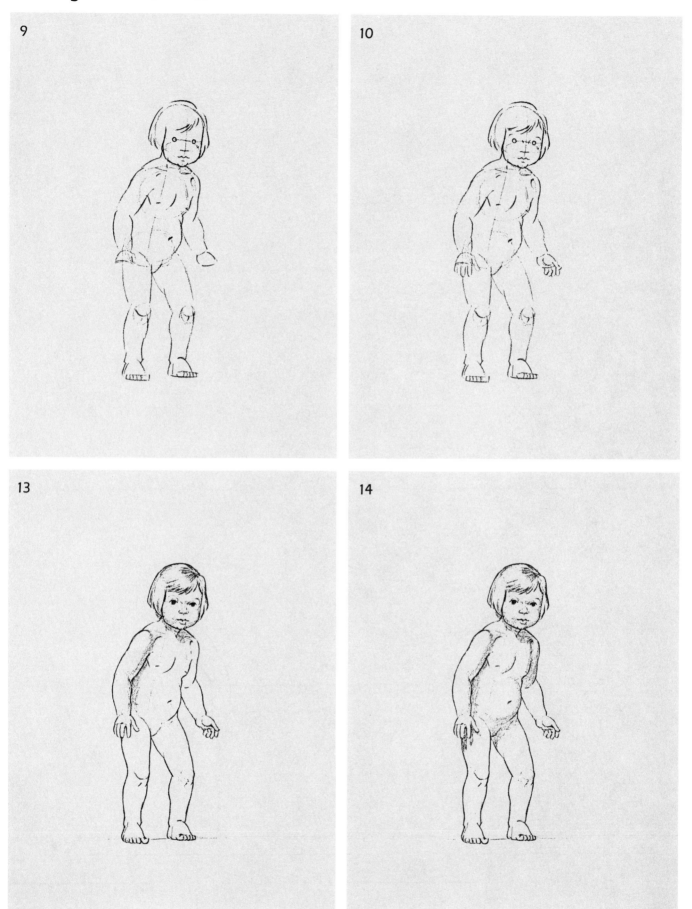

9

10

13

14

CHILD NO. 2

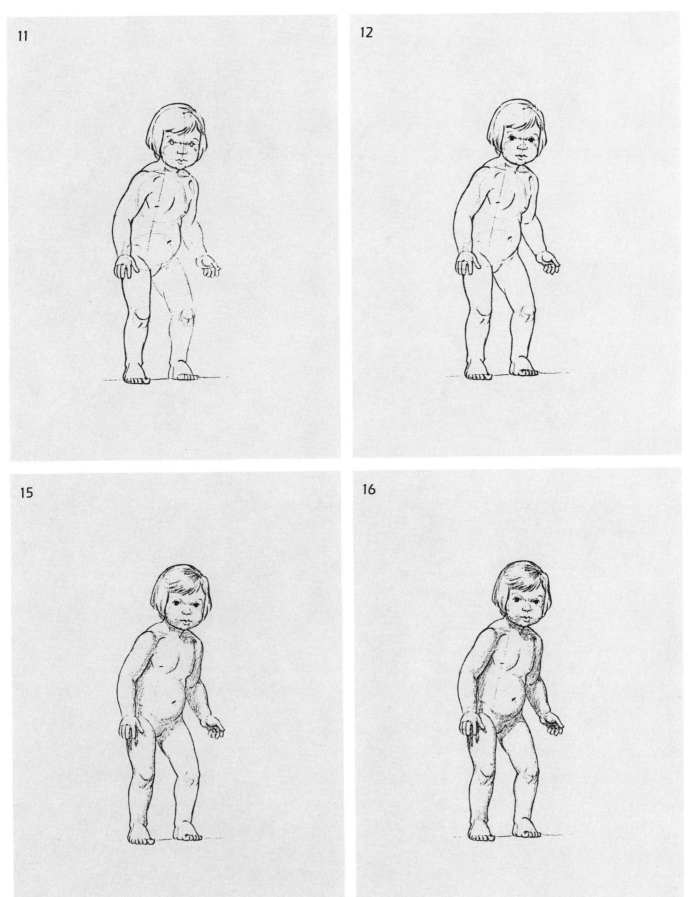

THE CLOTHED HUMAN FIGURE

The Mini-roughs for the Clothed Human Figure

Once again, from photographs, books, magazines, friends who posed, or just, forgive the pun, out of whole cloth, I've gathered these roughs.

I think of these as a kind of doodling and they were given as little attentive thought as one usually gives to doodling. Of course, behind the capability shown are many years of study, strenuous practice, and hard experience, "eyes first"! Paying those kinds of dues perhaps entitles me to have developed a good "hands first" competence.

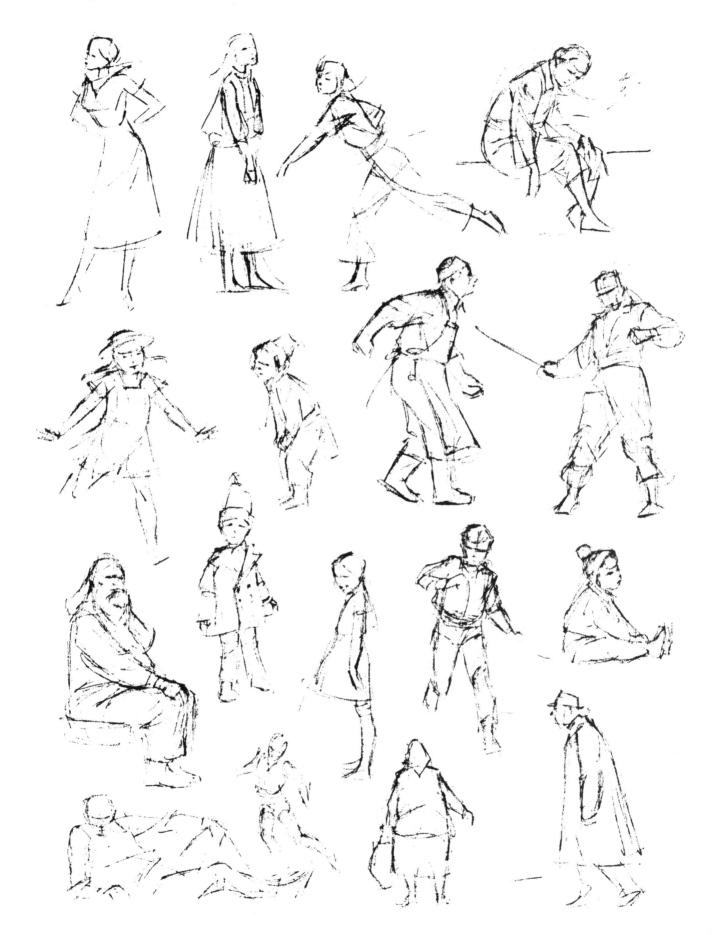

The Mini-roughs

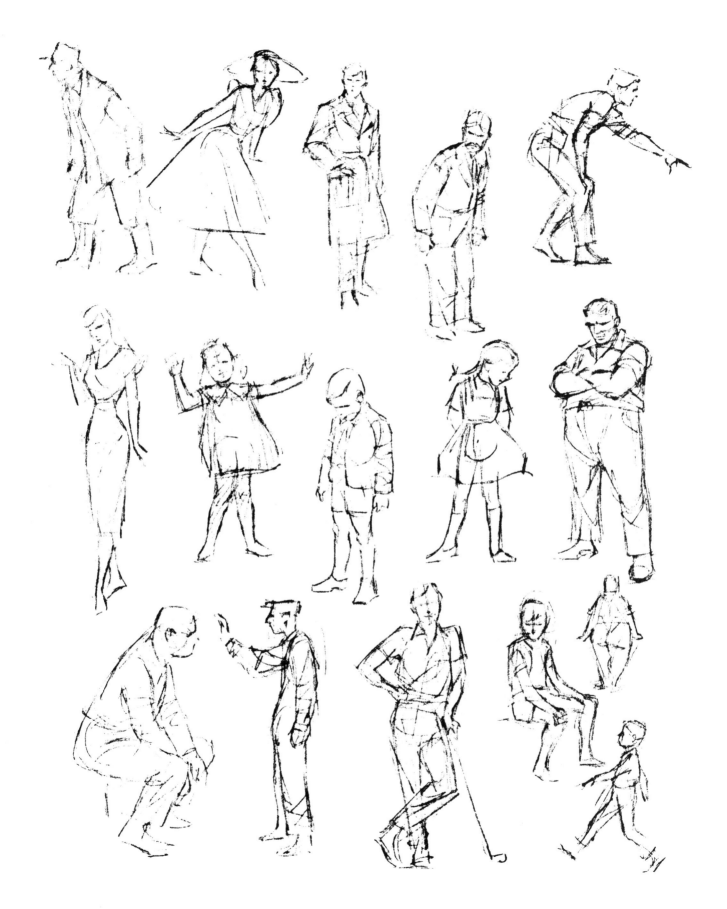

The Mini-roughs

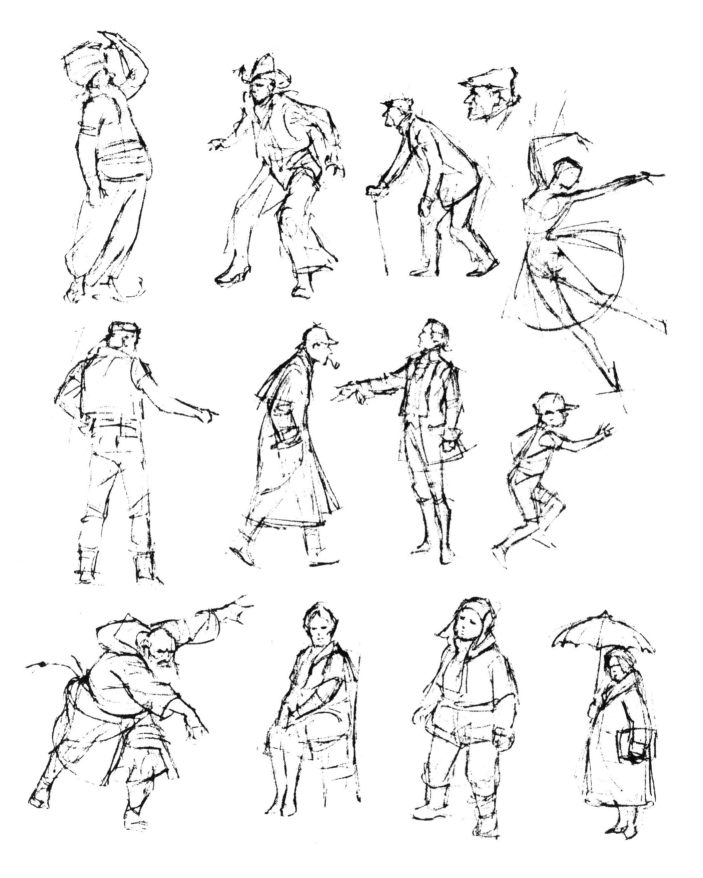

Drawing the Clothed Human Figure

Under a garment, be it a fur coat or a bathing suit, there is a body. Please, always remember this as you define and mold your drawing.

Solving the problem of drawing drapery and learning fabric behavior and variety require much study and much practice. You should find doing so interesting, rewarding, and fascinating. There are many works that deal skillfully with drapery. Check the books by Andrew Loomis and Betty Edwards (see the bibliography on page 261). These and others in your library will help.

For now, though, examine the eight models, choose one, sense the body within, sense the fall of the fabric, but draw what you see, step-by-step.

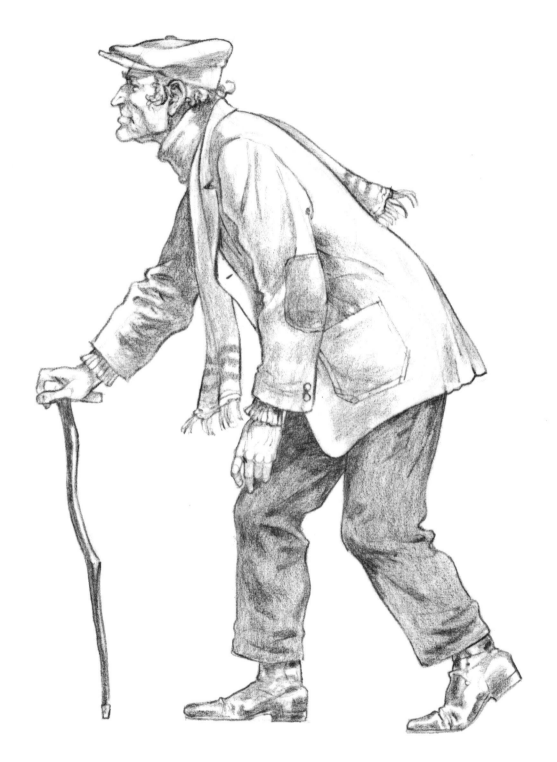

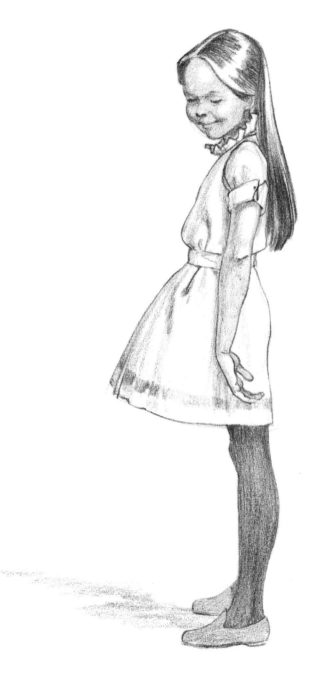

SHY GIRL

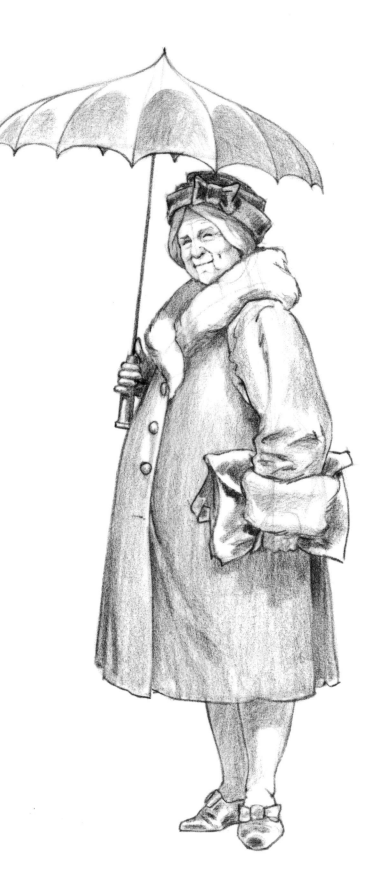

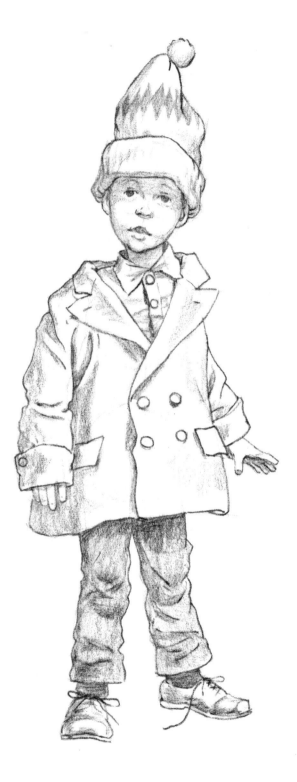

BOY WITH WOOL CAP

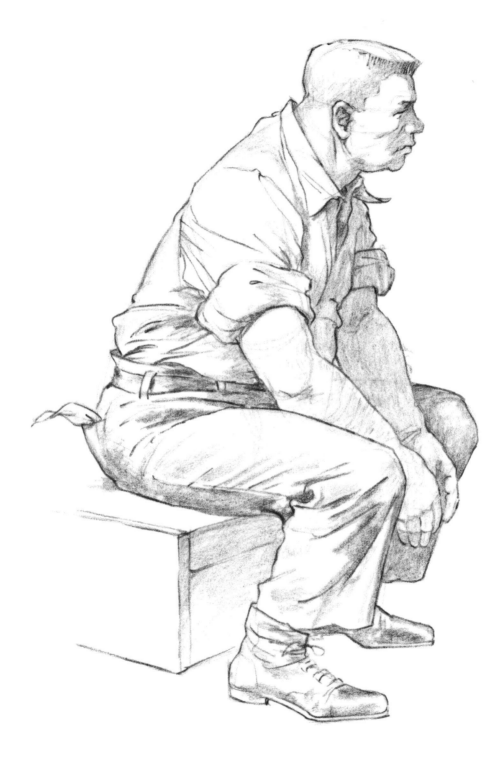

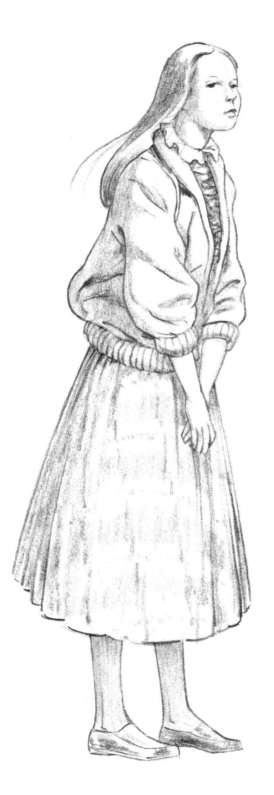

WOMAN IN SWEATER

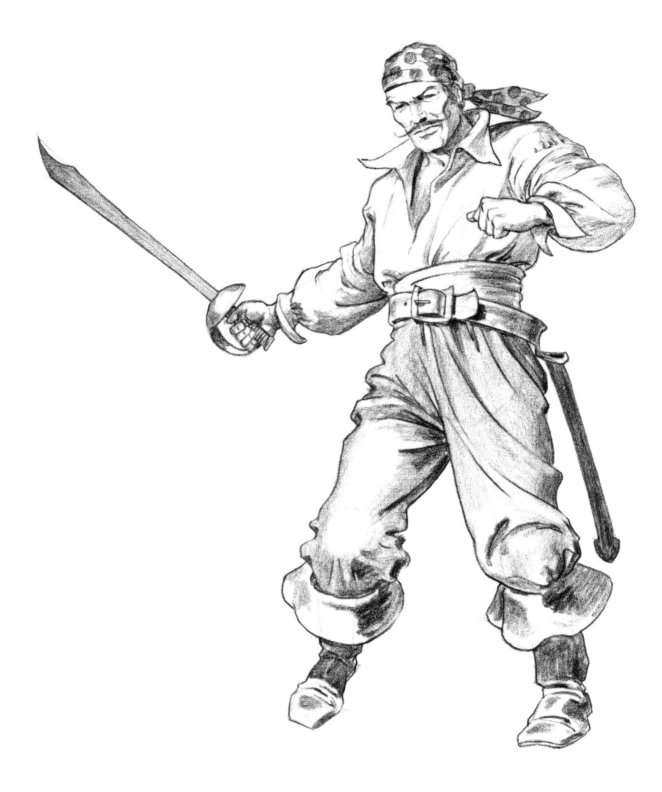

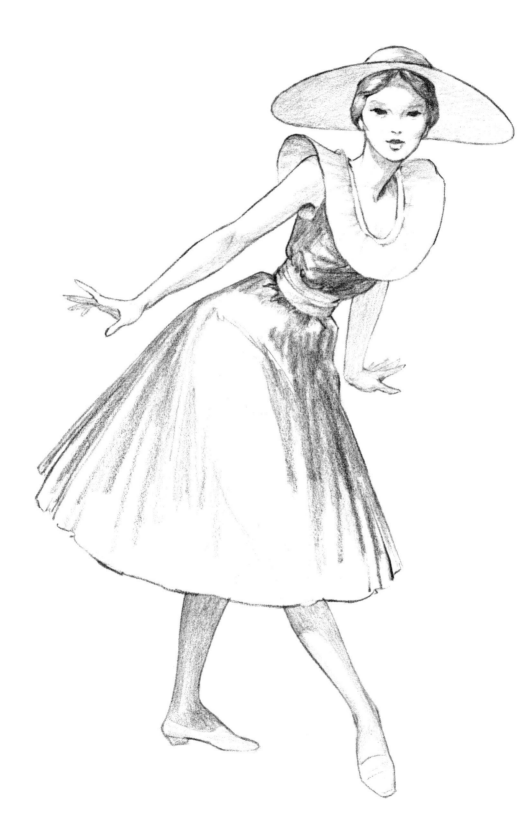

BELLE

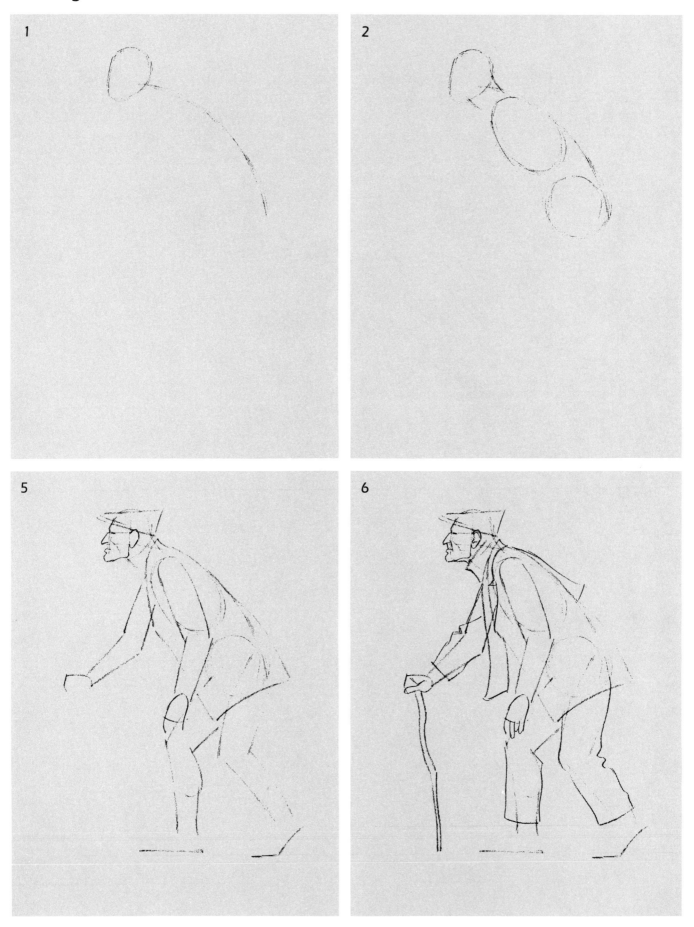

1

2

5

6

MAN WITH CANE

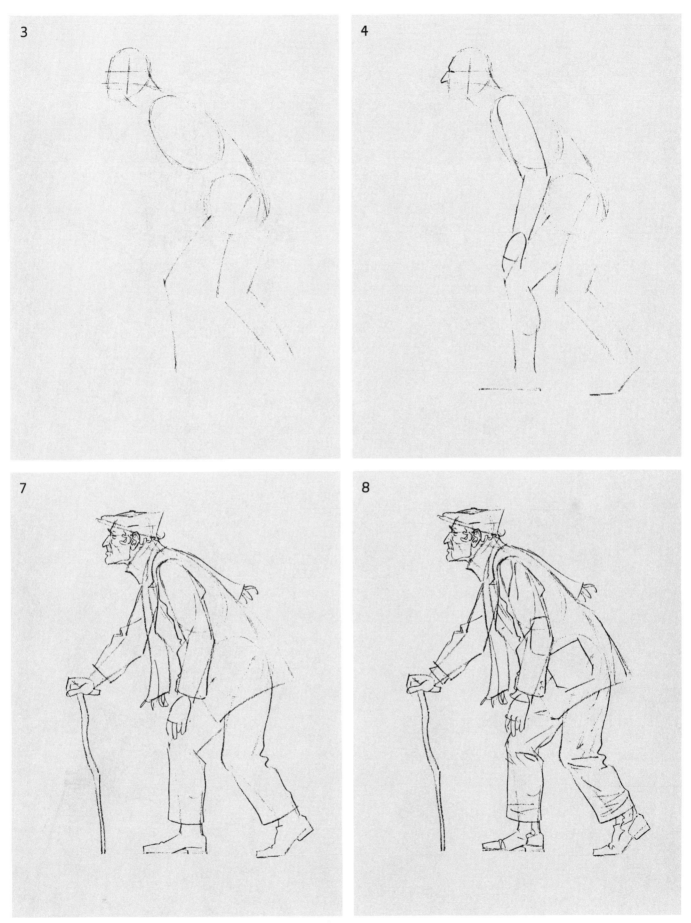

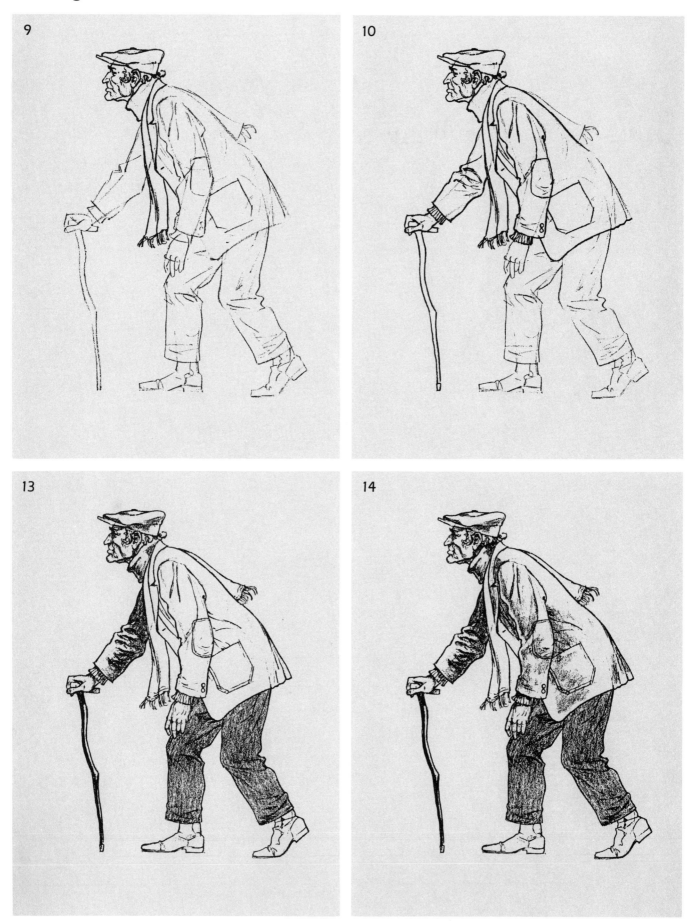

9

10

13

14

MAN WITH CANE

11

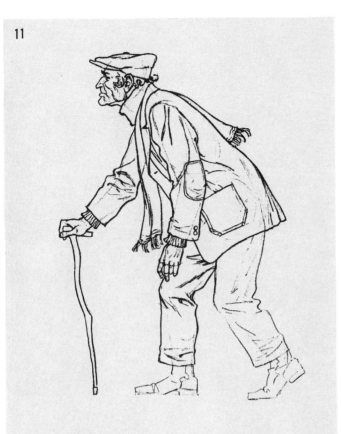

12

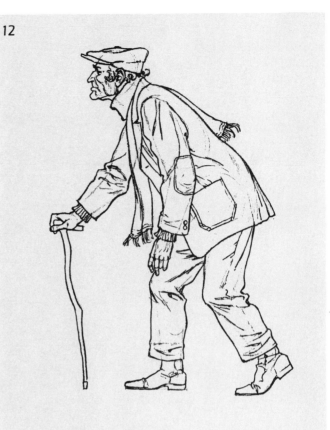

15

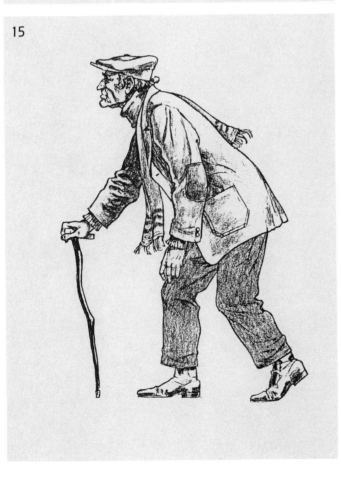

16

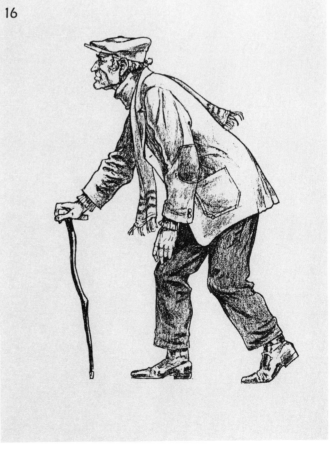

1

2

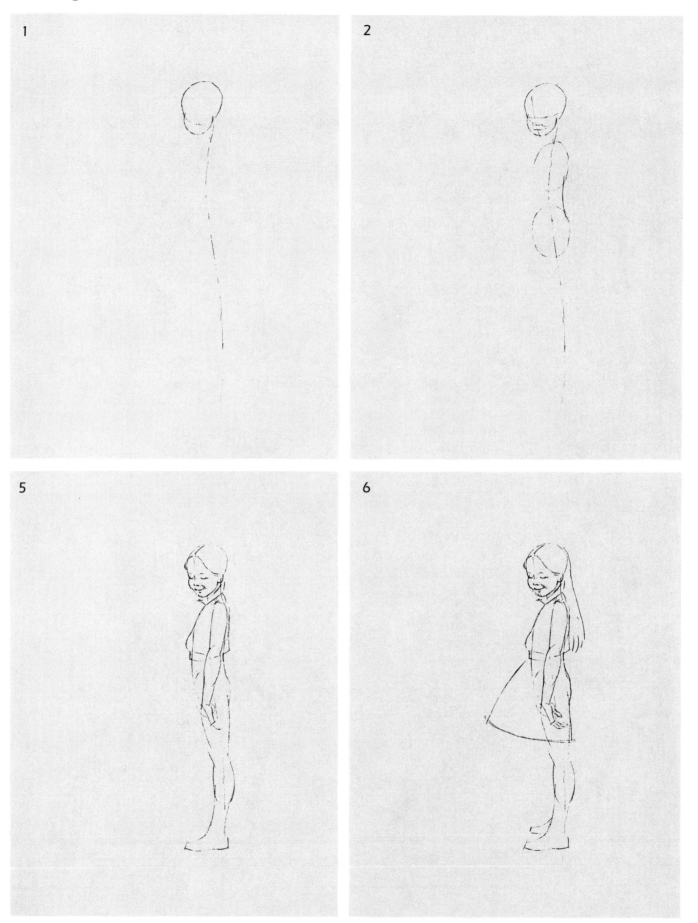

5

6

SHY GIRL

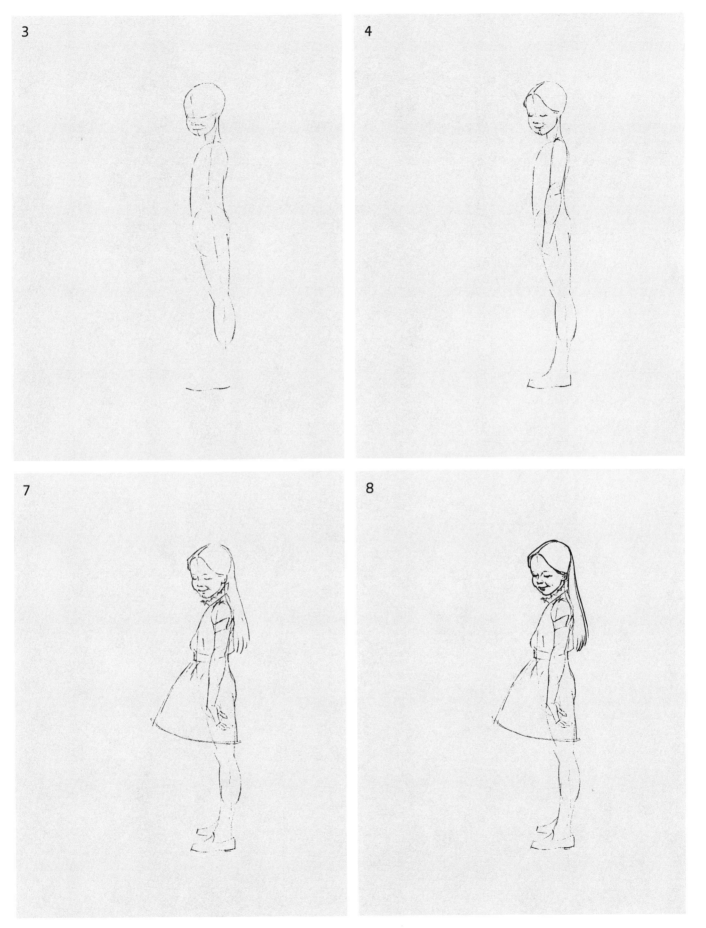

3

4

7

8

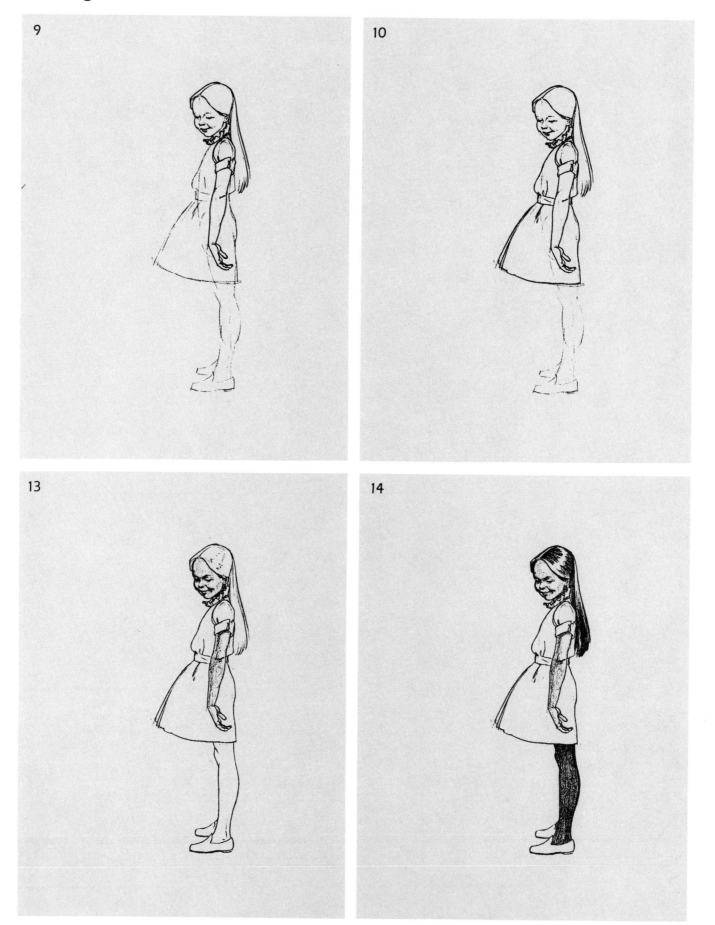

SHY GIRL

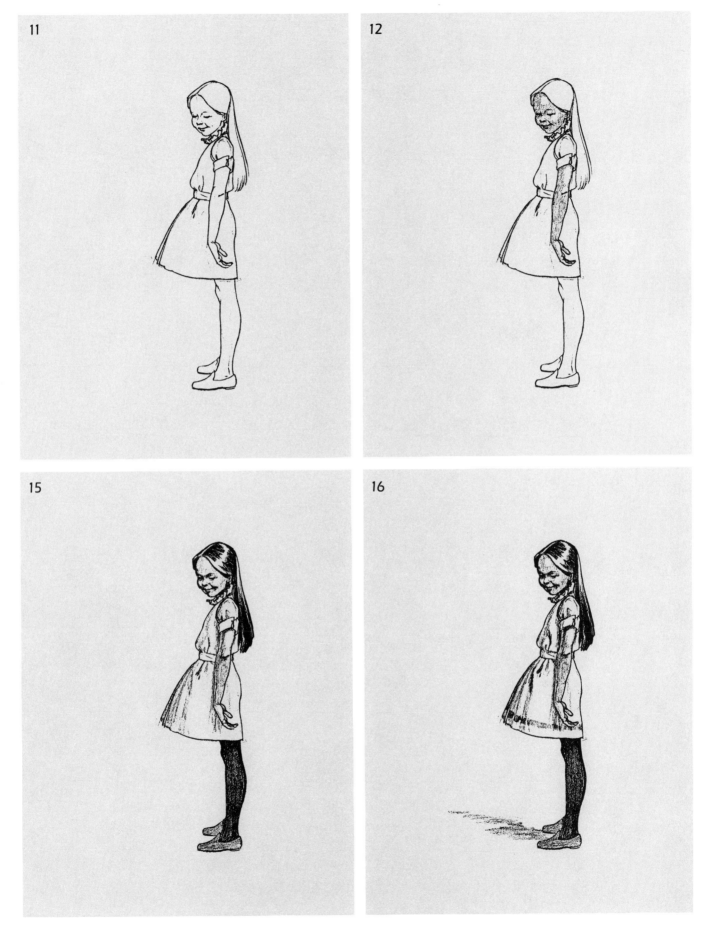

11

12

15

16

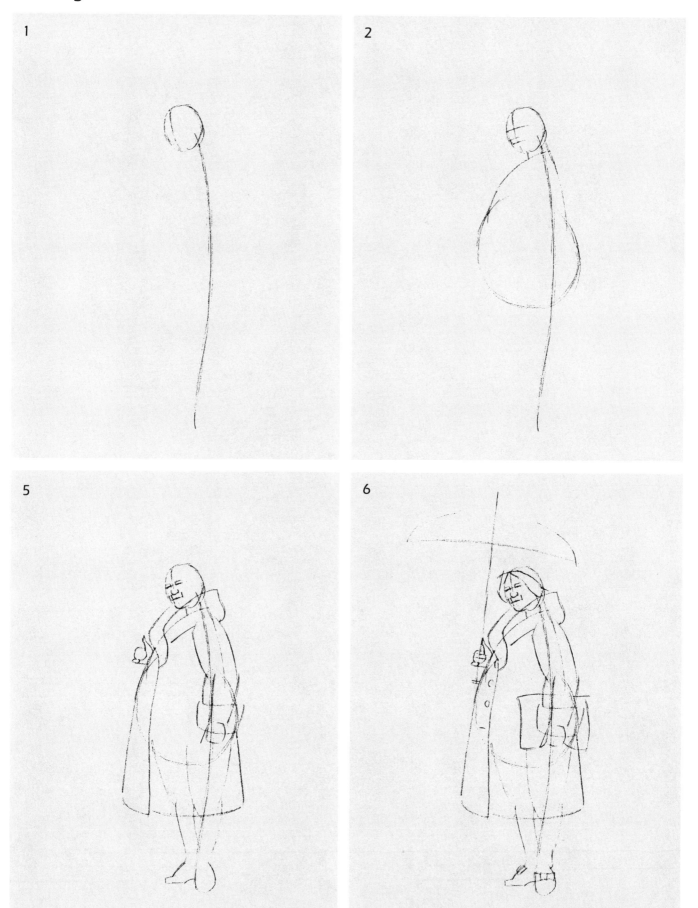

1

2

5

6

WOMAN WITH UMBRELLA

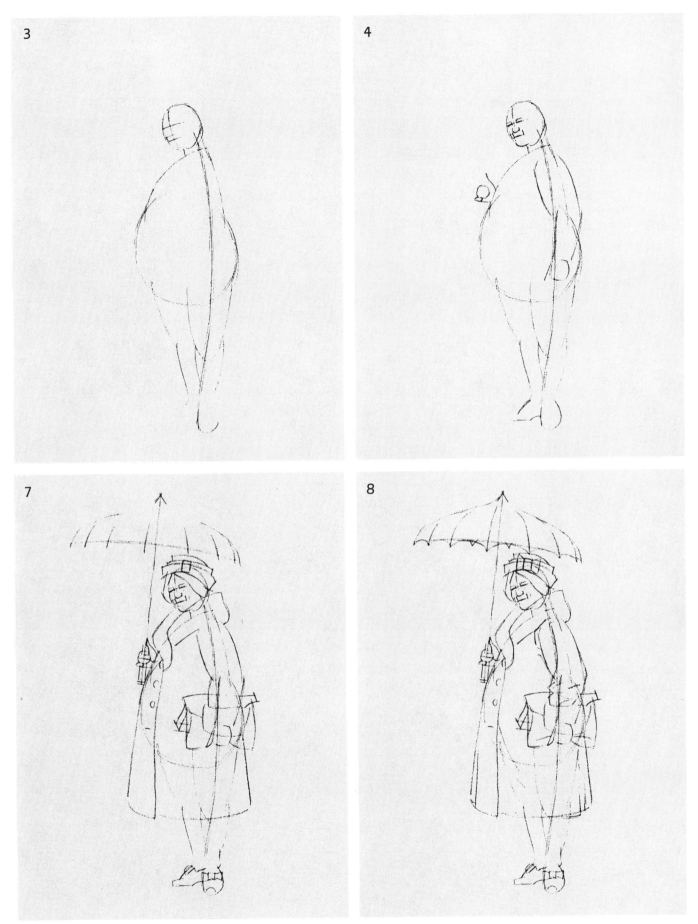

3

4

7

8

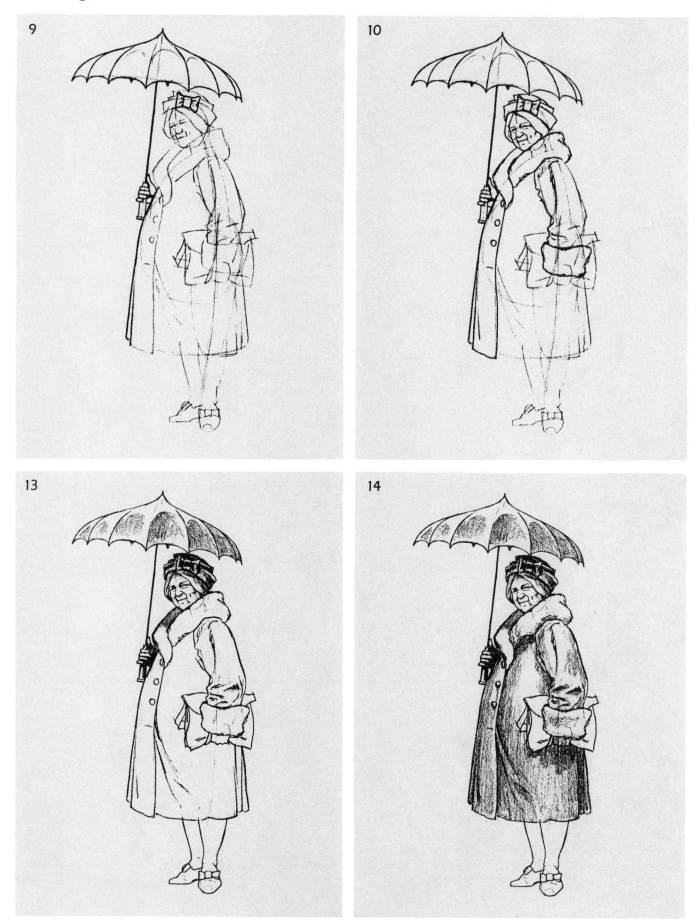

11

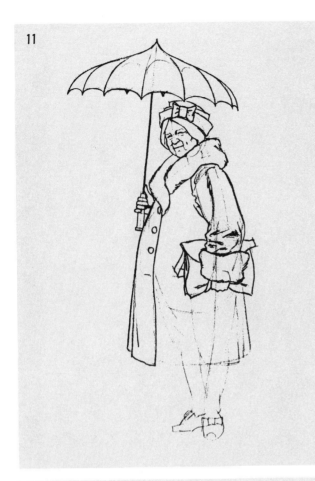

12

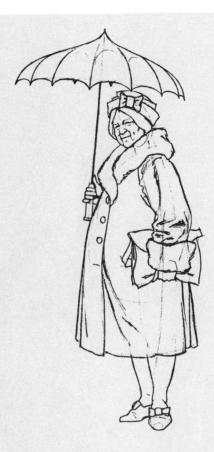

15

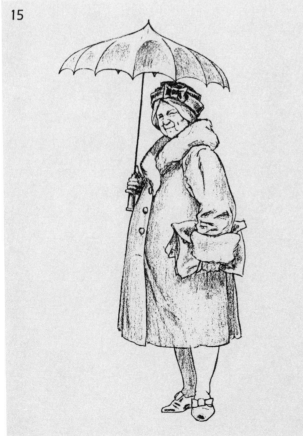

16

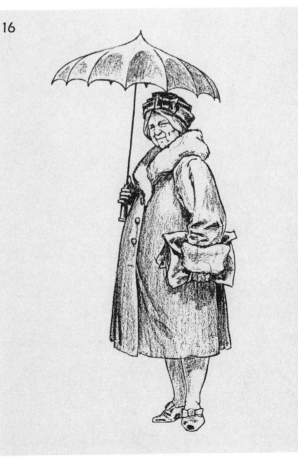

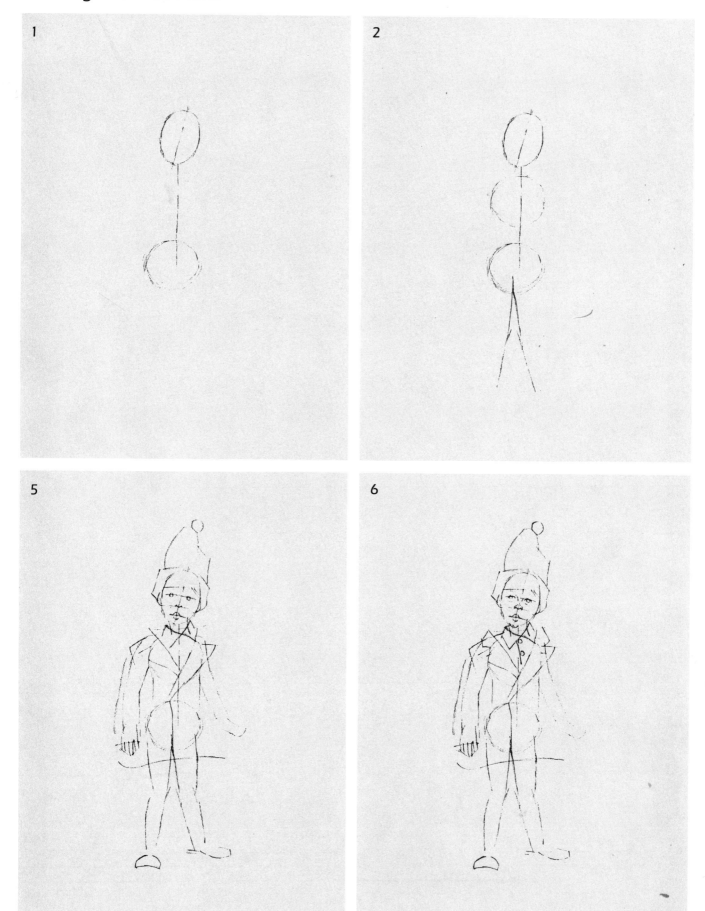

1

2

5

6

BOY WITH WOOL CAP

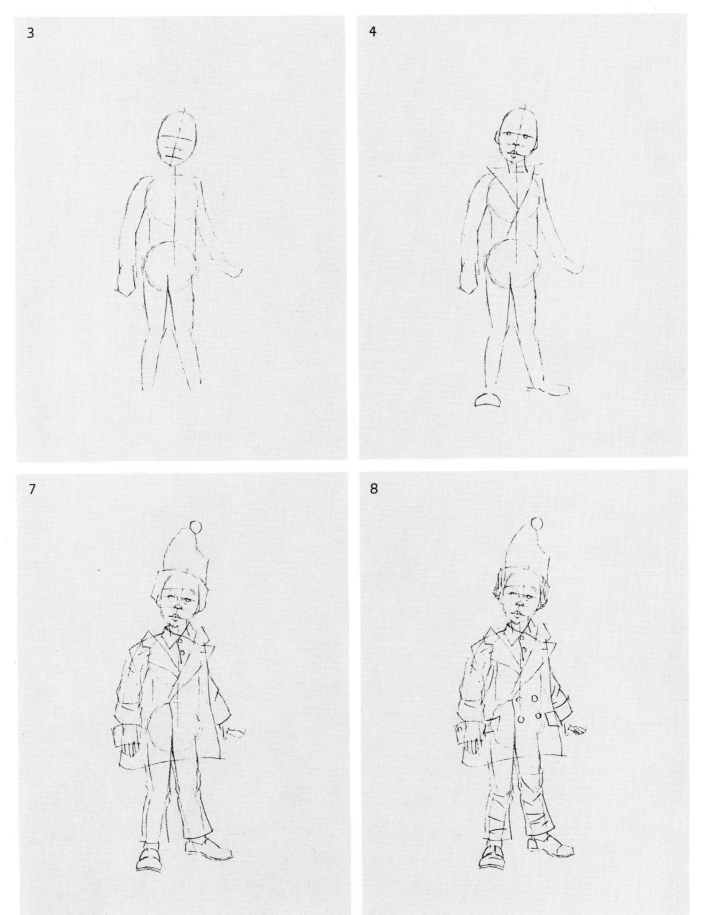

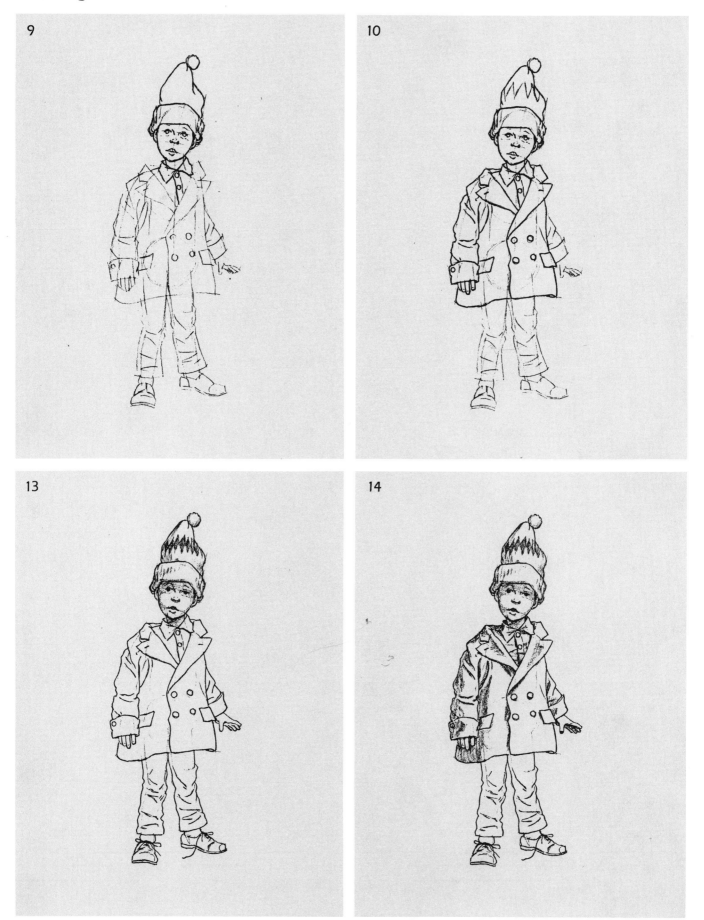

9

10

13

14

BOY WITH WOOL CAP

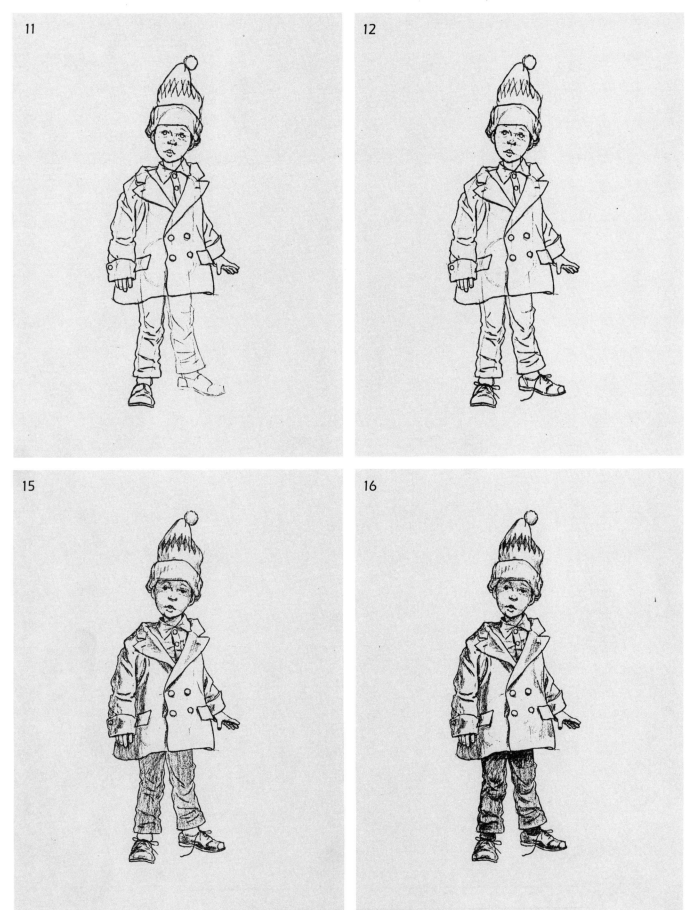

11

12

15

16

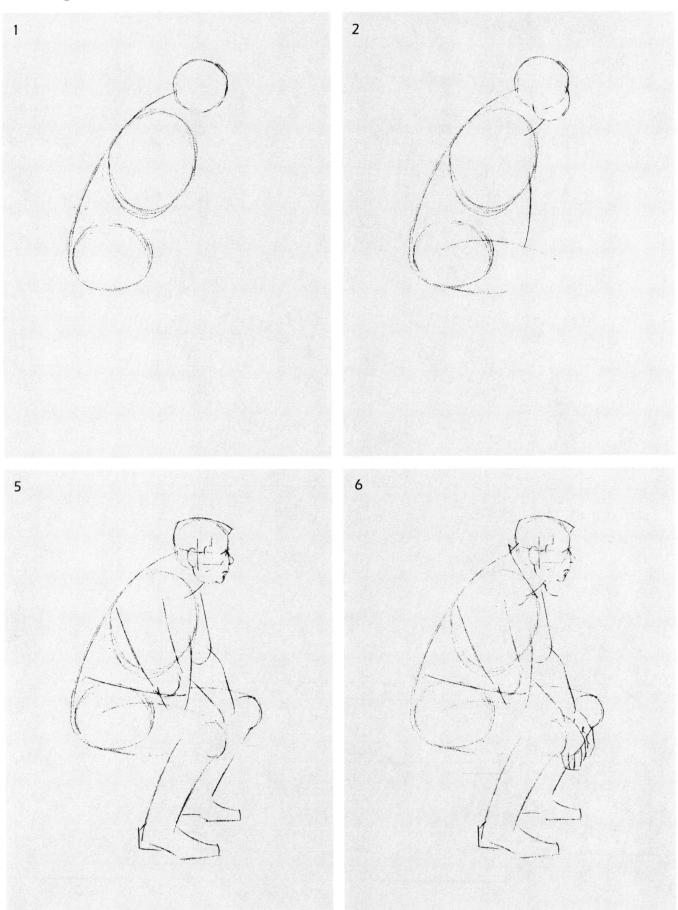

1

2

5

6

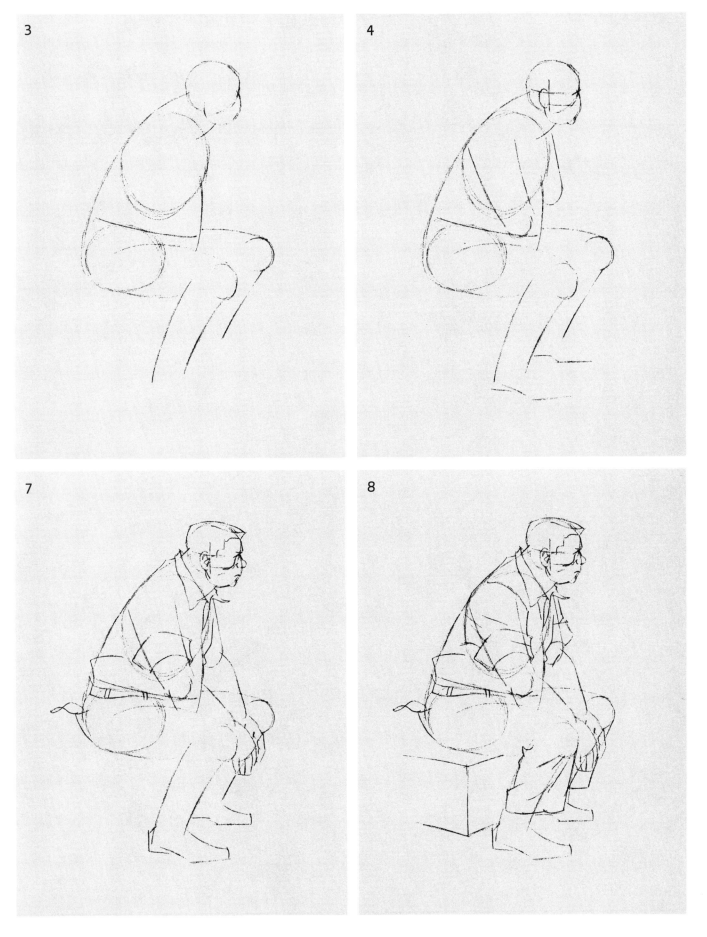

3

4

7

8

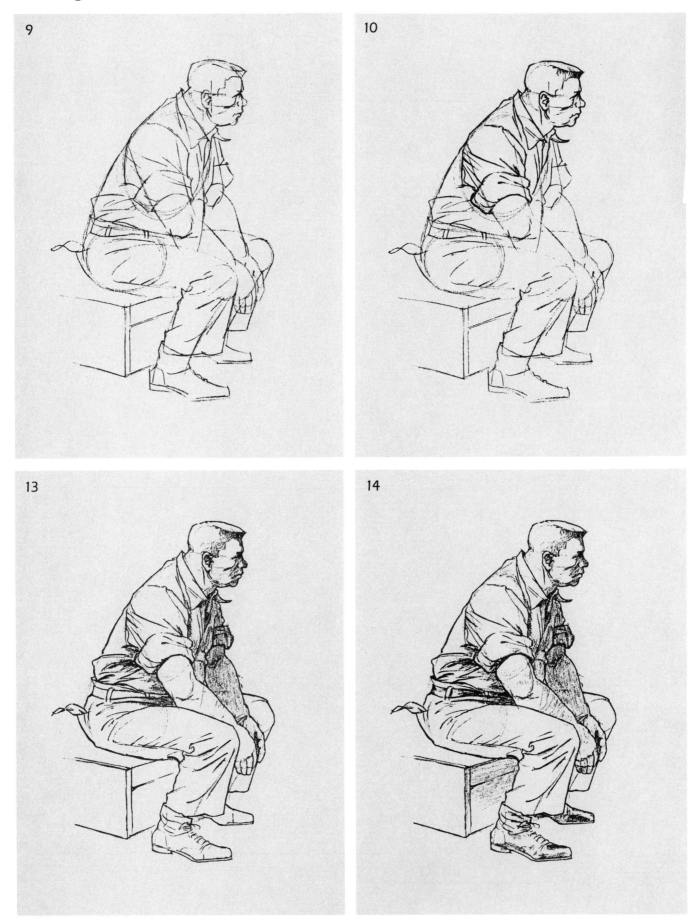

SEATED MAN

11

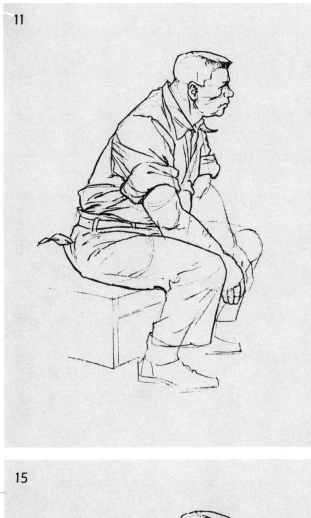

12

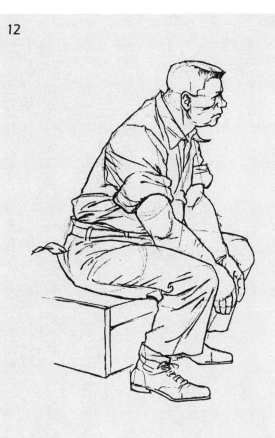

15

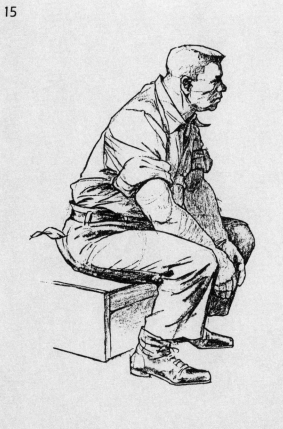

16

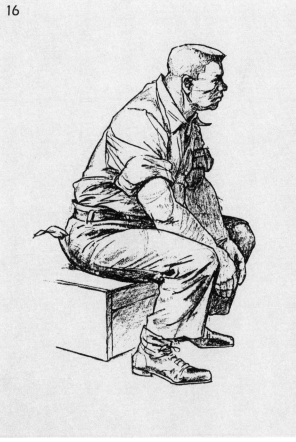

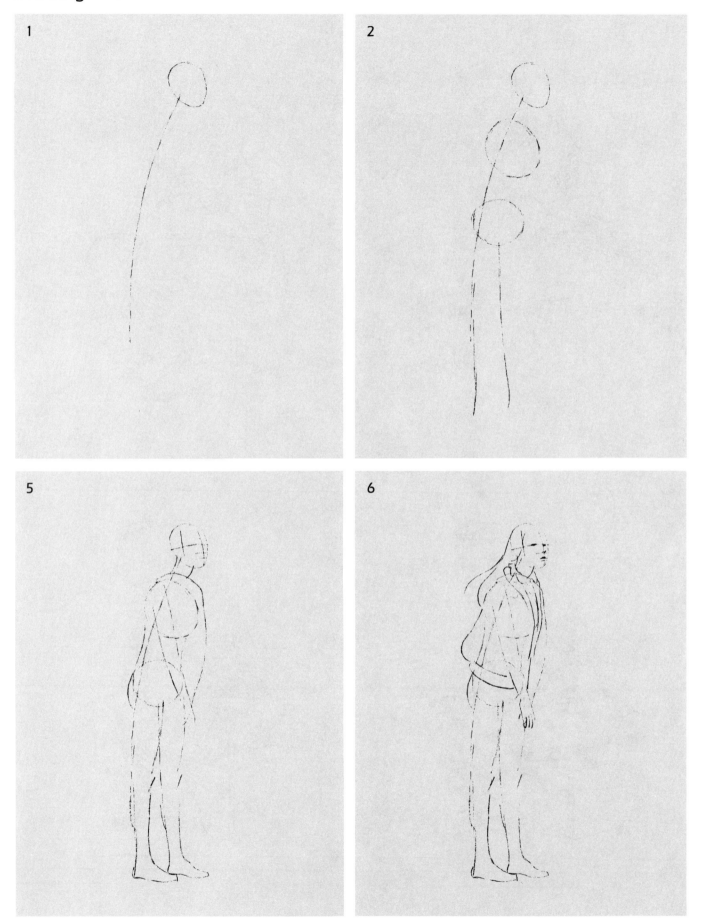

1

2

5

6

WOMAN IN SWEATER

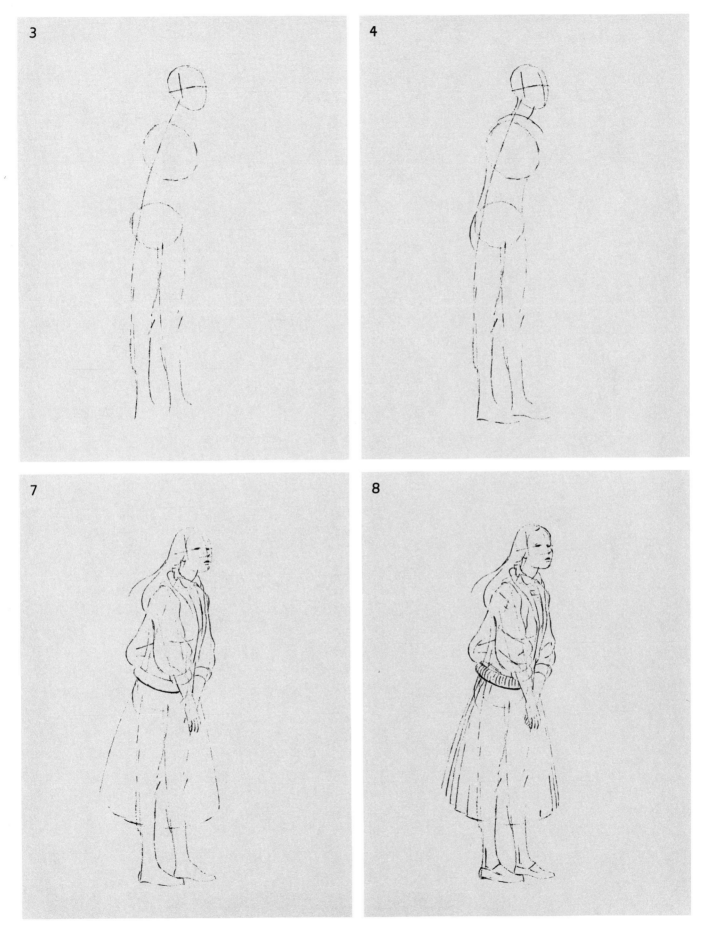

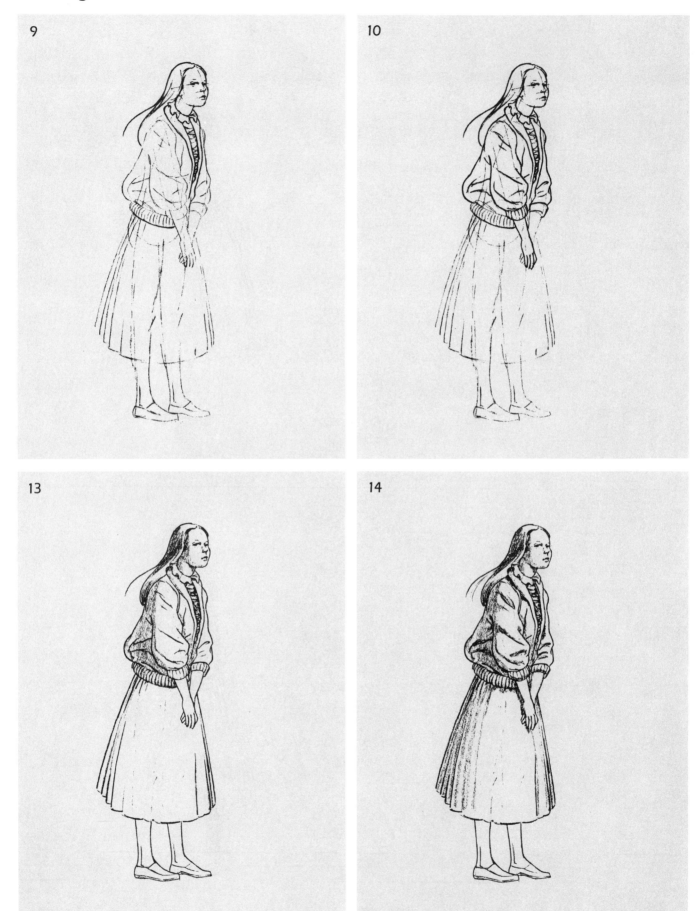

9

10

13

14

WOMAN IN SWEATER

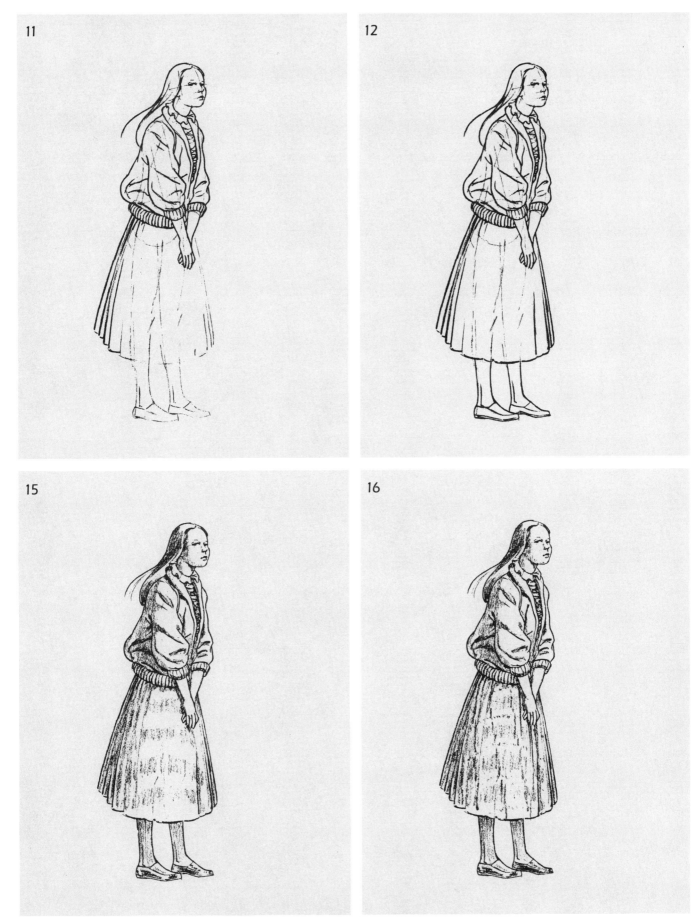

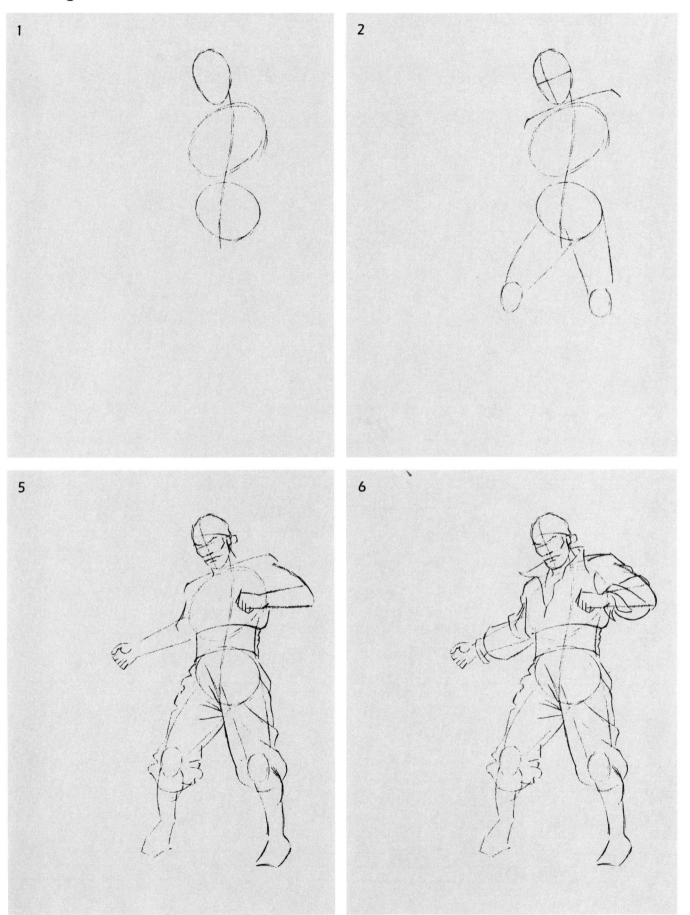

1

2

5

6

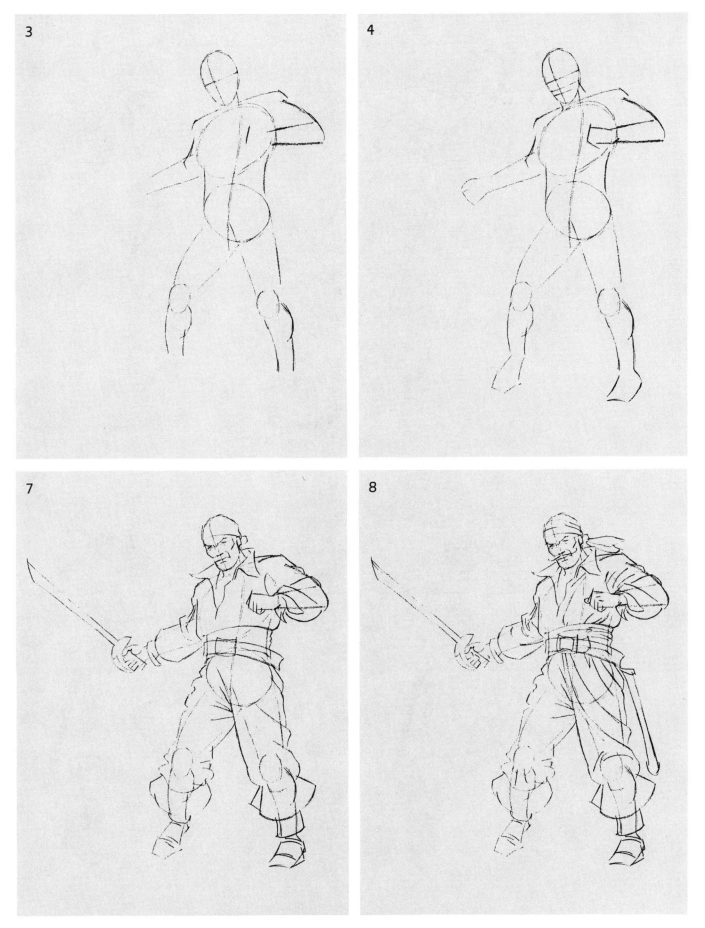

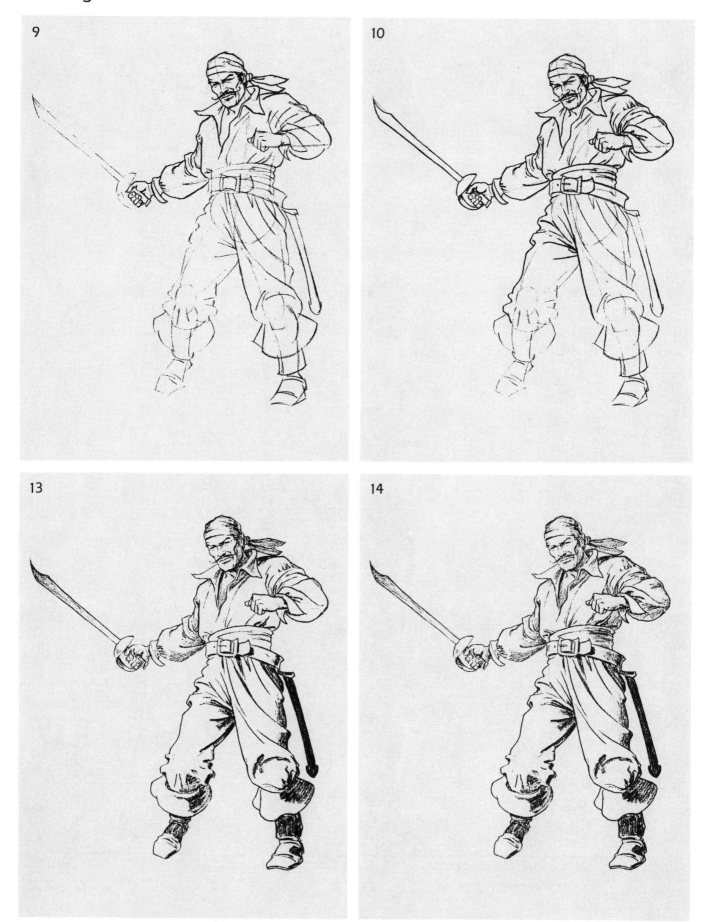

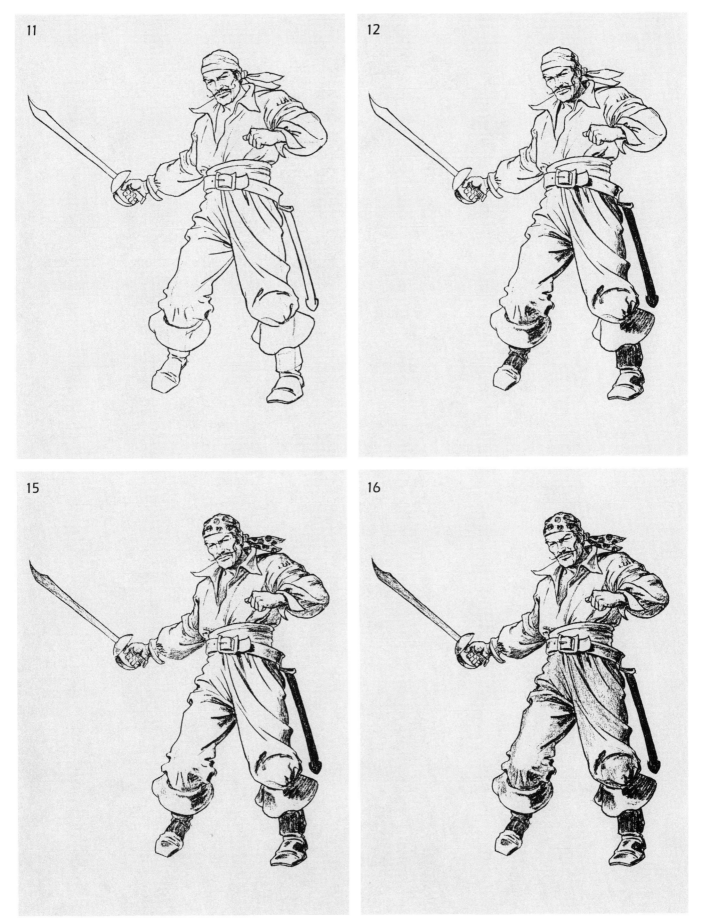

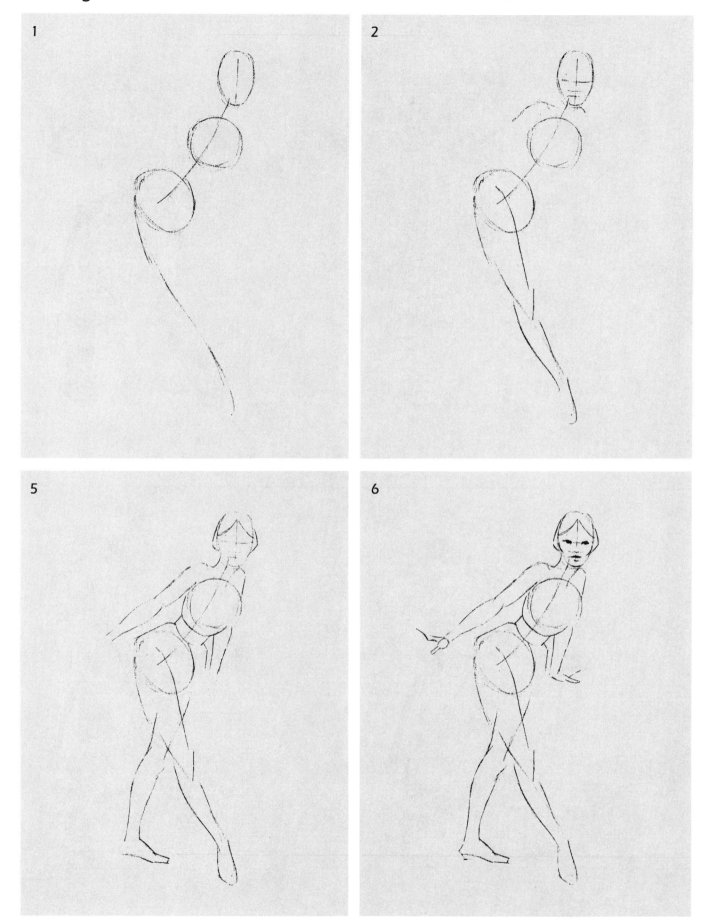

1

2

5

6

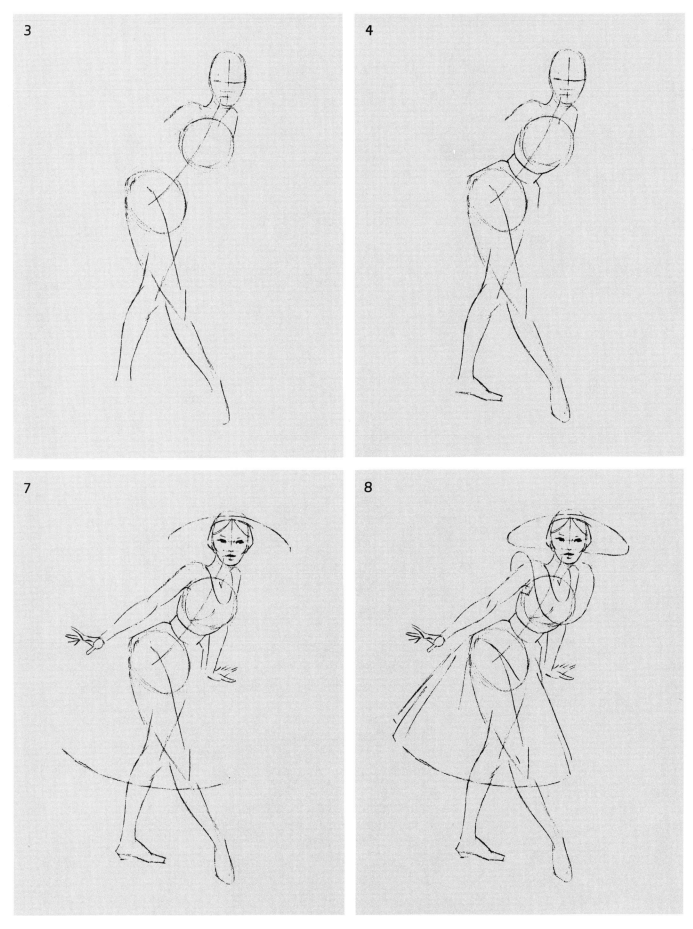

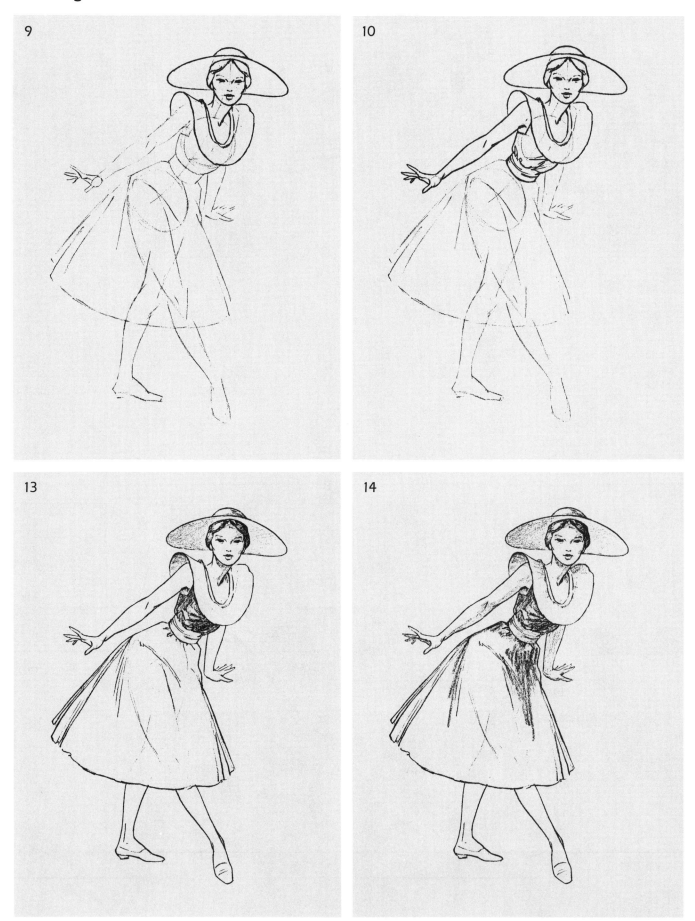

9

10

13

14

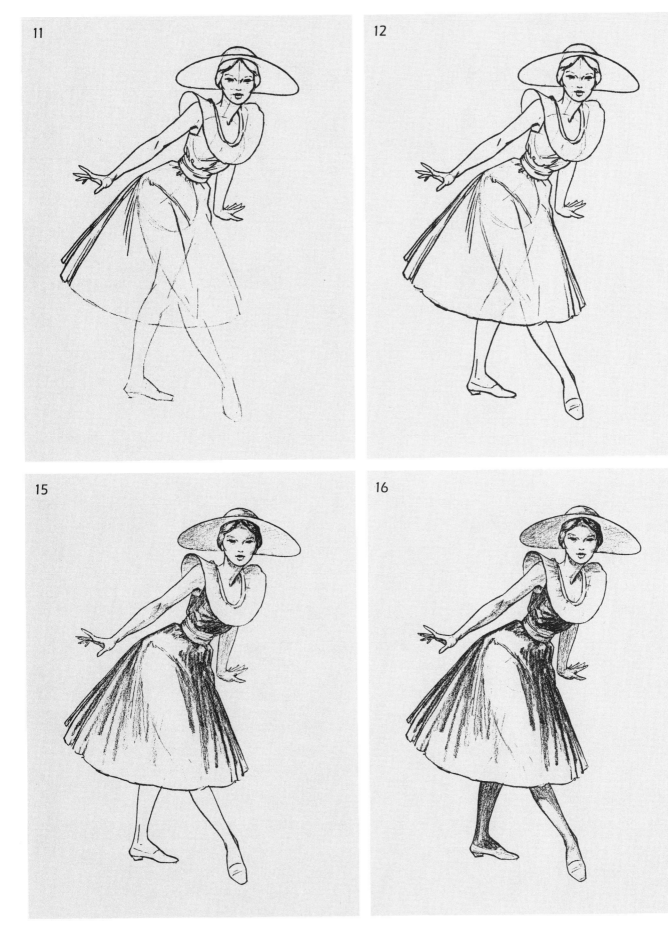

PORTRAITS

The Mini-roughs of the Portraits

From imagination, from models, from photographs (including my youngest granddaughter's), and from magazines I've collected and sketched this crowd of heads. I hope you will enjoy drawing the ones I chose to finish.

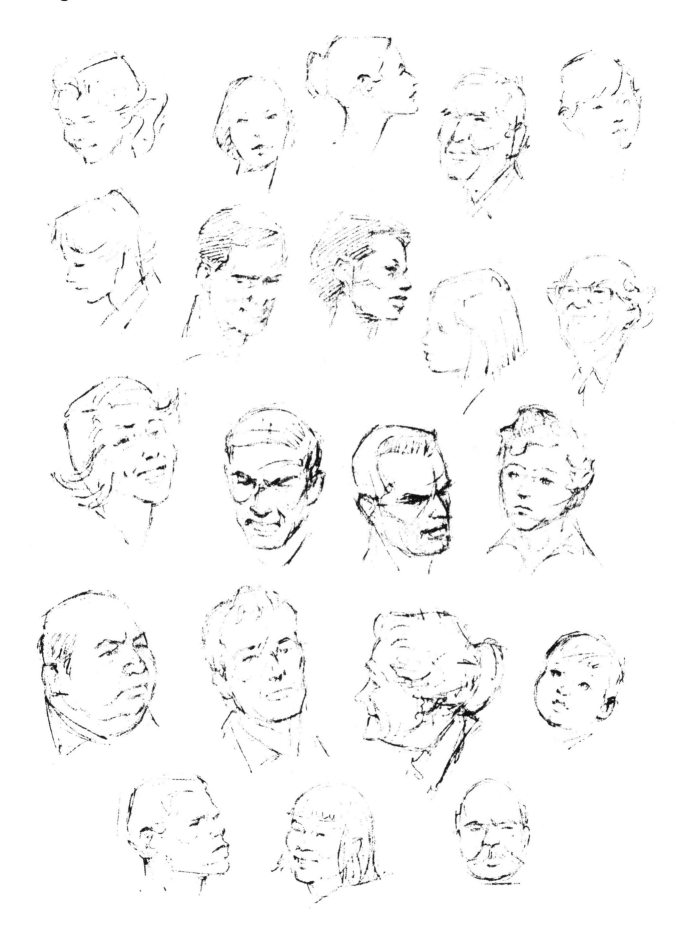

The Mini-roughs

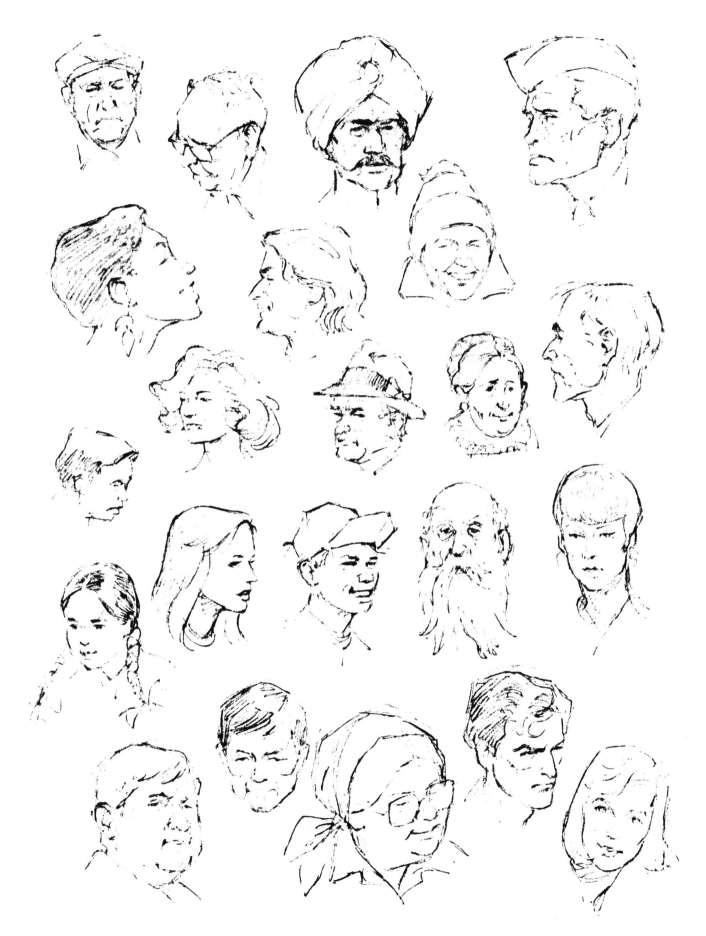

The Mini-roughs

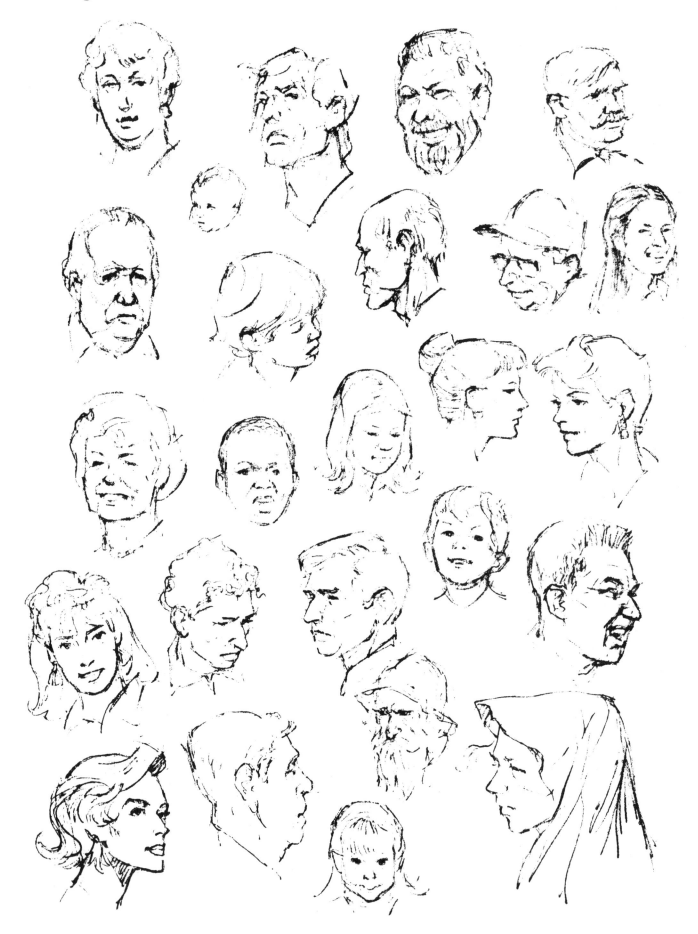

The Mini-roughs

Drawing a Portrait

My approach to portrait drawing is a very common one. I establish large, general shapes and overall lines of action and build on these until enough data has been accumulated to permit the accurate placement of fine (and final) detail.

The portrait painter László de Lombos wrote a book[1] on oil portrait technique. That book influenced me profoundly as a young artist. László de Lombos's approach to painting the human head was not constructional, not in the sense that I try to use. He recommended that one start with the eyes and then work outward to the rest of the picture, then return to the eyes and work outward again. And again, and again, continuing until a satisfaction with the work had been achieved. László de Lombos felt that since in the course of human interaction we look each other in the eye, we must also expect the viewer of a portrait to look initially into the eyes. The eyes, then, are the major point of interest and focus. A portrait begins and ends with the eyes! His achievements were extraordinary.

All this to let you know there are many ways to approach drawing or painting. László de Lombos's method was very different from mine and worked very well. Now, though, let's get on with my method, but . . . remember the eyes.

[1]László de Lombos, P. A. *Painting a Portrait*, Studio Publications, 1934.

217

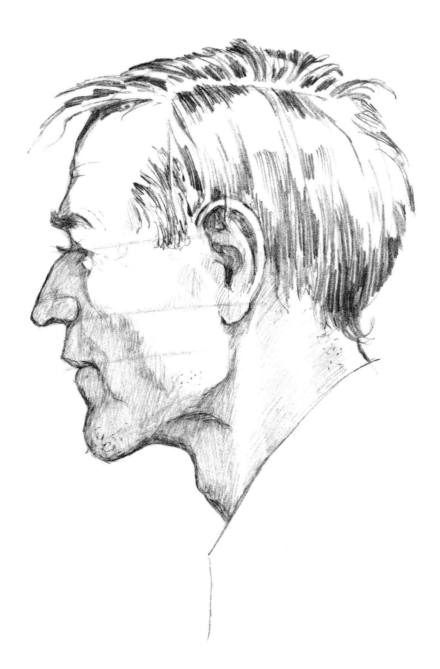

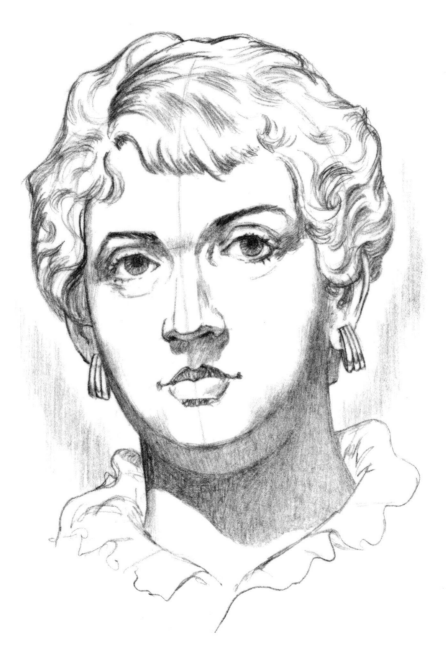

ROBERTA

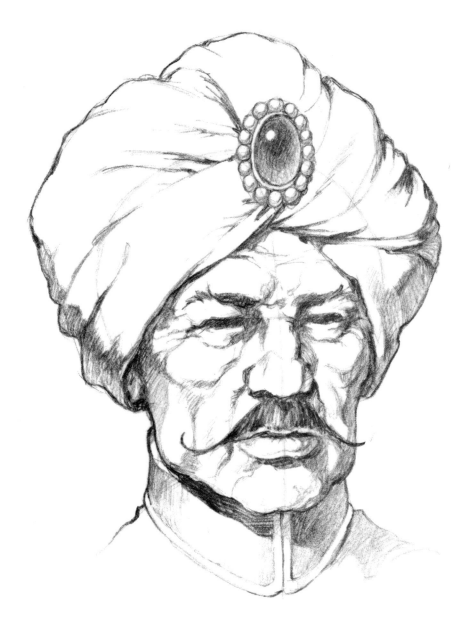

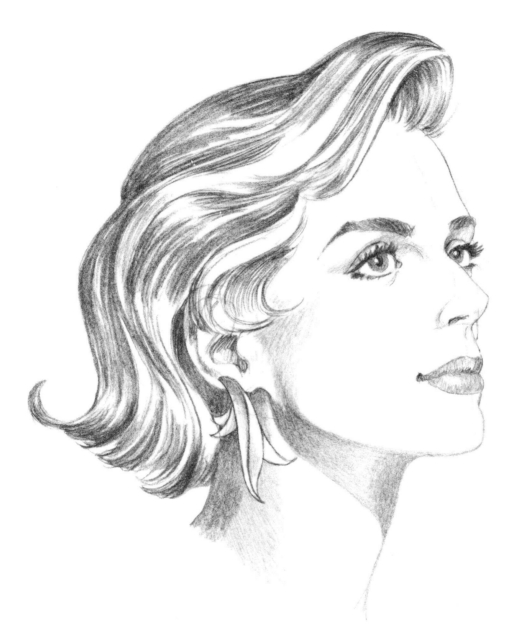

MELISSA

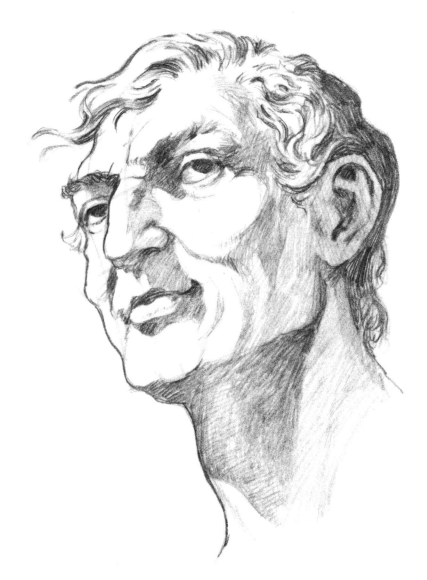

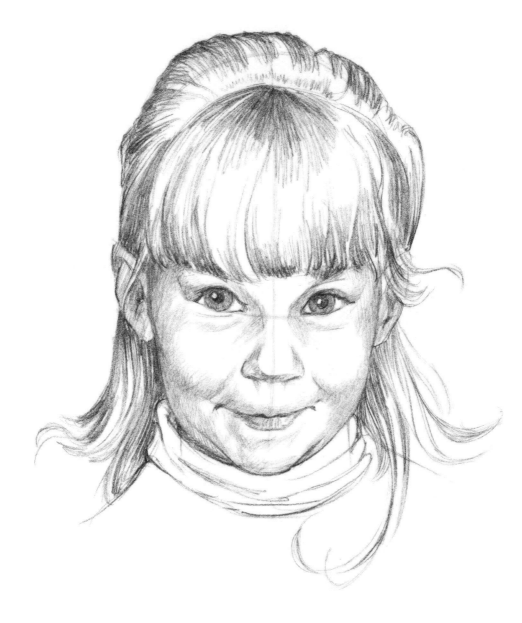

LAUREN

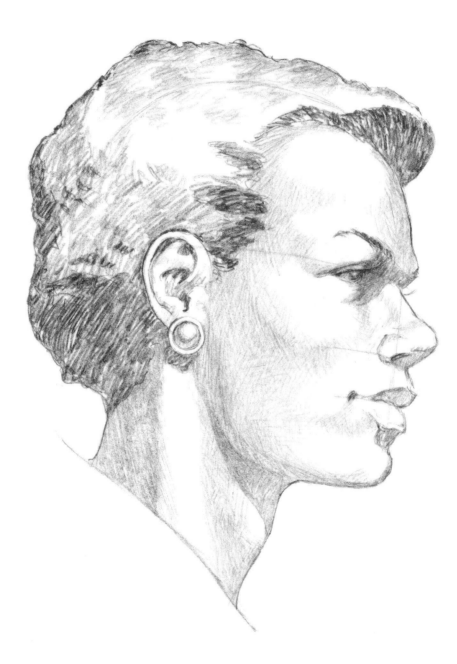

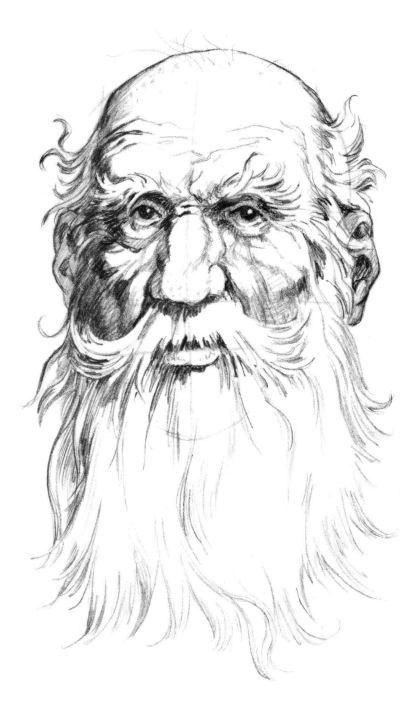

CALEB

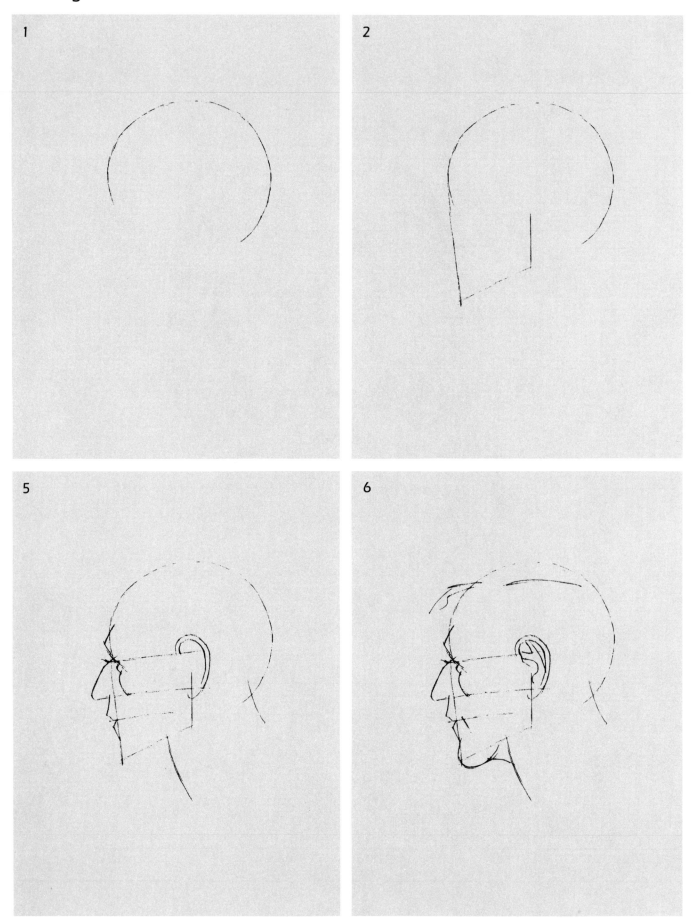

1

2

5

6

HARRY

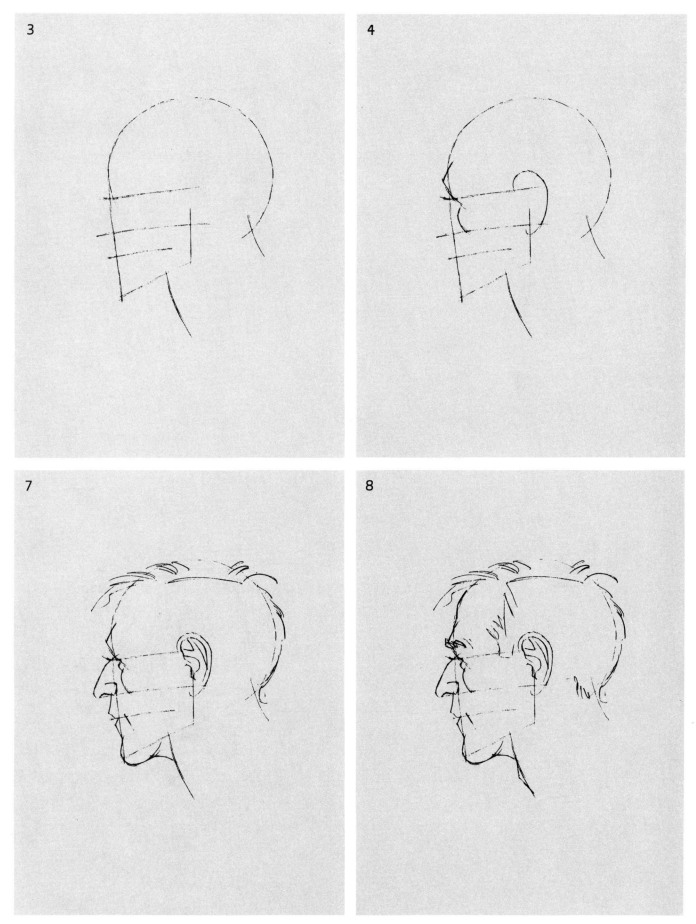

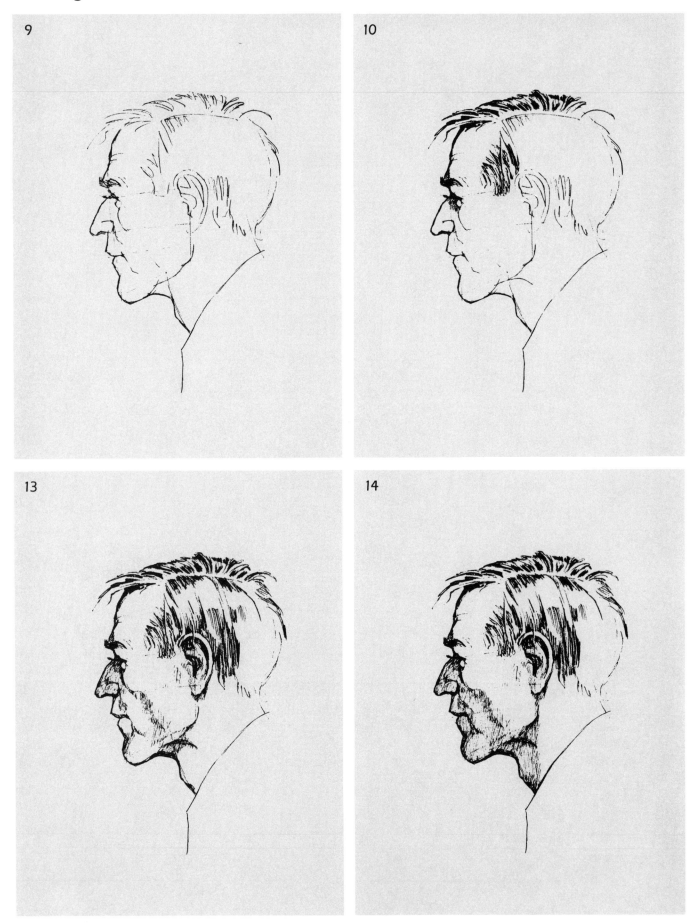

9

10

13

14

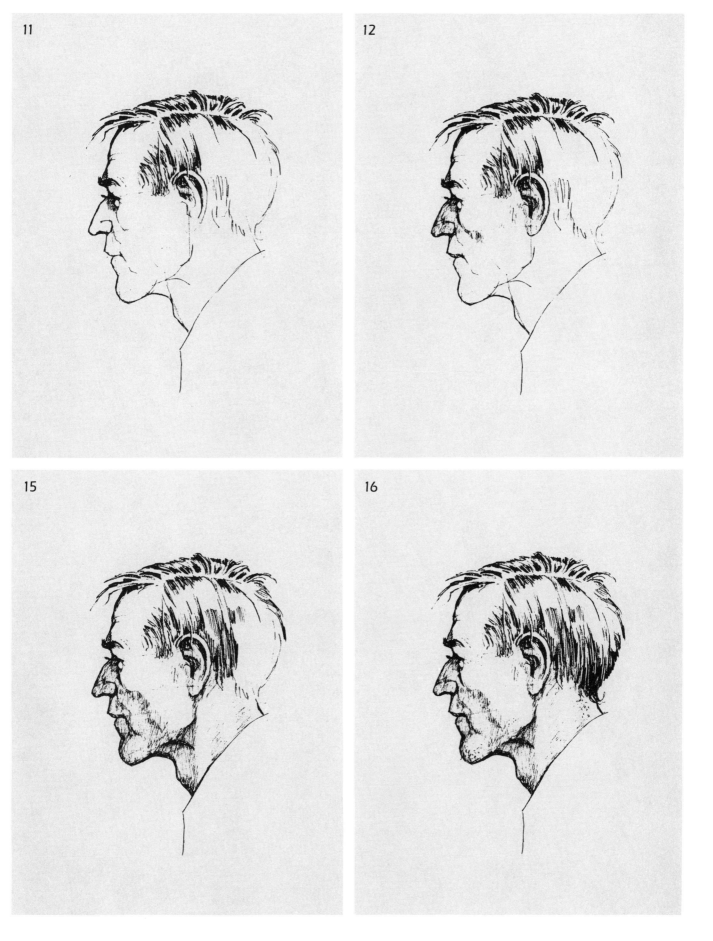

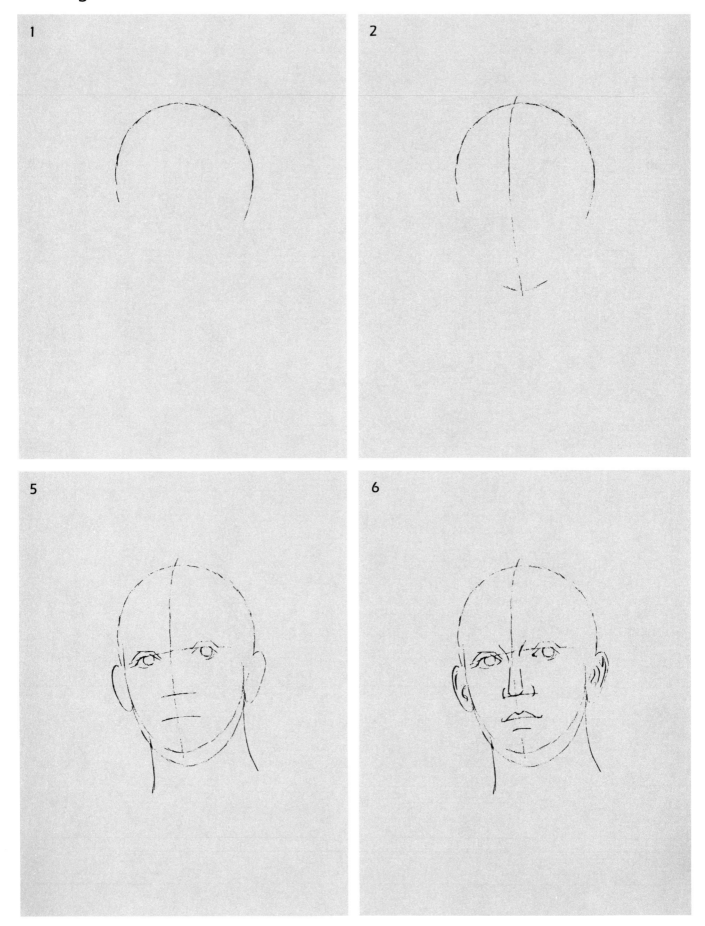

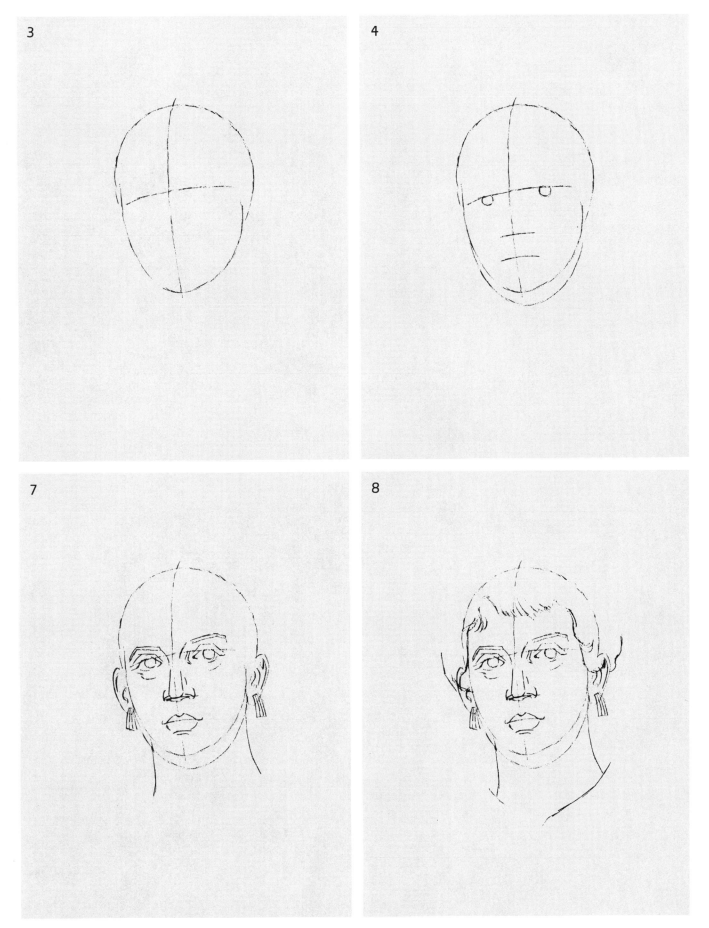

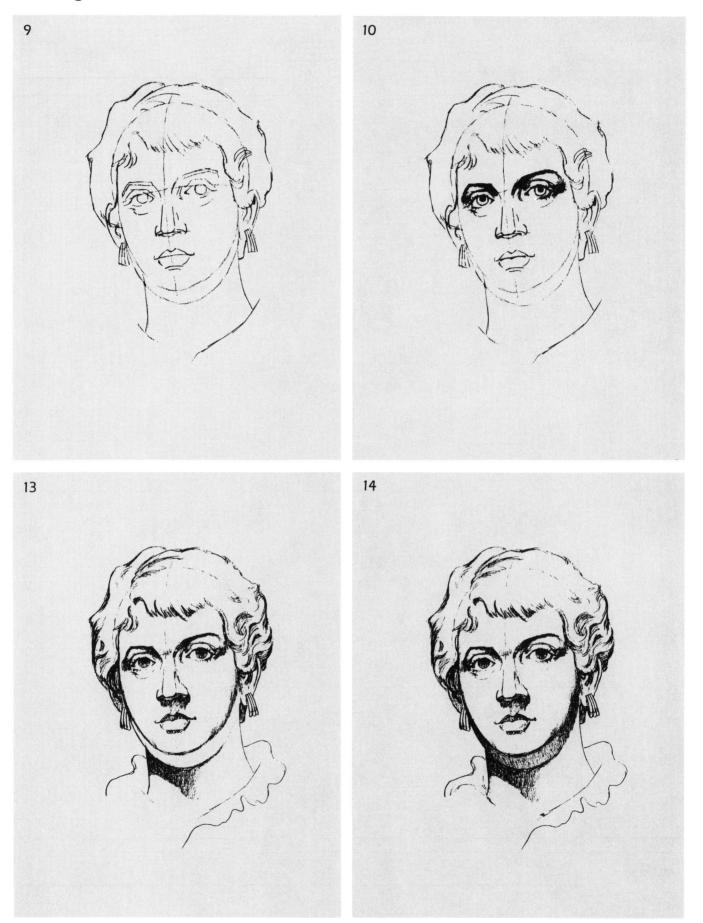

9

10

13

14

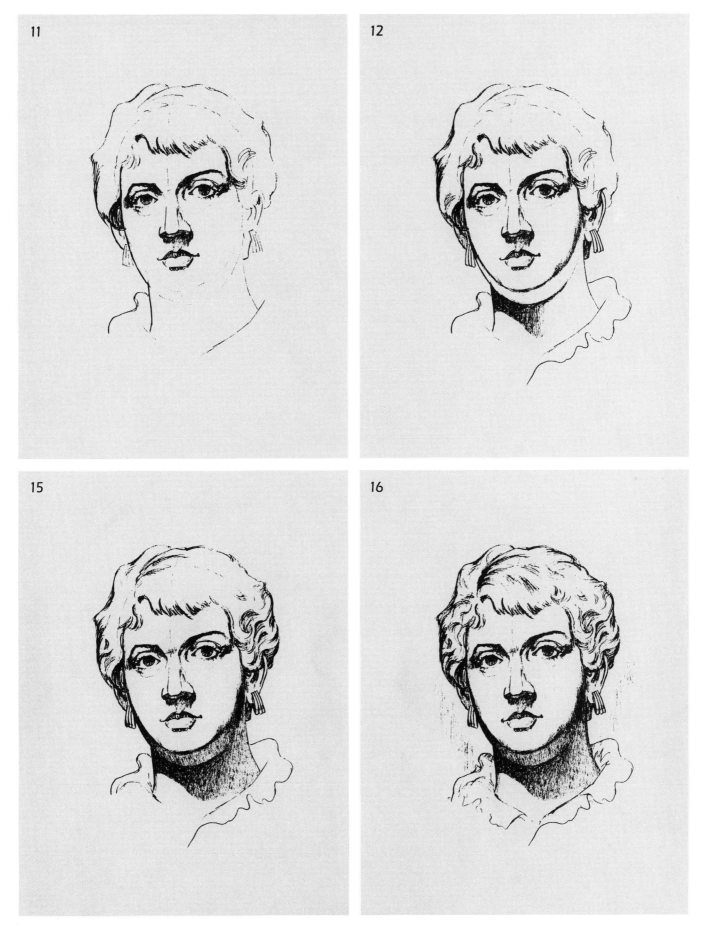

11

12

15

16

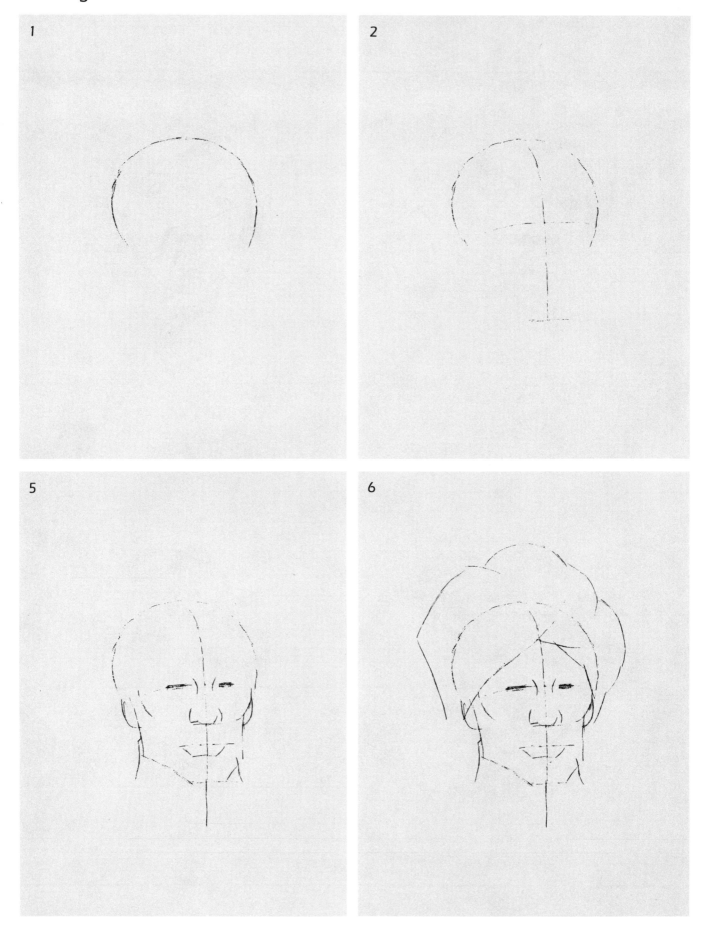

1

2

5

6

MAN WITH TURBAN

3

4

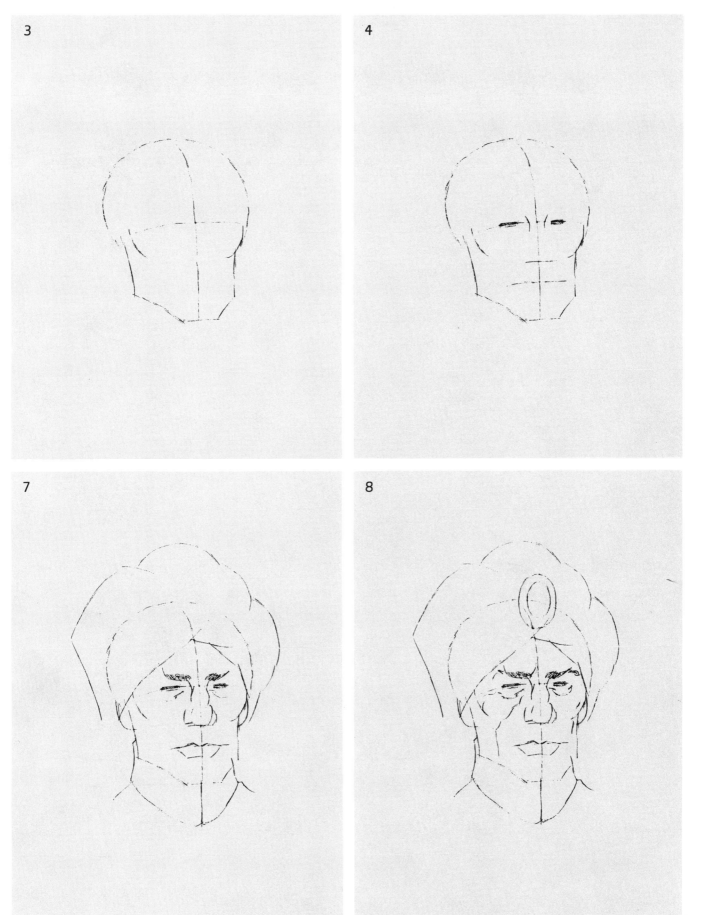

7

8

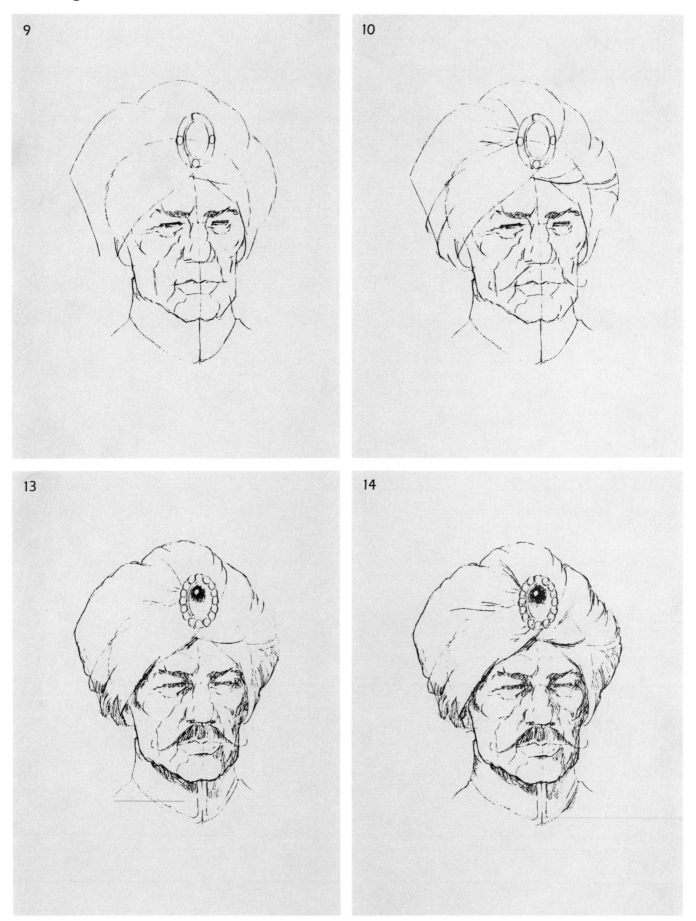

9

10

13

14

MAN WITH TURBAN

11

12

15

16

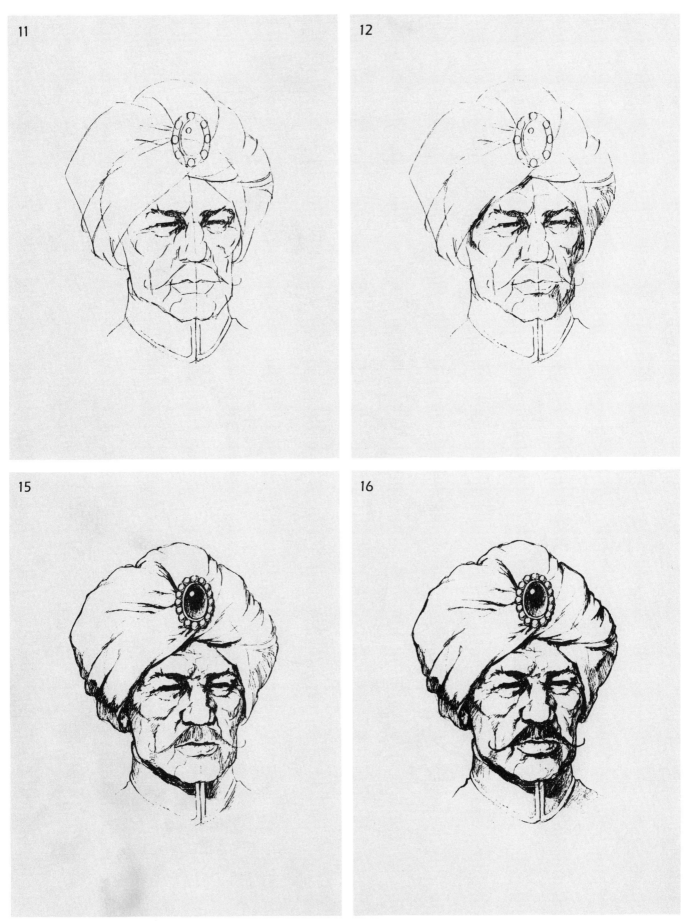

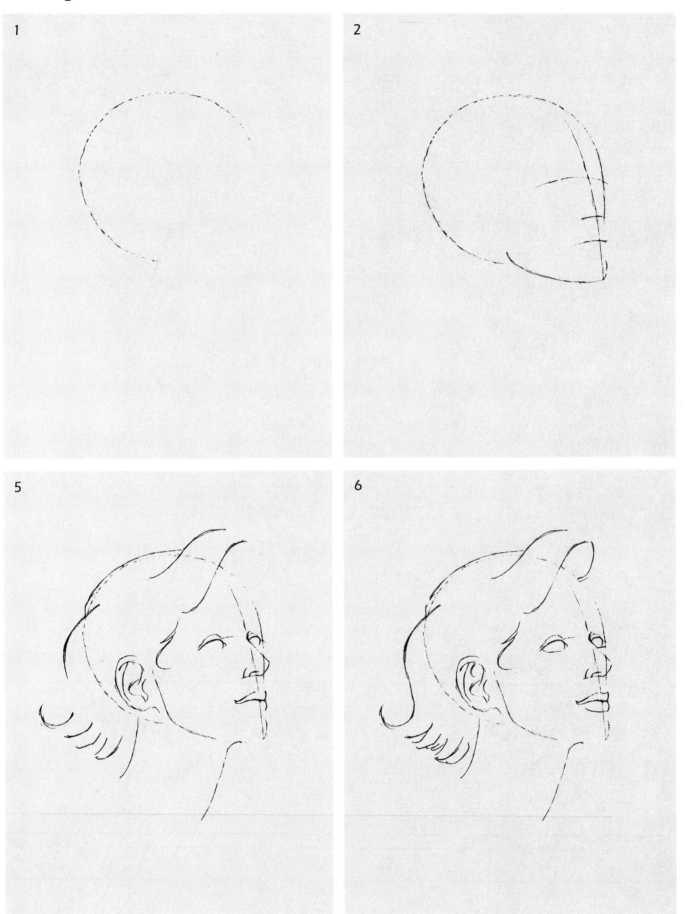

1

2

5

6

3

4

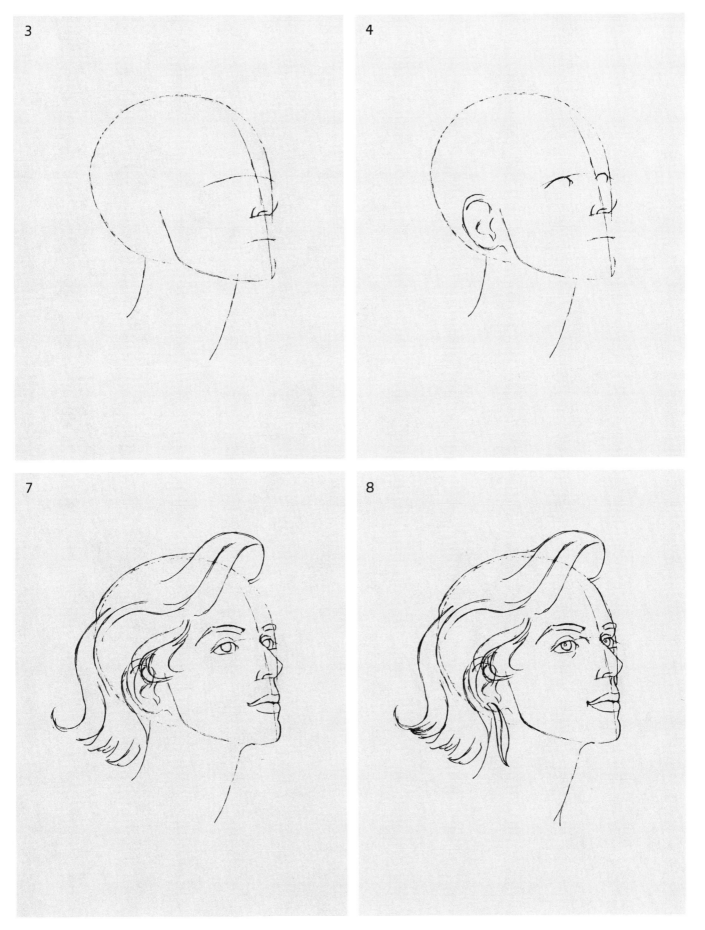

7

8

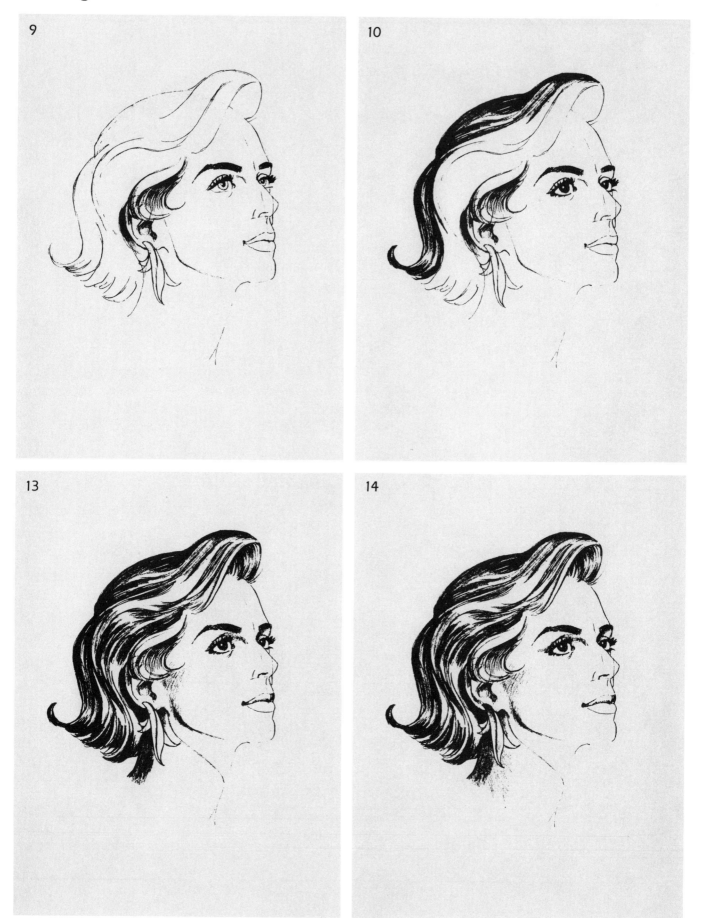

9

10

13

14

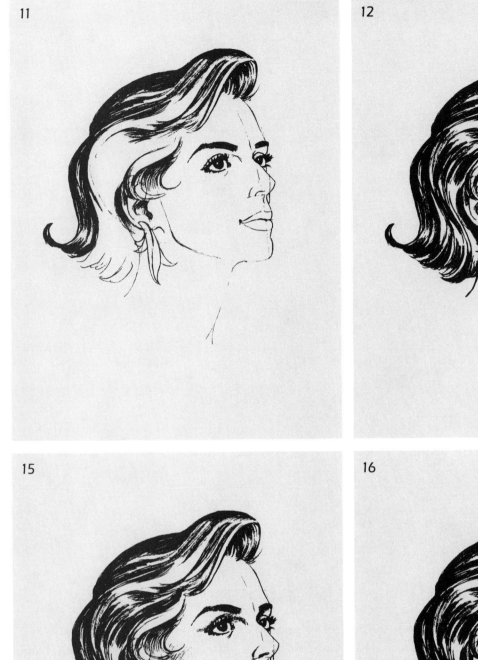

11

12

15

16

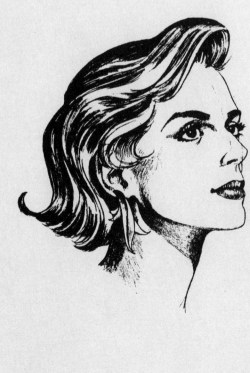

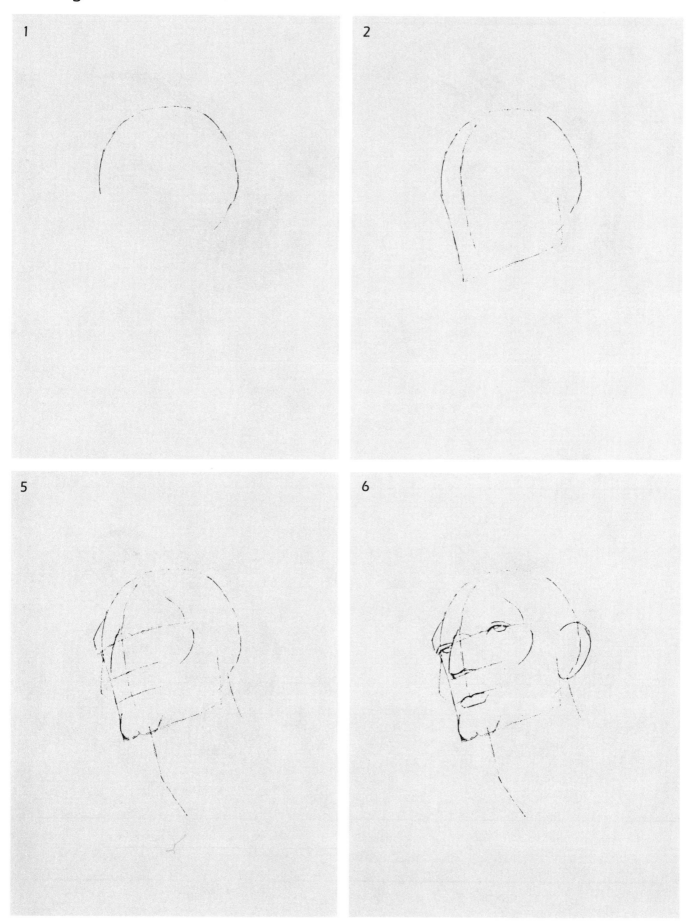

1

2

5

6

ANTHONY

3

4

7

8

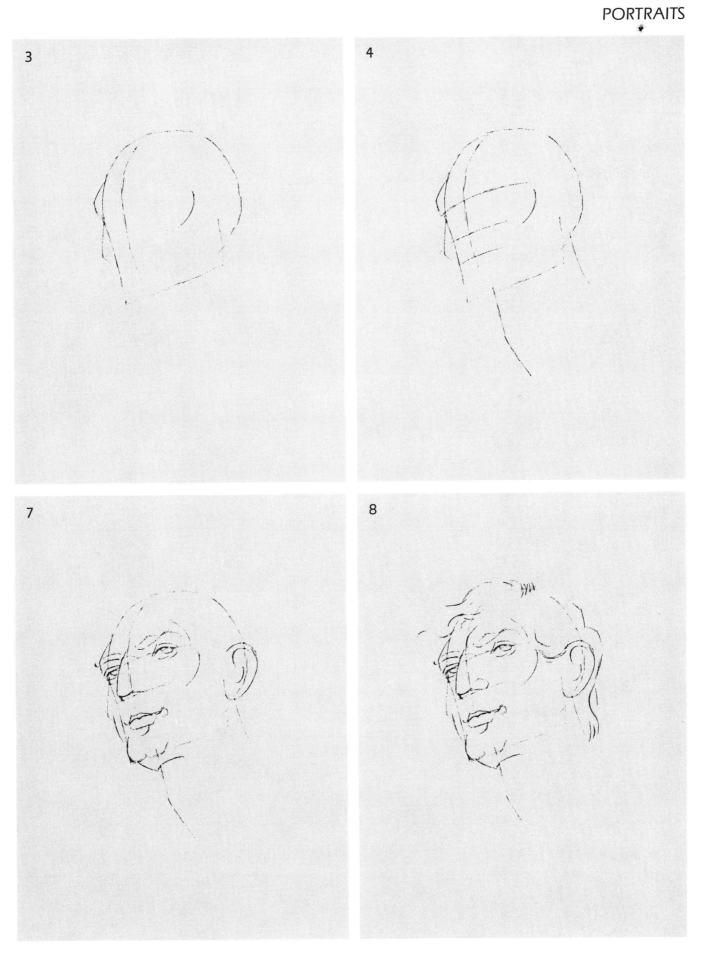

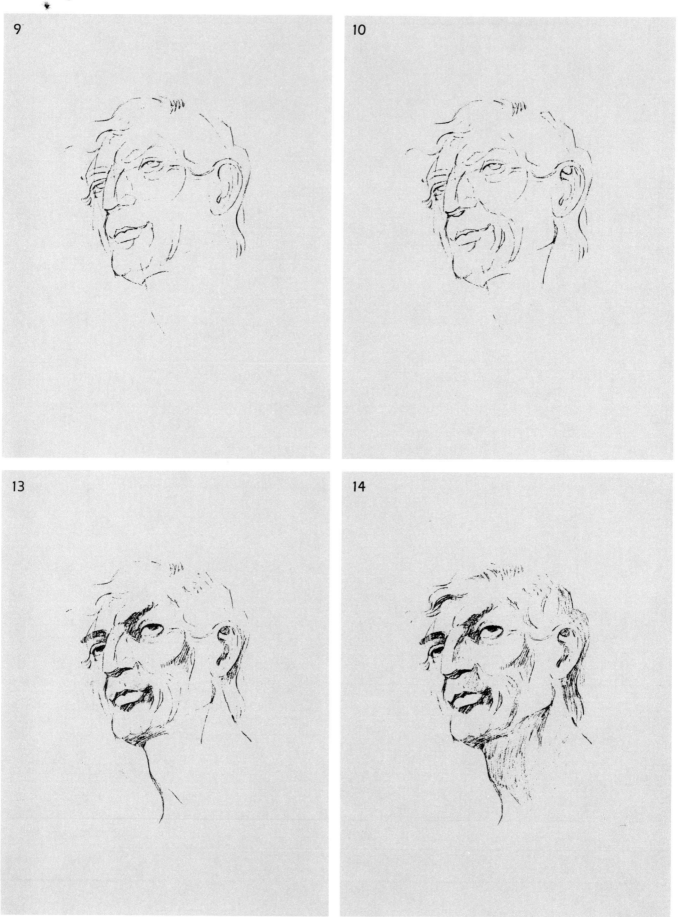

9

10

13

14

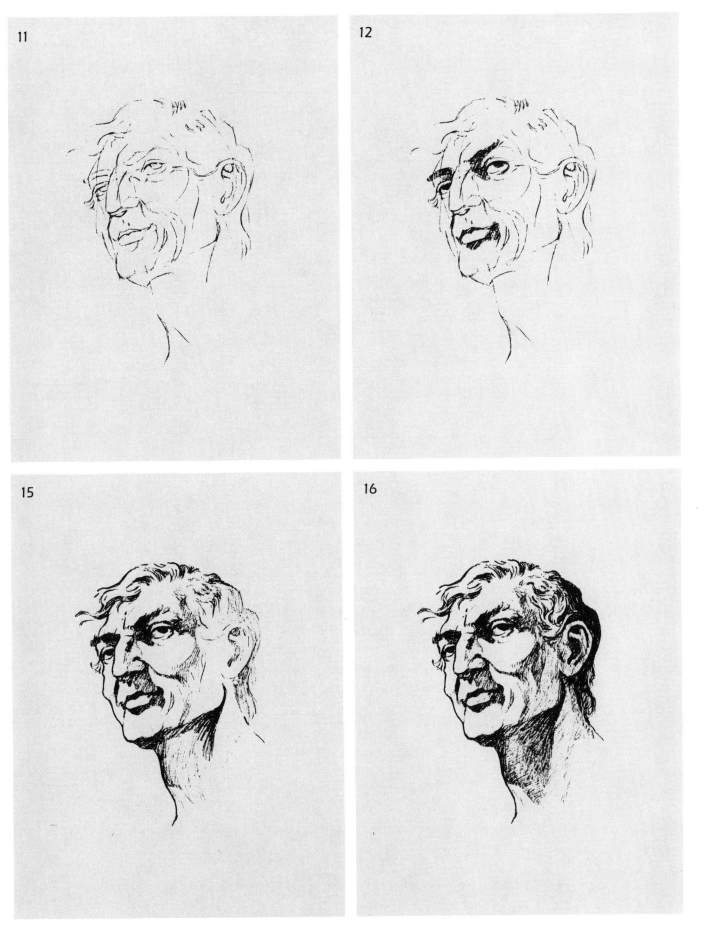

11

12

15

16

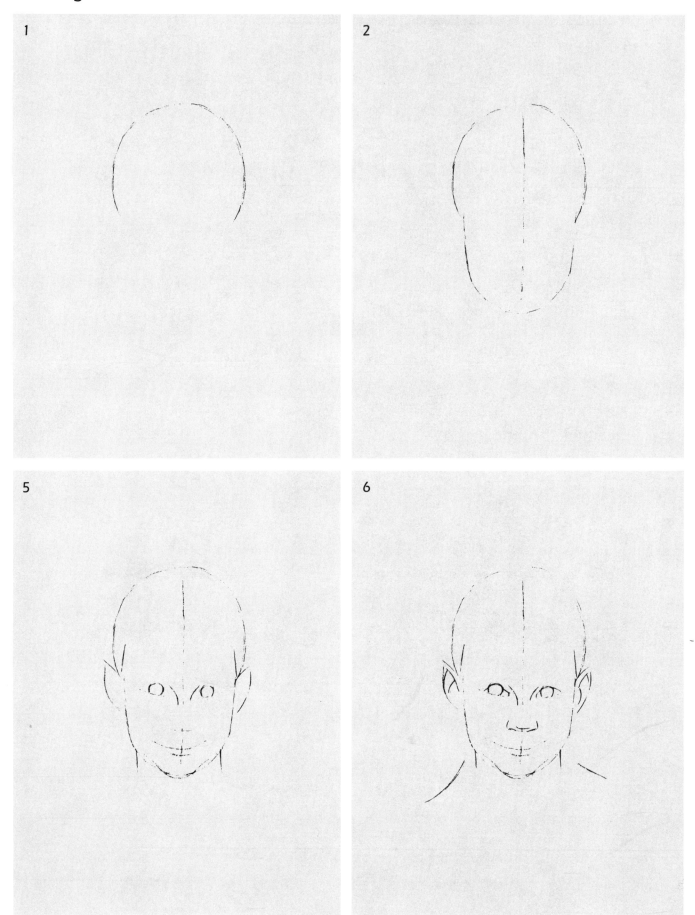

1

2

5

6

LAUREN

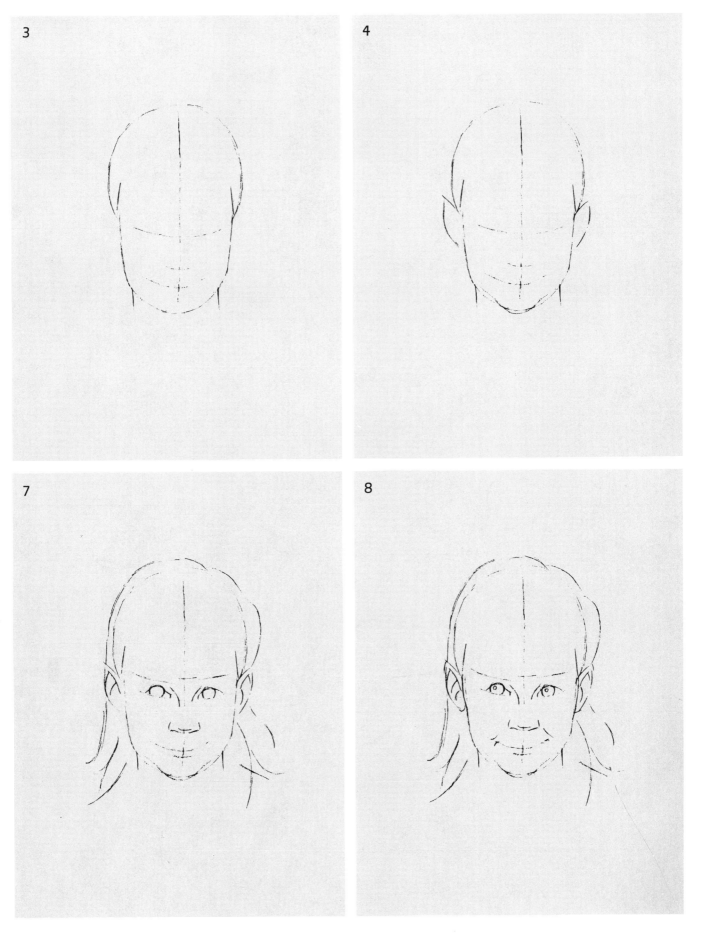

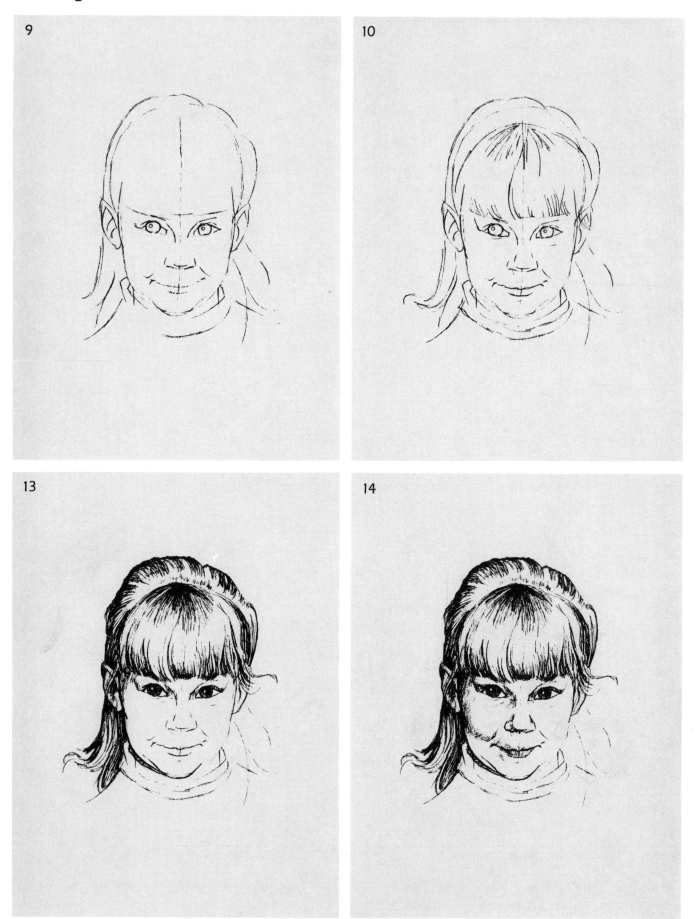

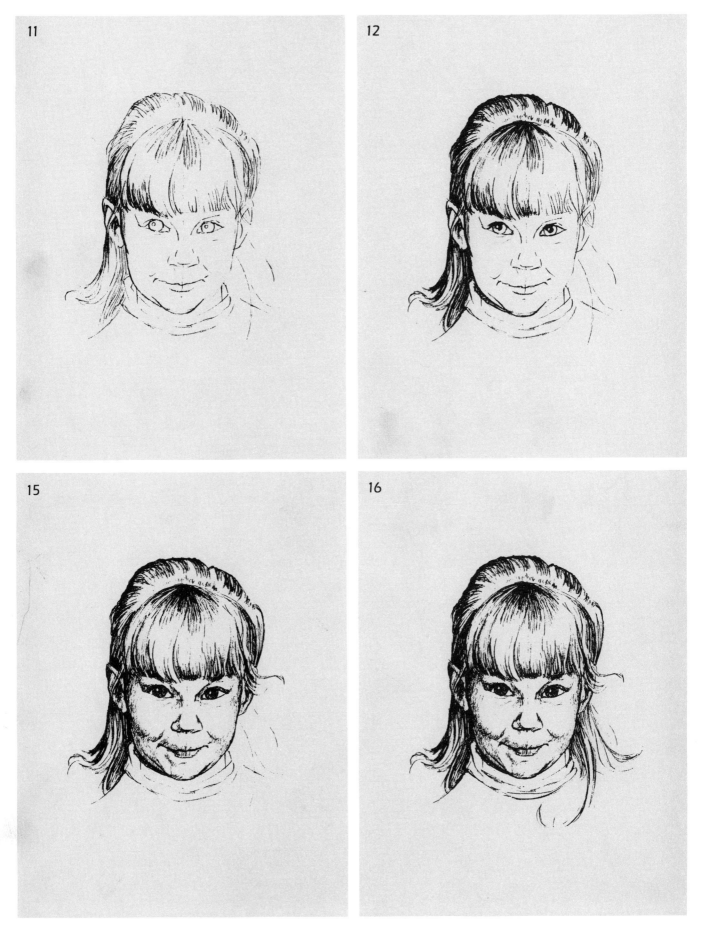

11

12

15

16

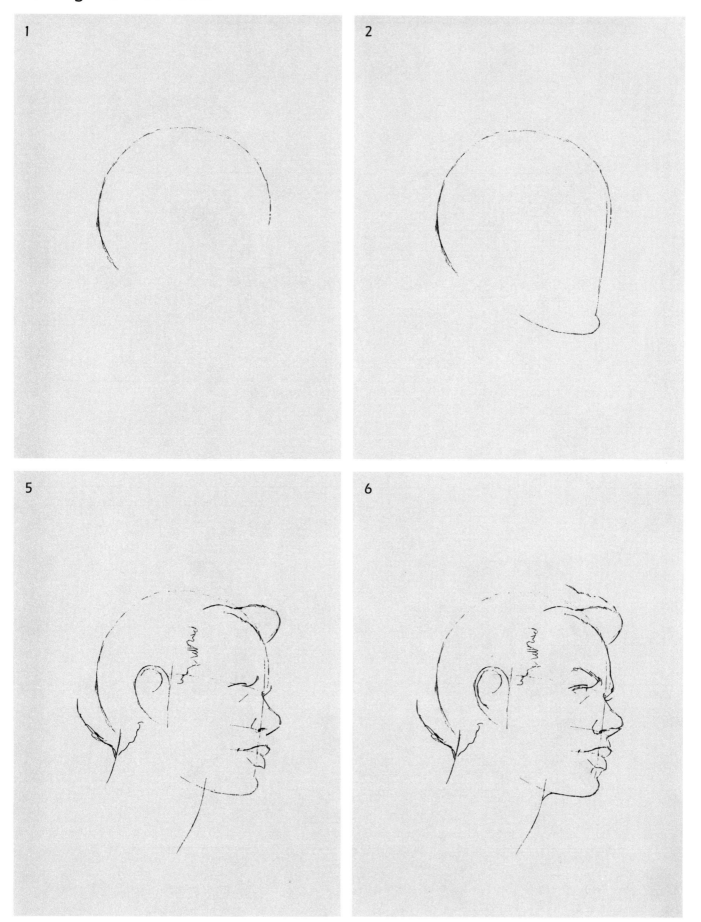

1

2

5

6

SYLVIA

3

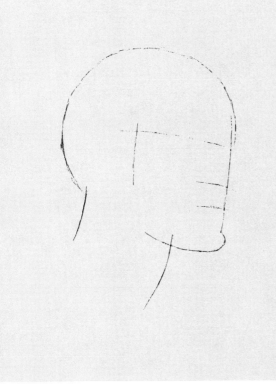

4

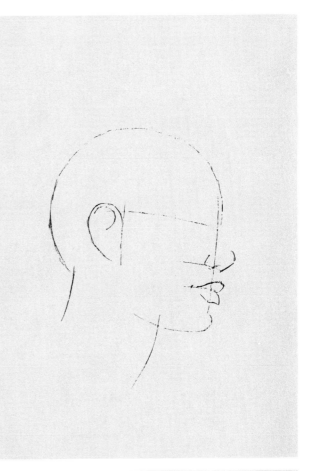

7

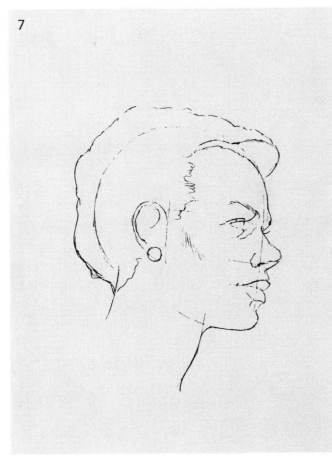

8

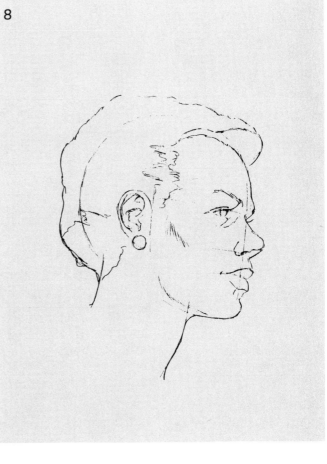

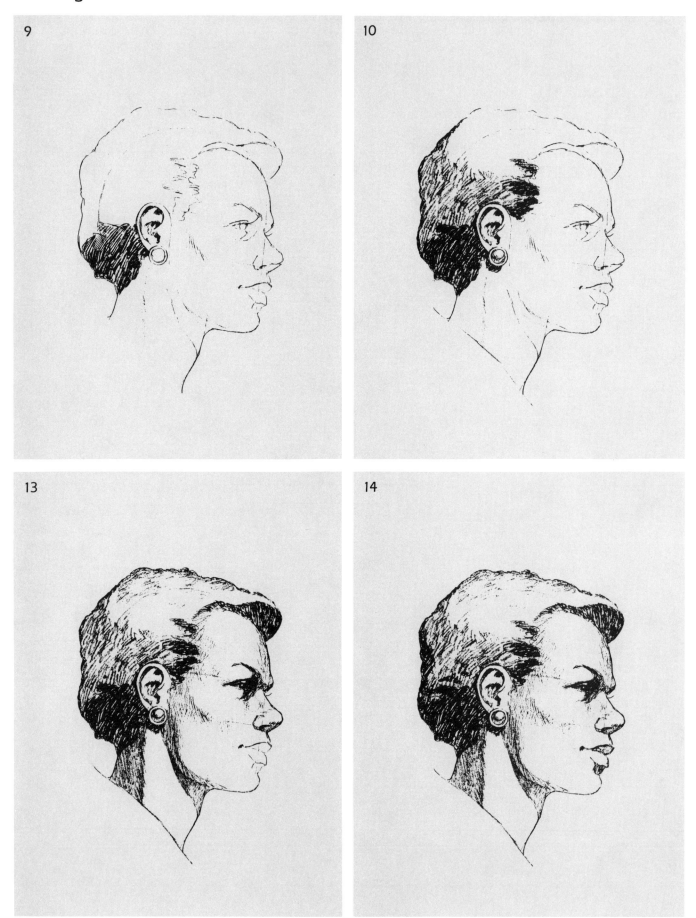

9

10

13

14

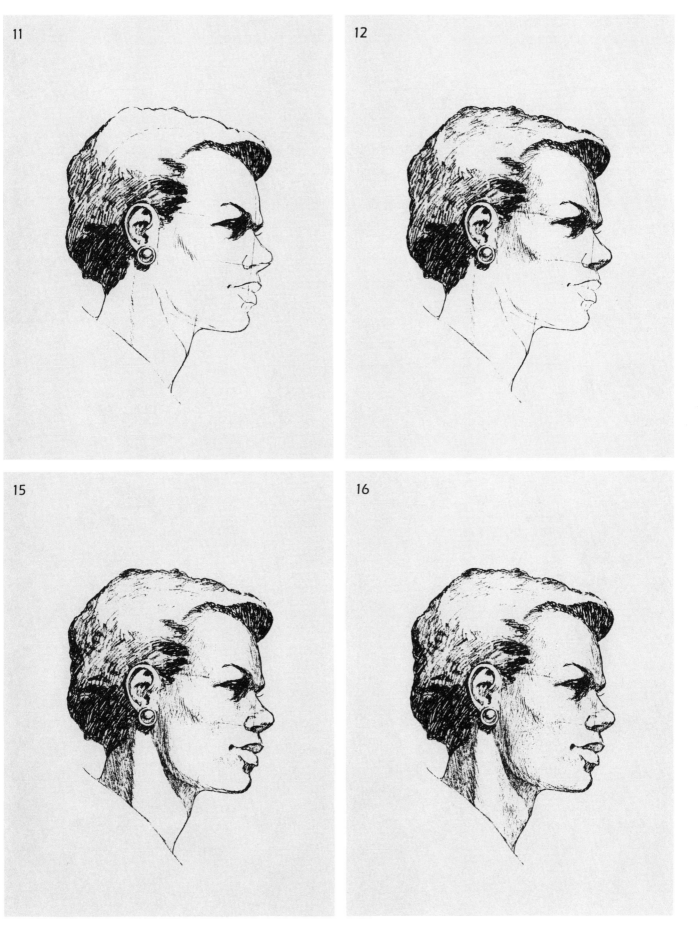

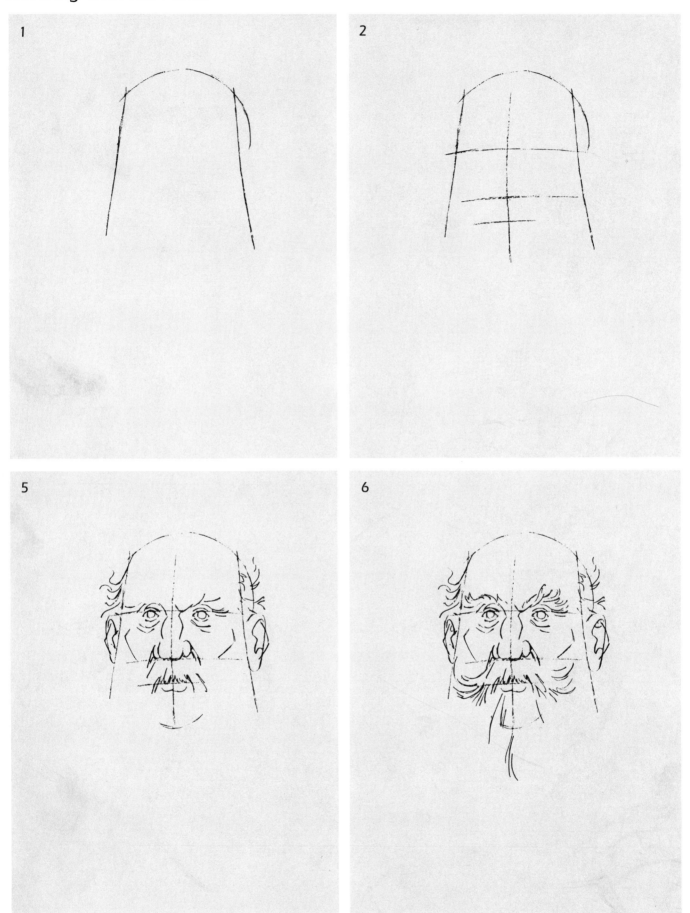

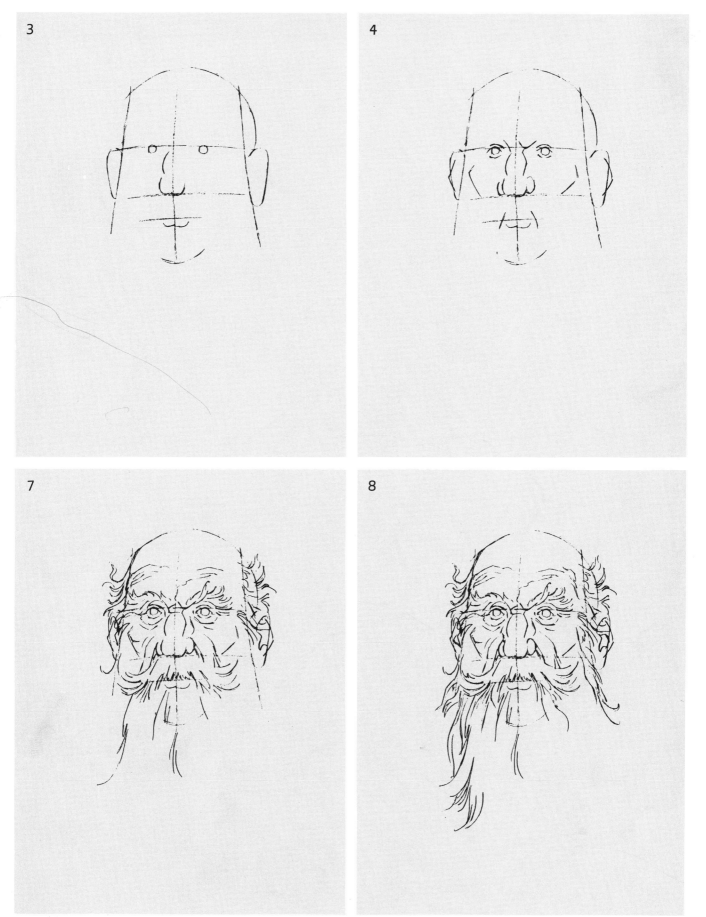

3

4

7

8

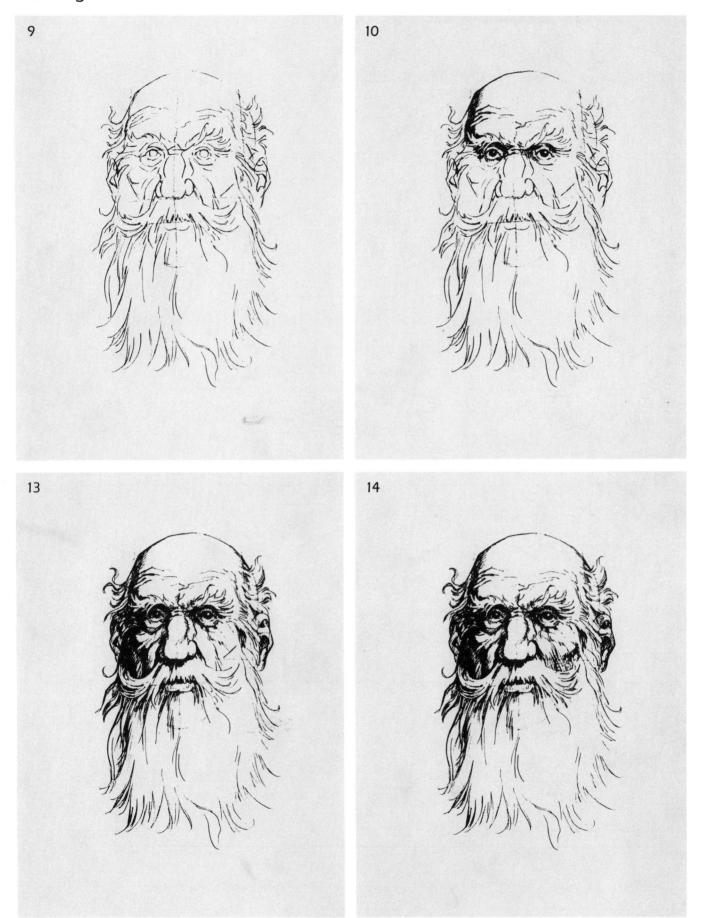

9

10

13

14

CALEB

11

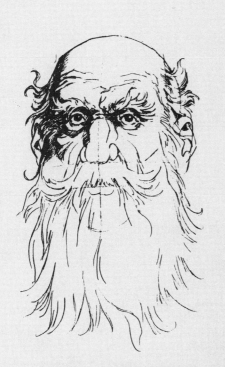

12

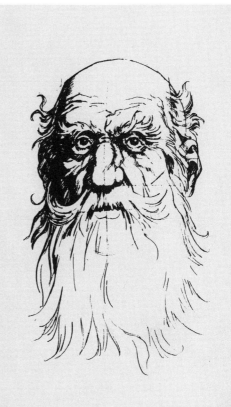

15

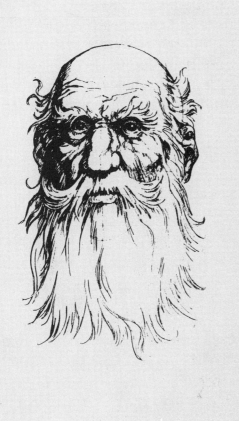

16

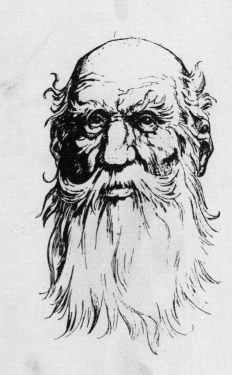

A Note on the Rough Sketching of the Preliminary Steps

The initial light steps used in this book that lead to the finished drawings are not quite like those I normally use. As mentioned on page 39, when I draw I'm not usually burdened by the need to condense the preliminaries to so few crucial steps. I can keep "roughing in," as you can, with many more "steps," until, somewhere in the broad stroking, the essential lines that seem correct can be sensed.

The sketches on these two pages are examples of the looser penciling, the light "scribbling" quality normally used. Remember, keep these basic constructions light.

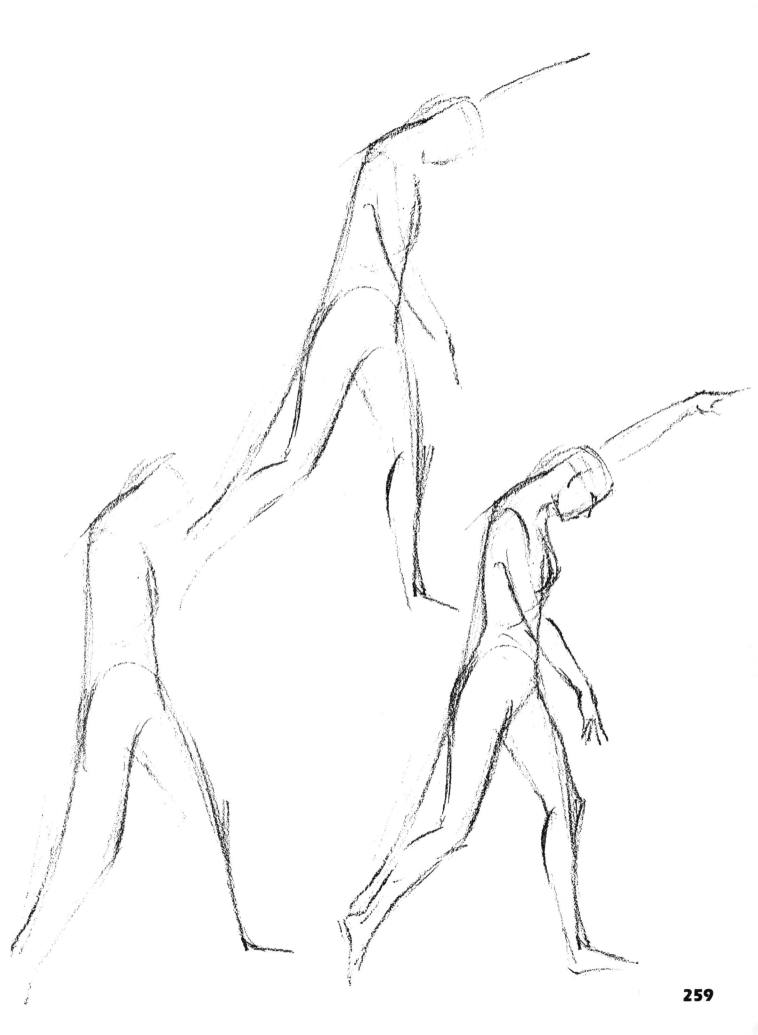

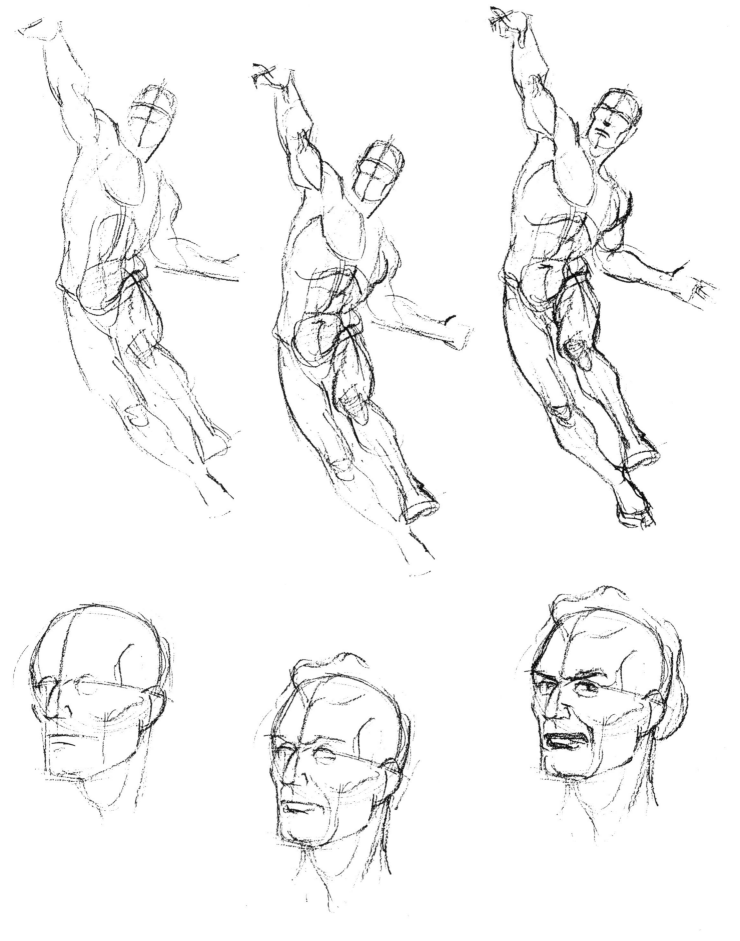

BIBLIOGRAPHY

Following are some of the books that have been helpful to me. There have been innumerable others, too many to list here. Some unfortunately, are no longer available. In fact, when it comes to the subject of art instruction I never found a book I didn't like. Each, at the very least, had something of value to offer.

Barcsay, Jeno
Anatomy for the Artist. Octopus Books, Ltd., 1975

Blake, Wendon, and Ferdinand Petrie
Starting to Draw (paperback) (The Artist's Painting Library). Watson-Guptill Publications, 1981

Bridgman, George Brant
Bridgman's Life Drawing. Dover Publications, 1971

Heads, Features and Faces. Dover Publications, 1974

The Human Machine. Dover Publications, 1972

Brown, Paul
Drawing the Horse—His Gaits, Points, and Conformation. Van Nostrand Reinhold, 1981 (among the very best illustrators of horses)

Croney, John
Drawing Figure Movement. Van Nostrand Reinhold, 1983

Edwards, Betty
Drawing on the Artist Within. Simon & Schuster, 1987 (Betty Edwards's revolutionary teaching method has proven to be notably successful)

Drawing on the Right Side of the Brain. Houghton Mifflin, 1980

Goldstein, Nathan
Figure Drawing: The Structure, Anatomy, and Expressive Design of the Human Form. Prentice-Hall, 1981

Gordon, Louise
How to Draw the Human Head: Techniques and Anatomy. The Viking Press, 1977 (study of the head in depth)

Henning, Fritz
Drawing and Painting Animals. North Light Books, 1981 (well-rounded, various treatments)

Hogarth, Burne
Drawing Dynamic Hands. Watson-Guptill Publications, 1977

Drawing the Human Head. Watson-Guptill Publications, 1965

Dynamic Anatomy. Watson-Guptill Publications, 1959

Johnson, Peter D., editor
Painting with Pastels. North Light Books, 1987 (landscapes, still lifes, buildings, people, animals)

László de Lombos, P. A.
Painting a Portrait. Studio Publications, 1934

Loomis, Andrew
Creative Illustration. The Viking Press, 1948

Figure Drawing for All It's Worth. The Viking Press, 1943

Three-dimensional Drawing. The Viking Press, 1958

Nicolaides, Kimon
The Natural Way to Draw. Houghton Mifflin, 1975

Parramon, J. M.
Drawing (paperback). HP Books, 1980

Pitz, Henry C.
Charcoal Drawing. Watson-Guptill Publications, 1981

How to Draw Trees. Watson-Guptill Publications, 1980

Reed, Walt, editor
The Figure: An Approach to Drawing and Construction. North Light Books, 1984 (a variety of approaches, techniques and constructions of the human figure)

Simpson, Ian
Drawing: Seeing and Observation. Van Nostrand Reinhold, 1981 (many drawing styles and approaches)

Painter's Progress. Van Nostrand Reinhold, 1983

Drawing with Lee Ames

Singer, Joe
How to Paint Figures in Pastel. Watson-Guptill Publications, 1980 (shows fine drawing in his ''painting'')

Taubes, Frederic
The Human Body: Aspects of Pictorial Anatomy. Clarkson N. Potter, Inc.

Vanderpoel, J. H.
The Human Figure. Dover Publications, 1935

Watson, Ernest W., and Aldren A. Watson
The Watson Drawing Book. Van Nostrand Reinhold, 1981

Zaidenberg, Arthur
How to Draw Period Costumes. Abelard-Schuman, 1966

Lee J. Ames has been ''drawing 50'' since 1974 when the first Draw 50 title — *Draw 50 Animals* — was published. Since that time, Ames has taught millions of people to draw everything from dinosaurs and sharks to boats, buildings, and cars. There are currently nineteen titles in the Draw 50 series and nearly two million books in print.

Ames divides his time between Long Island, New York — where he runs an art studio — and southern California. At the moment, he is working on a new drawing series for very young children.